THE WORLD'S MOST
AMAZING PLACES

CENTENNIAL BOOKS

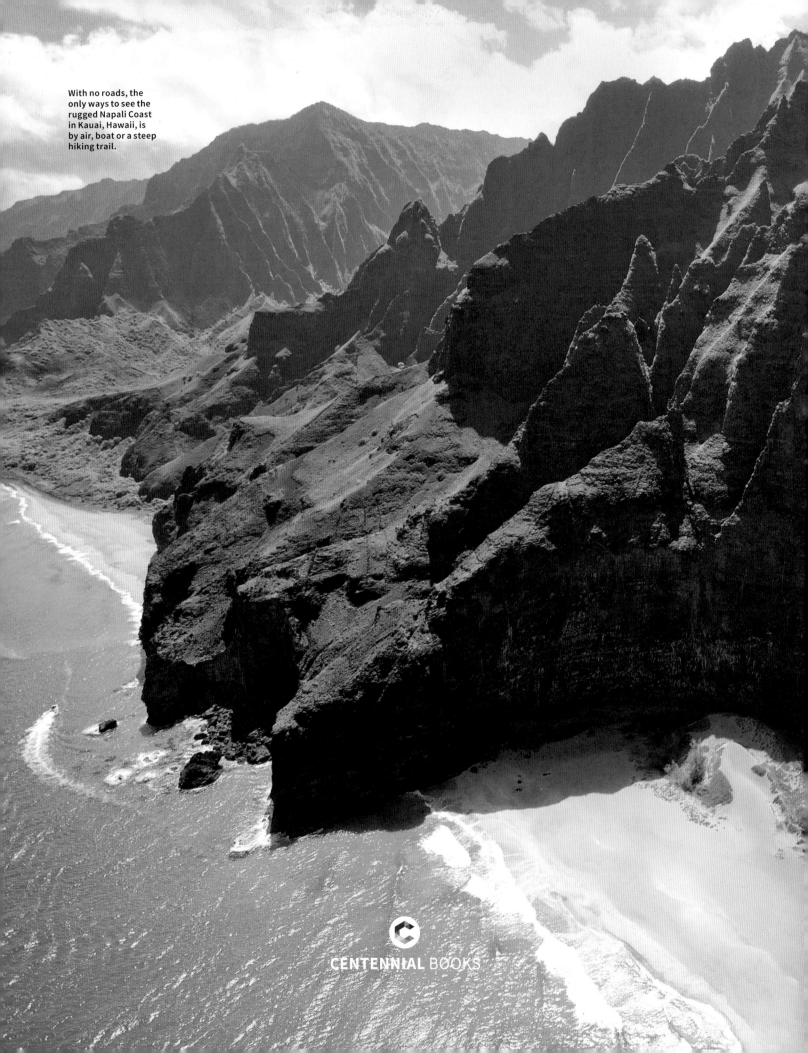

With no roads, the only ways to see the rugged Napali Coast in Kauai, Hawaii, is by air, boat or a steep hiking trail.

CENTENNIAL BOOKS

THE WORLD'S MOST
AMAZING PLACES

82 Destinations to See in Your Lifetime

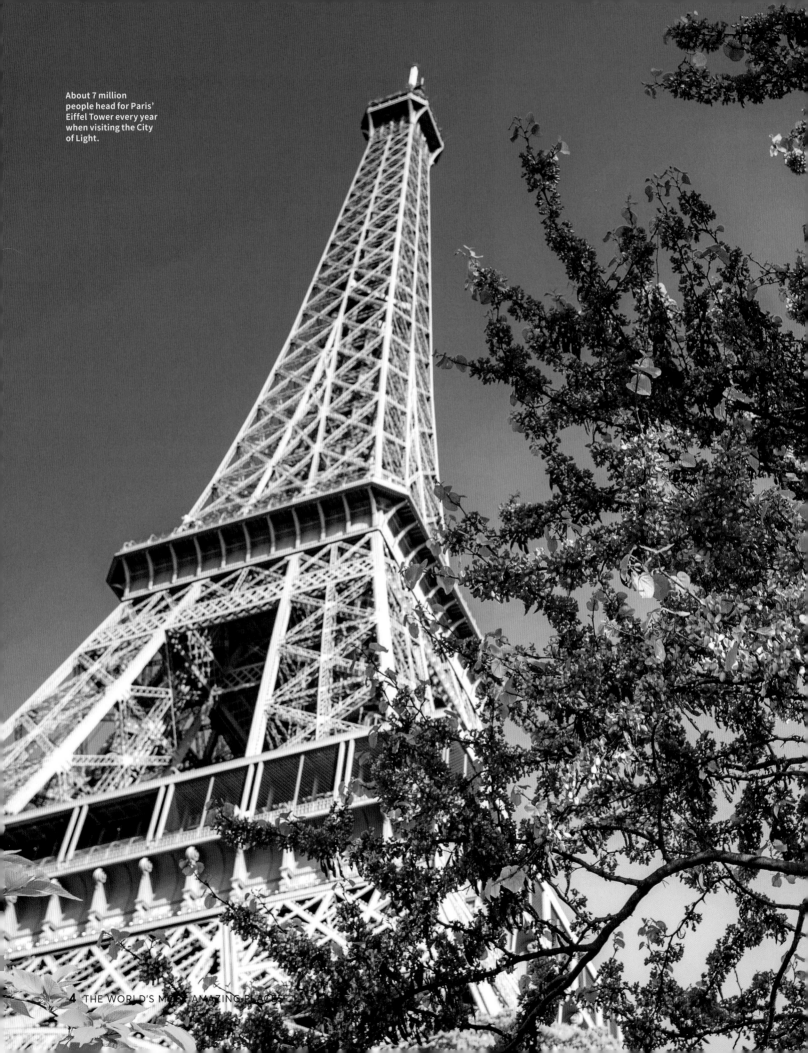

About 7 million
people head for Paris'
Eiffel Tower every year
when visiting the City
of Light.

CONTENTS

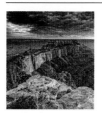

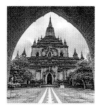

ON THE COVER The granite peaks of Los Cuernos del Paine are reflected in the still waters of Lago Nordenskjöld in Torres del Paine National Park, Patagonia, Chile. **Page 1:** Up to one third of China's 2,600-year-old Great Wall has disappeared under the ravages of time.

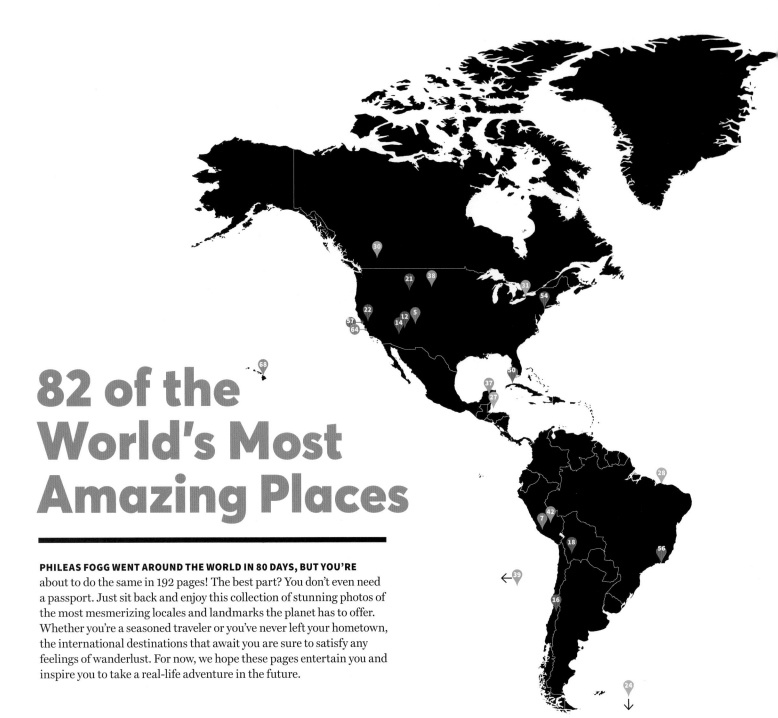

82 of the World's Most Amazing Places

PHILEAS FOGG WENT AROUND THE WORLD IN 80 DAYS, BUT YOU'RE about to do the same in 192 pages! The best part? You don't even need a passport. Just sit back and enjoy this collection of stunning photos of the most mesmerizing locales and landmarks the planet has to offer. Whether you're a seasoned traveler or you've never left your hometown, the international destinations that await you are sure to satisfy any feelings of wanderlust. For now, we hope these pages entertain you and inspire you to take a real-life adventure in the future.

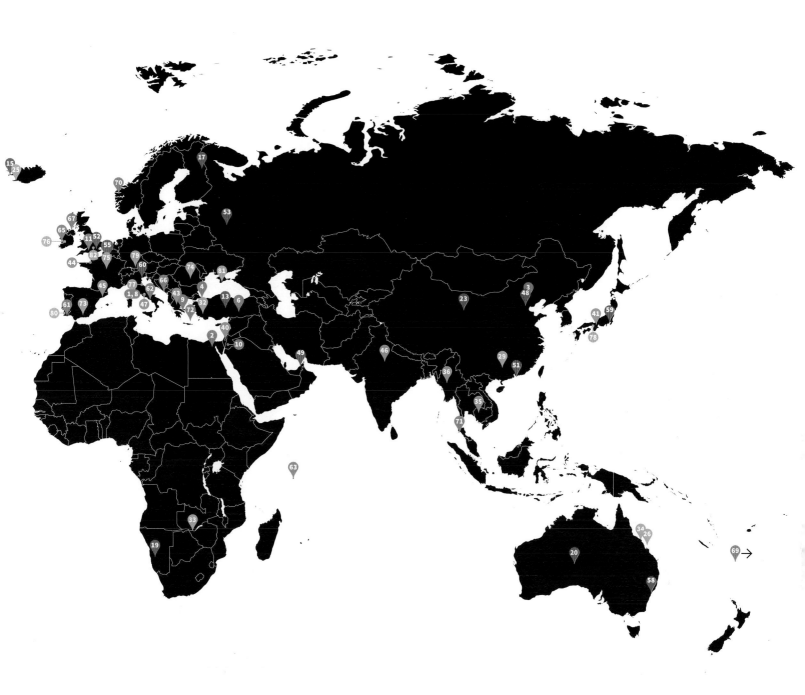

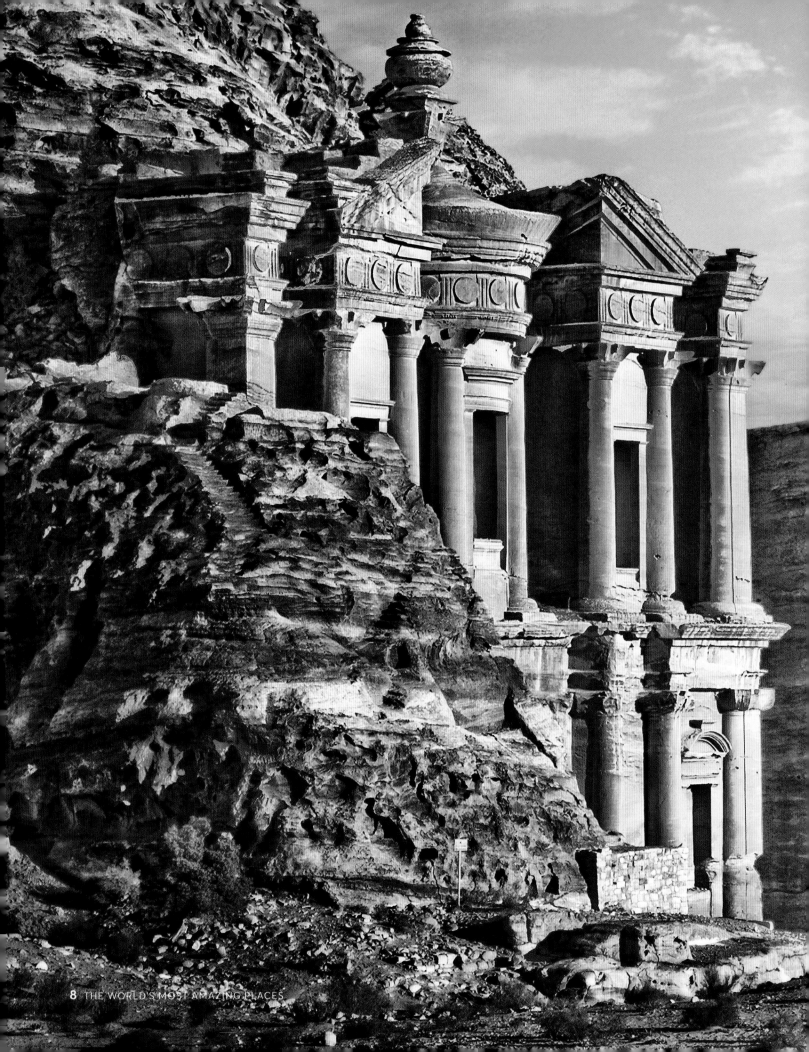

Ancient
MARVELS

CHAPTER
1

IF THE WALLS OF THESE LEGENDARY AND
AWE-INSPIRING MAN-MADE MONUMENTS COULD TALK,
THE STORIES THEY WOULD TELL WOULD BE ROOTED IN
SOME OF THE GREATEST EVENTS IN WORLD HISTORY.

In Petra, Jordan, sightseers must climb 800 rock steps to reach the Ad-Deir Monastery, a scenic hilltop temple.

9

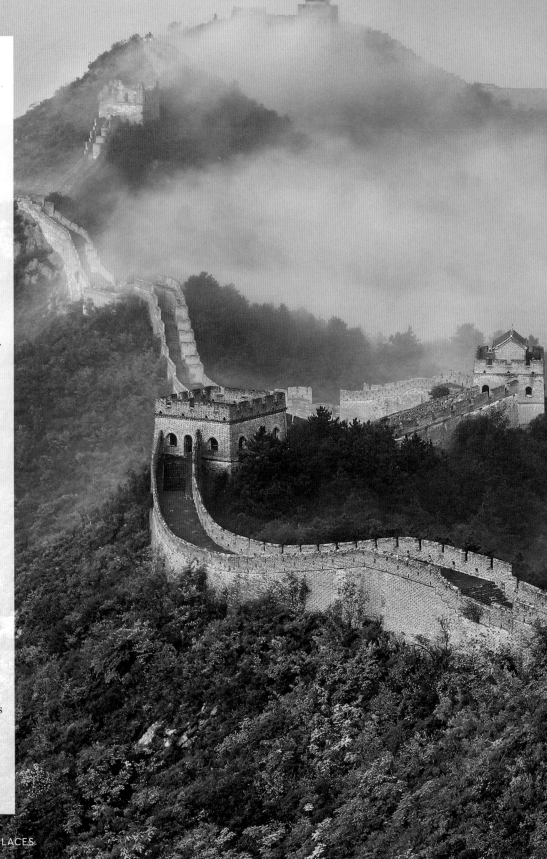

The Great Wall

CHINA

THE WORLD'S LONGEST WALL
(13,248 miles and counting) is rich
with irony: Built to keep invaders
out, it has become China's biggest
tourist attraction. Tens of millions
of people visit the Great Wall
annually, thanks to its 2,600-year
history and scenic path that snakes
across nine provinces—spanning
beaches, deserts, grasslands,
plateaus and, most famously,
rugged mountain ranges.

Designated as a UNESCO
World Heritage site in 1987, the
wall is not one continuous rampart
but a network of multiple walls,
watchtowers and fortresses
originally built in pieces by three
clashing kingdoms. At least six
dynasties reconstructed it over time.
Most of the wall that stands today—
the 5,500-mile section most people
recognize as the Great Wall—is a
relic of the Ming Dynasty, which
ruled from 1368 to 1644.

The majority of visitors pinpoint
the Badaling segment because of
its proximity to Beijing, less than
50 miles away. The first section of
the wall to open to the public (in
1957), Badaling has since welcomed
more than 370 foreign leaders
and celebrities. To the east, well-
preserved Mutianyu is the most
popular area for foreign tourists but
still less crowded than Badaling.
The dramatic Jiankou section,
with its unrestored ruins and
ultra-steep passes, is the most
photogenic—and dangerous.

Whatever section you climb,
comfortable shoes or hiking
boots are in order, as steps were
intentionally built at varying heights
to thwart enemies. But once you've
braved the sharp rises and taken
in the majestic surroundings, you
can count yourself a warrior among
those who defended their territories
all those centuries ago.

Seven sections of the 13,248-mile Great Wall are easily accessible by bus, train or taxi from Beijing.

China Highlights offers half- and full-day hiking tours of the most popular segments (plus multiday outings), while **Great Wall Hiking** prides itself on taking clients off the beaten track. For something less strenuous, cable cars are available in popular areas like **Badaling, Simatai, Jinshanling** and **Mutianyu**. In the last, a toboggan will even deliver riders back to the entrance. Combine bucket-list achievements with the Conquer the Wall marathon, held every May.

11

The Colosseum

ROME, ITALY

ONCE HOME TO BARBARIC FIGHTS meant to entertain emperors and rowdy spectators, the Colosseum is one of Italy's most famous icons. While the stadium is still an impressive sight today, it was especially stunning in its heyday.

Known as the Flavian Amphitheater, its outer walls were made of sparkling travertine stone, with floors and seats fashioned of polished marble. The top level of the exterior was adorned with gilded bronze shields and marble statues of emperors and gods posing in the alcoves.

Emperor Vespasian commissioned the stadium in A.D. 72, but his son and successor, Titus, completed the endeavor and celebrated its inauguration eight years later with games that lasted 100 days and nights. Designed to hold 50,000 spectators, the amphitheater boasted 80 entrances, each marked by a portico topped with a gilded horse-drawn chariot.

Romans gathered to watch brutal events like gladiator contests, wild-animal hunts and religious sacrifices—even mock naval battles (with very real deaths). The arena was outfitted with trap doors leading to the hypogeum, a maze of underground passageways and chambers where animals were kept until they were unleashed onto the main floor via pulley system.

After four centuries, the Colosseum was abandoned with the fall of the Roman Empire. Restoration efforts began in the 1990s and continue to this day, ensuring the UNESCO site remains Rome's most popular attraction, drawing more than 7 million visitors per year.

Low season (November through March) is the best time to visit, although crowds are thick year-round. Arrive before 8:30 a.m., or purchase tickets online in advance to avoid long entry lines. The site is mostly ruins, so a certified tour guide can really help paint the picture of the Colosseum's glory days and offer VIP access to restricted areas. Splurge at the **Rome Cavalieri**, a **Waldorf Astoria Hotel** that offers spectacular views thanks to its perch on one of the Seven Hills of Rome.

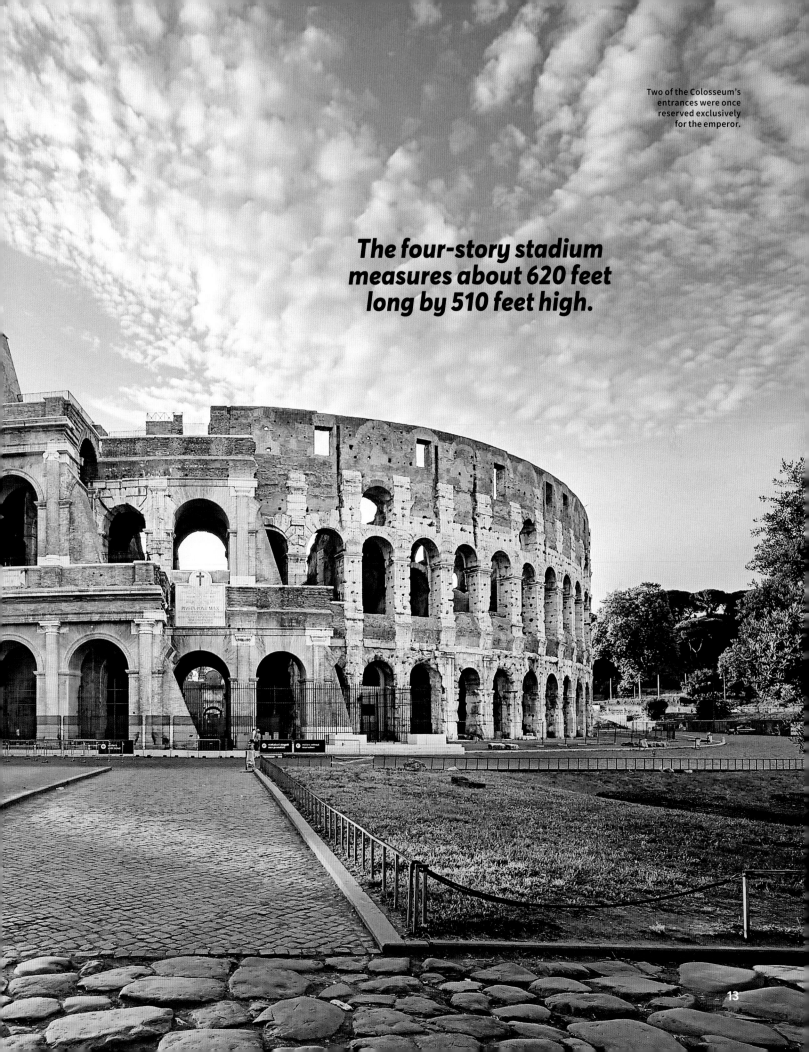

Two of the Colosseum's entrances were once reserved exclusively for the emperor.

The four-story stadium measures about 620 feet long by 510 feet high.

Petra

JORDAN

THE BUILDUP TO PETRA'S MOST famous attraction is dramatic: Visitors walk three-quarters of a mile through a narrow gorge, called the Siq, in the middle of a mountain range that connects the Dead Sea to the Gulf of Aqaba. They emerge on the other side, and there—towering 140 feet tall—is the Treasury, carved into the side of a 656-foot sheer sandstone face by the Nabataeans, an early Arab people.

The detail of this ancient temple is mesmerizing, from the Corinthian columns to the friezes and figures. The crown piece is a funerary urn, rumored to contain treasure that once belonged to a pharaoh.

Petra's origin date remains elusive. Historians estimate it was built as early as the fifth century B.C. But some maintain the city dates back to the time of Moses, when Egyptian pharaohs relied on Petra to bank their great wealth. Truly, the entire site—once called the Lost City of Petra—was the stuff of legends until an 1812 rediscovery by Swiss explorer Johann Ludwig Burckhardt.

Beyond the Treasury, Petra is home to an entire collection of wonders. A similar temple is the 148-foot Monastery, believed to honor a first-century king. Nearby lies an 8,500-capacity amphitheater etched into the mountains. For some, the greatest engineering feat is the city's hydrology system of pipes and waterways: Set at a four-degree angle and spanning 5 miles, it delivered the water that made all the carving possible.

Petra's 140-foot-
tall Treasury
(Al Khazneh) once
functioned as a
royal tomb.

Ample trails link the
ancient sites, and the
common ones are easy
to find. To explore
lesser-trod paths, like
the two-hour trail to the
vantage overlooking the
Treasury, hire a guide.
Travel companies such as
Kensington Tours and
Intrepid Travel offer
multiday itineraries that
include Petra and other
stops such as the **Dead
Sea** and **Wadi Rum**.

Stonehenge

WILTSHIRE, ENGLAND

WAS IT A TEMPLE CREATED FOR THE worship of ancient deities? An astronomical observatory? A sacred burial site? A place of healing? So much of Stonehenge's allure stems from the mysteries of its prehistoric purpose and cultural significance.

Believed to be built and used by Neolithic and Bronze Age inhabitants between 3700 and 1600 B.C., the monument originated as a massive circular ditch and bank, called a henge, dug on Salisbury Plain using primitive tools. An estimated 80 bluestones—some weighing up to 4 tons and hauled, incredibly, 200 miles from the Preseli Hills in Wales—were added several hundred years later (43 remain). Around 2000 B.C., at least 50 sarsen stones were positioned to form the monument's outer arc. Builders continued to tinker with the bluestones, arranging and rearranging them, until roughly 1600 B.C. Modern theories speculate the transportation and erection of Stonehenge's monoliths required substantial manual labor using sledges, rafts, ropes, levers, teams of oxen and hundreds of men.

The real wonder of this UNESCO World Heritage site lies in seeing it in person, surrounded by esoteric burial mounds and sheep grazing in the misty countryside. Close contact has been prohibited since 1978, but even separated by rope from these ancient circles, visitors are struck by their mystical aura, eerie symmetry and impressive stature (the tallest sarsen is 24 feet). In his 1891 novel *Tess of the d'Urbervilles*, Thomas Hardy described Stonehenge as "a very temple of the winds." That depiction still rings true today.

If you really must touch the stones, plan a visit during the English Heritage's **Managed Open Access** events during the summer and winter solstices, as well as the spring and fall equinoxes (no climbing on the rocks). Additional nearby points of interest include the henge monument of **Avebury**, the Roman-era baths in **Bath** and the **Salisbury Cathedral**, home to one of the four original copies of the Magna Carta.

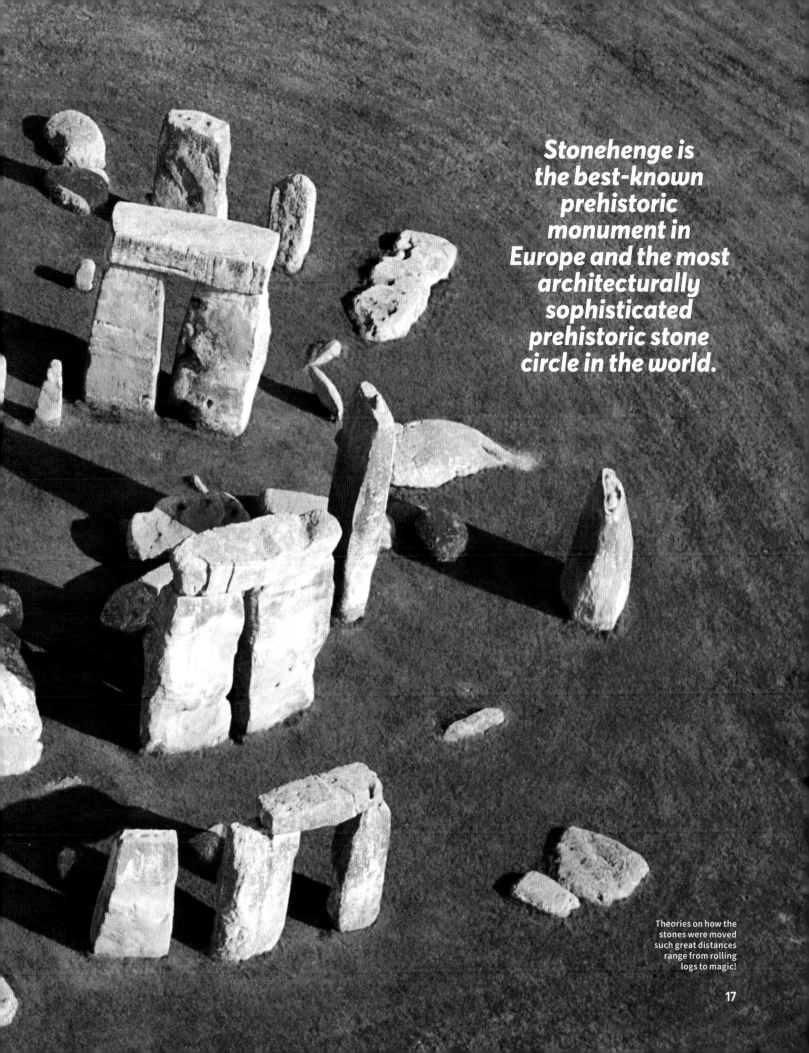

Stonehenge is the best-known prehistoric monument in Europe and the most architecturally sophisticated prehistoric stone circle in the world.

Theories on how the stones were moved such great distances range from rolling logs to magic!

Hagia Sophia

ISTANBUL, TURKEY

CONSIDERED THE PINNACLE OF Byzantine architecture and artisanship, the Hagia Sophia was the largest building on Earth when it was constructed in six short years between 531 and 537—and remained the greatest cathedral in the world for another millennium after that. Its lofty 105-foot-wide dome appears to float in the air, thanks to its unique design that features rows of stone columns transported from the ancient Greek city of Ephesus. Minutely detailed mosaics glow gold in the light from high-arched windows, while the floors and larger support columns are patterned in multiple colors of marble.

Set on the site of a former pagan temple, the Hagia Sophia, whose name translates as Church of Divine Wisdom, was built by the Emperor Justinian as the main seat of the Eastern Orthodox church and a symbol of the power of Constantinople. Its tumultuous history also included a relatively brief 60-year stint as a Roman Catholic cathedral during the 13th-century crusades. Finally, when Constantinople fell to the Ottoman Empire in 1453, the Hagia Sophia became a mosque with the addition of minarets and an overlay of Islamic art.

Since becoming a museum in 1934 at the instigation of Turkish President Kemal Atatürk, the Hagia Sophia— or Ayasofya in Turkish—has undergone refurbishments to restore and preserve its Byzantine splendor, while also maintaining its Islamic heritage. Today this magnificent monument is a key component of the UNESCO World Heritage site that encompasses the historic areas of Istanbul.

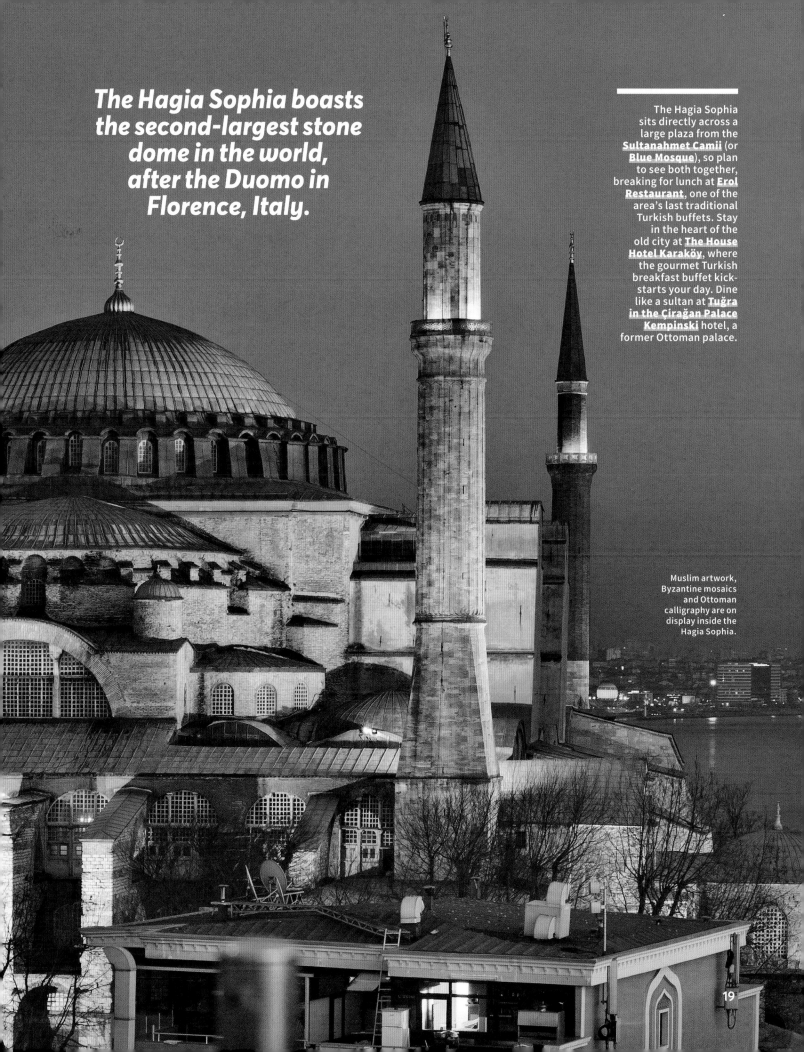

The Hagia Sophia boasts the second-largest stone dome in the world, after the Duomo in Florence, Italy.

The Hagia Sophia sits directly across a large plaza from the **Sultanahmet Camii** (or **Blue Mosque**), so plan to see both together, breaking for lunch at **Erol Restaurant**, one of the area's last traditional Turkish buffets. Stay in the heart of the old city at **The House Hotel Karaköy**, where the gourmet Turkish breakfast buffet kick-starts your day. Dine like a sultan at **Tuğra in the Çirağan Palace Kempinski** hotel, a former Ottoman palace.

Muslim artwork, Byzantine mosaics and Ottoman calligraphy are on display inside the Hagia Sophia.

Mesa Verde

COLORADO, USA

Time your trip from April through October, and plan to spend more than four hours in the park—it takes at least two hours to drive in and out. Ranger-guided tours are required to see Cliff Palace, Balcony House and Long House. Tickets can only be purchased in person and sell out quickly, so arrive early or book for the following day. Cliff dwellings are at high altitudes (7,000 feet), and visiting can be strenuous. Expect steep, uneven conditions with steps or ladders. Lodging options inside the park include RV and tent camping at **Morefield Campground**, or comfortable hotel rooms at **Far View Lodge**.

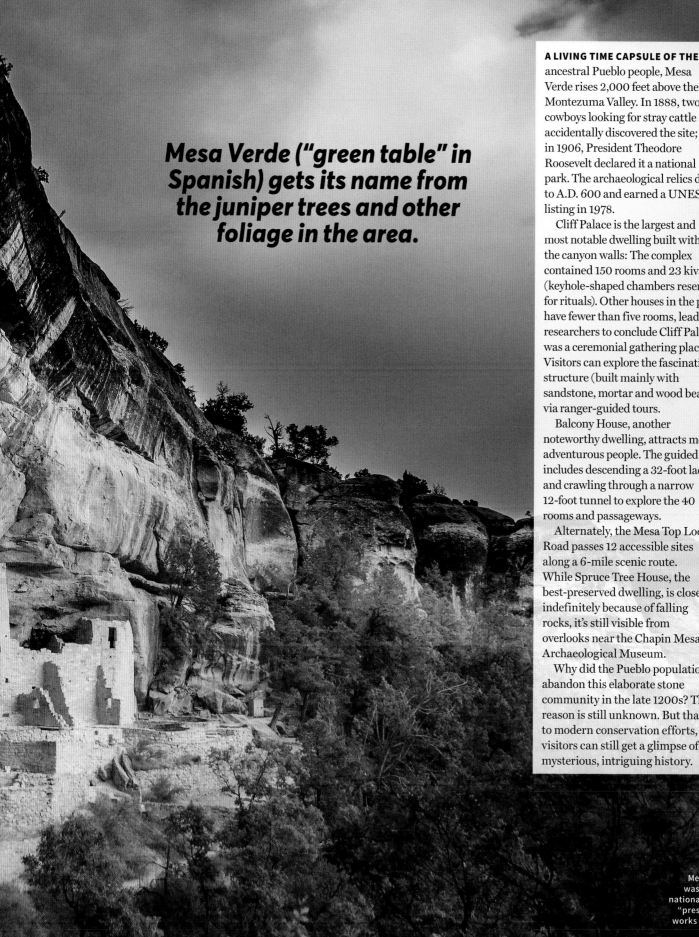

Mesa Verde ("green table" in Spanish) gets its name from the juniper trees and other foliage in the area.

A LIVING TIME CAPSULE OF THE ancestral Pueblo people, Mesa Verde rises 2,000 feet above the Montezuma Valley. In 1888, two cowboys looking for stray cattle accidentally discovered the site; in 1906, President Theodore Roosevelt declared it a national park. The archaeological relics date to A.D. 600 and earned a UNESCO listing in 1978.

Cliff Palace is the largest and most notable dwelling built within the canyon walls: The complex contained 150 rooms and 23 kivas (keyhole-shaped chambers reserved for rituals). Other houses in the park have fewer than five rooms, leading researchers to conclude Cliff Palace was a ceremonial gathering place. Visitors can explore the fascinating structure (built mainly with sandstone, mortar and wood beams) via ranger-guided tours.

Balcony House, another noteworthy dwelling, attracts more adventurous people. The guided tour includes descending a 32-foot ladder and crawling through a narrow 12-foot tunnel to explore the 40 rooms and passageways.

Alternately, the Mesa Top Loop Road passes 12 accessible sites along a 6-mile scenic route. While Spruce Tree House, the best-preserved dwelling, is closed indefinitely because of falling rocks, it's still visible from overlooks near the Chapin Mesa Archaeological Museum.

Why did the Pueblo population abandon this elaborate stone community in the late 1200s? The reason is still unknown. But thanks to modern conservation efforts, visitors can still get a glimpse of their mysterious, intriguing history.

Mesa Verde was the first national park to "preserve the works of man."

21

Pantheon

ROME, ITALY

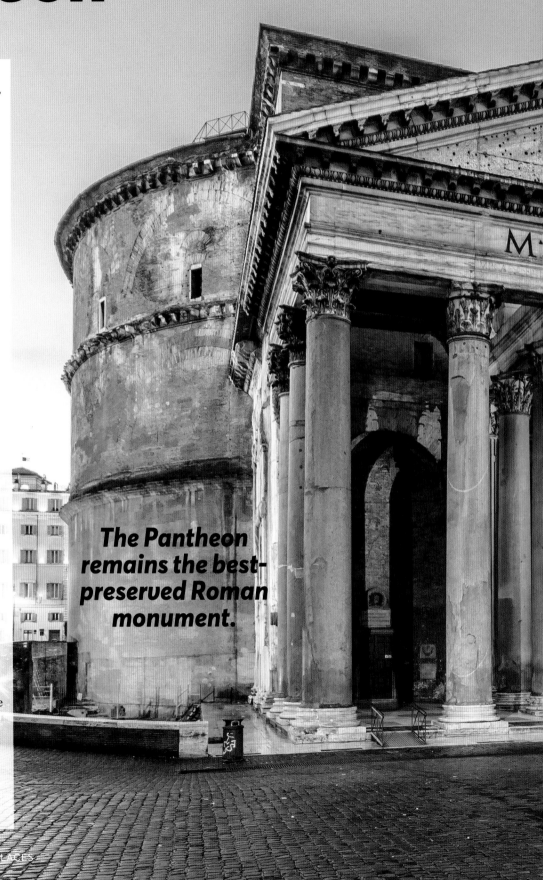

READING ABOUT THE PANTHEON in history books is impressive enough, but seeing it up close is unforgettable. Completed in A.D. 125, it stands almost untouched by the 2,000 years of human history that have passed since it was finished during the reign of Hadrian. The grand dome with its open oculus remains the largest ever built of unreinforced concrete, a timeless testament to the genius of ancient Roman architects. Interestingly, no one knows for certain the Pantheon's original purpose; however, its name comes from the Greek word *pan*, meaning all, and *theos*, meaning gods, suggesting it may have been used as a temple.

What visitors see today is actually the third Pantheon, built on the site of two earlier buildings, the first destroyed by fire and the second by lightning. The inscription over the columned entrance dedicates the current Pantheon to statesman Marcus Agrippa, who built the second Pantheon. The smaller inscription, which dates to A.D. 202, reads: "With every refinement they restored the Pantheon, worn by age," showing the architects' commitment to durability. Once covered in sheets of bronze, the Pantheon would have shone in the sun, suggesting the might and wealth of the Roman Empire.

In the Piazza della Rotonda stand an elegant fountain and the Obelisco Macutèo, which once stood at the Temple of Ra Heliopolis. Inside the Rotonda, highlights include elaborate marble and gilt decorations and the tombs of the painter Raphael, composer Corelli and the Italian kings Victor Emmanuel II and Umberto I. Mass is still held on Saturday evenings and Sunday mornings and is open to visitors.

The Pantheon remains the best-preserved Roman monument.

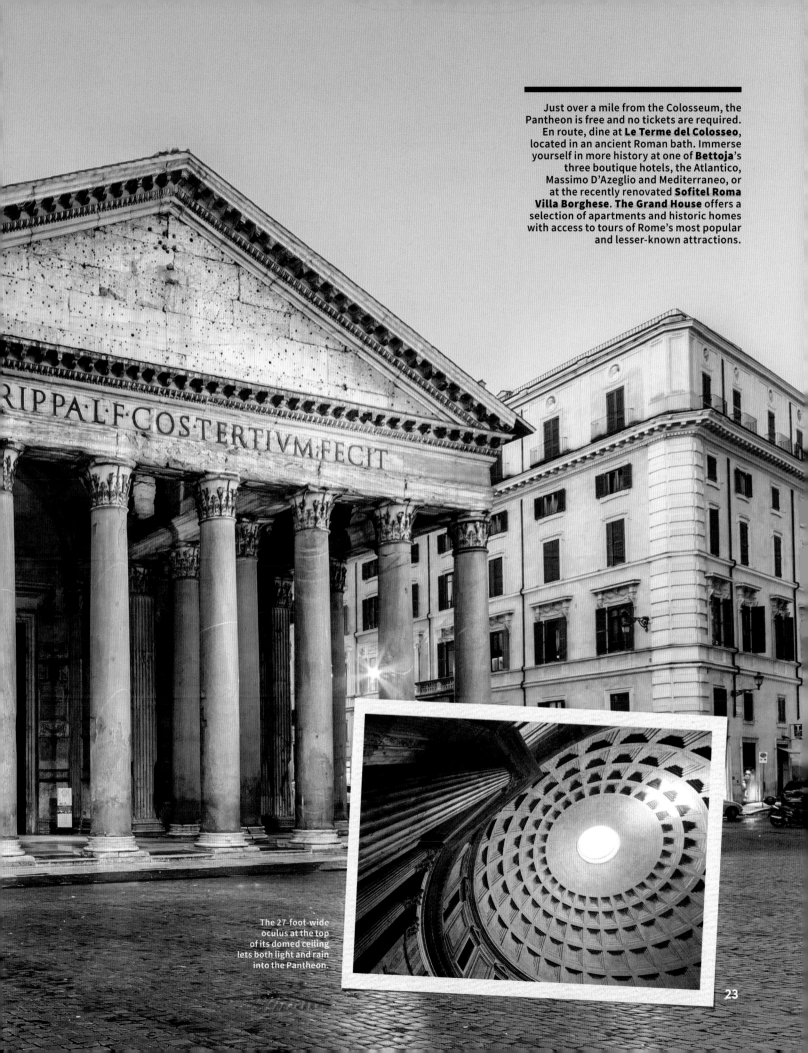

Just over a mile from the Colosseum, the Pantheon is free and no tickets are required. En route, dine at **Le Terme del Colosseo**, located in an ancient Roman bath. Immerse yourself in more history at one of **Bettoja**'s three boutique hotels, the Atlantico, Massimo D'Azeglio and Mediterraneo, or at the recently renovated **Sofitel Roma Villa Borghese**. **The Grand House** offers a selection of apartments and historic homes with access to tours of Rome's most popular and lesser-known attractions.

The 27-foot-wide oculus at the top of its domed ceiling lets both light and rain into the Pantheon.

23

Mount Nemrut

TURKEY

AMONG TURKEY'S MOST photographed spots, the eerie temple-tomb of Mount Nemrut (Nemrut Dag) lures visitors to explore its mysterious origins as one of the few ancient funeral sites to combine Western and Eastern influences.

Here the toppled remnants of enormous stone statues ring the towering pyramid-shaped burial mound honoring Antiochus 1, who fancied himself divine and built the monument in the belief that he would be worshiped as a god after his death. The site, which was placed on the UNESCO World Heritage list in 1987, is the most dramatic monument left behind by the Commagene Kingdom, which occupied this region of Mesopotamia between A.D. 109 and A.D. 72.

Located in the Taurus Mountains of southeastern Turkey, the 7,000-foot peak is topped by a mound of stone chips and boulders 164 feet high and 492 feet in diameter. This proved a successful deterrent to grave robbers, and part of Nemrut's appeal lies in the fact that the tomb hidden beneath the mound has never been found, its suspected treasures still inside.

But more impressive still are the enormous stone statues and inscribed panels that line terraces facing in the four cardinal directions. Among them, one depicts Antiochus, who claimed descent from both Alexander the Great of Greece and the Persian king Darius the Great, shaking hands with Hercules, while others show hybrid Greco-Persian deities unique to this culture.

Those with an interest in astronomy and astrology are fascinated by Mount Nemrut, where the terraces are arranged in astronomical alignment and the Lion panel is considered one of the oldest horoscopes in the world. Visitors ascend at sunrise and sunset to watch the light turn the statues gold.

The peak's impressive statues each weigh six tons and stand almost 33 feet tall.

Mount Nemrut is just over 50 miles from Adıyaman, served by Turkish Airlines from Istanbul and Ankara, where you'll find modern hotels such as the **Hilton Garden Inn Adiyaman**. Closer to the site, Kahta and Karadut have small, family-run hotels called pansiyons, which organize climbs. The easiest way to visit Mount Nemrut is with a **day tour**, which typically includes other sites such as the ruined castle at Kahta, or via an **overnight tour from Istanbul**.

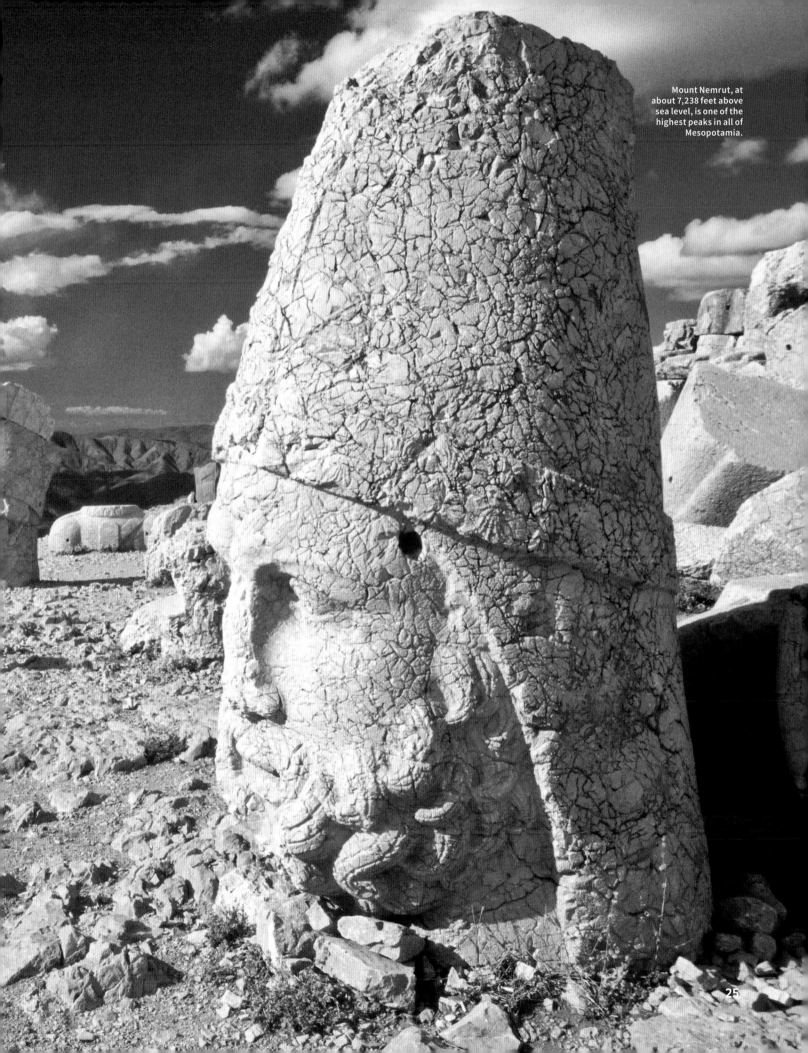

Mount Nemrut, at about 7,238 feet above sea level, is one of the highest peaks in all of Mesopotamia.

25

Parthenon

ATHENS, GREECE

At times, the building served as a treasury, an ammunition store and even a mosque.

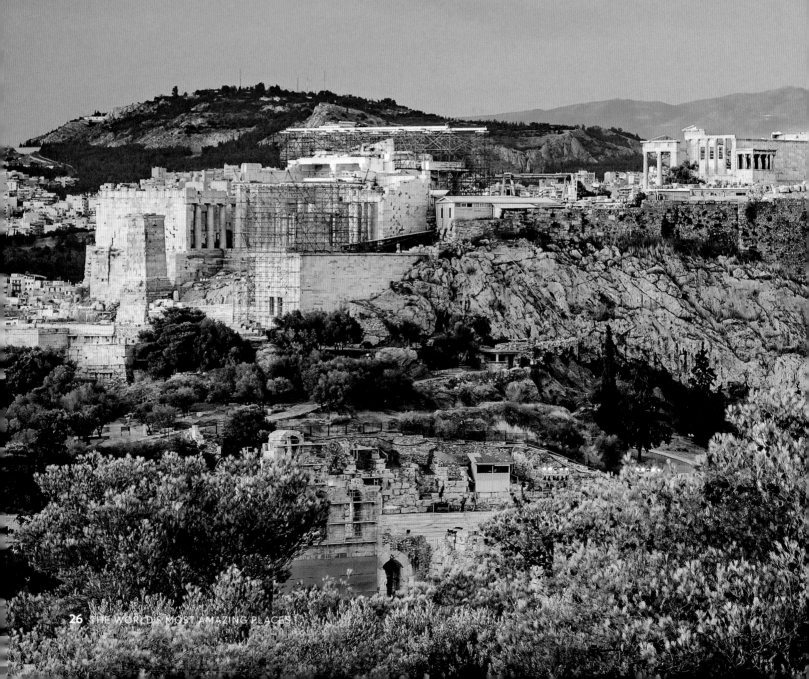

AS THE HISTORICAL AND cultural capital of ancient Europe, Athens was the hub for higher-education trade as well as the birthplace of democracy. At the center of it all? The Acropolis. Despite being more than 3,000 years old, this ancient citadel and collection of temples continues to stand tall over Athens. Its location on a rocky hilltop 490 feet above the city is part of its lure as a symbol of wealth and power. The Acropolis sheds light on an opulent era in history, when massive monuments of gleaming marble, along with statues carved of ivory and gold, were made to honor the gods.

The star of the Acropolis is the Parthenon, a Doric temple for Athena, the goddess of wisdom. As the myth goes, Athena secured power over Athens by offering the gift of an olive tree, which provided food, shade and wood for the Greek kingdom. Thus the city was named after her and the temple was built in her honor.

It took nine years—and some 100,000 tons of marble—to complete the Parthenon, which once housed a three-story statue in Athena's likeness, believed to be made from melted gold coins. While the statue was eventually destroyed, much of the Parthenon and surrounding temples stand strong—a true testament to the savvy and advanced architectural skills of the ancient Greeks.

While the ruins are the main draw, the **Acropolis Museum** is jam-packed with artifacts, galleries and exhibits in a recently rebuilt glass, concrete and steel building. For a deeper dive into the area's history, head out on Intrepid Travel's eight-day **Mainland Greece Discovery** tour, which adds on visits to Delphi and Thessaloniki.

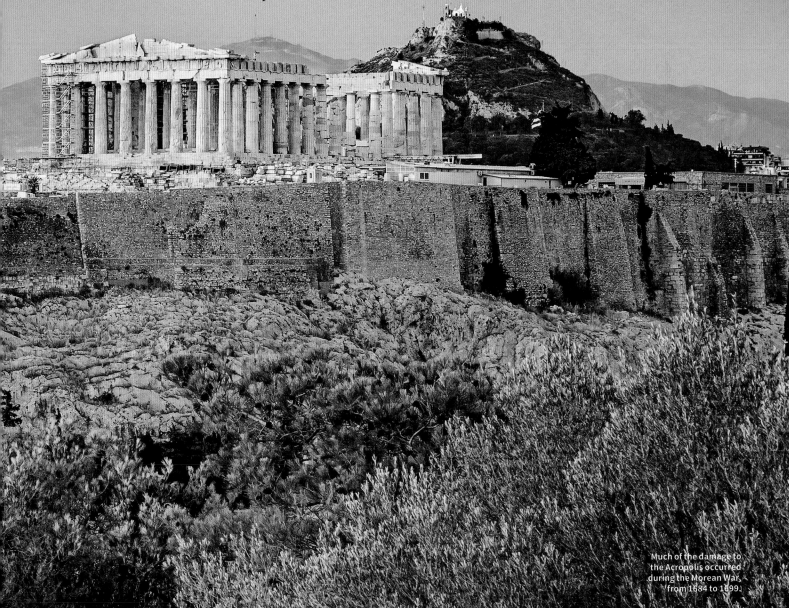

Much of the damage to the Acropolis occurred during the Morean War, from 1684 to 1899.

Giza Necropolis

GIZA, EGYPT

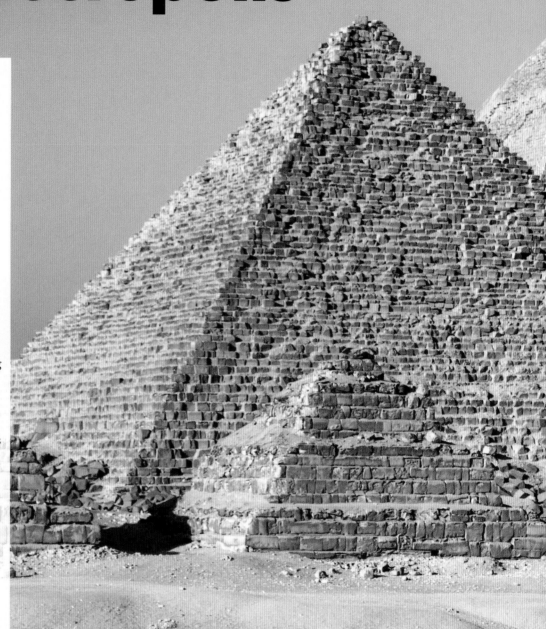

FEW SITES LIVE AS LARGE IN THE Western world's imagination as the Pyramids of Giza—aka the Giza Necropolis—and their guarding Sphinx. Constructed more than 4,500 years ago during Egypt's Old Kingdom (2558 to 2532 B.C.), these ancient tombs remain shrouded in mystery, despite centuries of scholarship. Built for the pharaohs Khufu, Khafre and Menkaure, each pyramid was the center of a surrounding complex.

How such massive and intricate structures were built so quickly remains the subject of great debate. For example, while scholars long believed slaves built the pyramids, that idea was upended with the discovery of additional tombs housing builders who were clearly respected artisans from local communities.

Visitors who aren't claustrophobic can venture inside the pyramids, although an empty stone sarcophagus is the only element remaining; the luxurious trappings having been removed to museums.

Rising straight out of the limestone bedrock from which the pyramids were quarried, the Great Sphinx of Giza is as enigmatic as the tombs it guards. A mythical creature with the body of a lion and the head of a human, the Sphinx is the oldest of ancient Egypt's monumental sculptures.

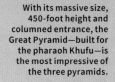

With its massive size, 450-foot height and columned entrance, the Great Pyramid—built for the pharaoh Khufu—is the most impressive of the three pyramids.

Each tomb housed everything a ruler would need to guide him to the afterlife.

You'll get the best panorama of the pyramids from a rocky butte some distance away; accept a ride from a guide since it's a tough walk in the heat. While Giza is just an hour from **Cairo**, stay nearby to see the pyramids lit up at night. **Le Meridien Pyramids Hotel & Spa** is widely considered to have the best views, while the five-star **Marriott Mena House** offers pyramid vistas and lush gardens.

29

Nazca Lines

PERU

THE INEXPLICABLE NAZCA LINES ARE massive—the condor, one of the most famous, is 440 feet long—and to decipher their outlines, one needs to circle above them in an airplane and peer down. But experts estimate they were created between 500 B.C. and A.D. 500, eons before humankind ever took flight. So who exactly were the ancient Nazca people trying to impress—or communicate with? Therein lies the mystery of the 1,100-plus geoglyphs etched into the arid coastal plains of southern Peru.

Discovered in 1927 and given notoriety by a 1968 best-seller, *Chariots of the Gods*, which spawned an alien conspiracy theory (one of the ancient drawings is an "astronaut"), the Nazca Lines were designated a UNESCO World Heritage site in 1994 and deemed "among archaeology's greatest enigmas." Known for their precision, they're divided into two categories: 70 natural forms—among them a hummingbird, monkey, iguana, whale and spider (main)—and about 300 geometric shapes such as triangles, trapezoids and arrows, plus 800 straight lines (some 30 miles long).

Still, this 300-square-mile earthen canvas isn't done revealing its secrets: Japanese researchers recently detected 143 new drawings using satellite imagery and field studies. All are believed to have been drawn by the industrious pre-Inca Nazca people, who dug down through the dark top layer of earth to the white sand below.

Seeing them from the air is exhilarating—and even a bit trippy. One ponders how, guided solely by the sun and stars, the Nazca precisely rendered these mystical figures that can still captivate modern observers two millennia later.

**Many Nazca
geoglyphs are
drawn with a single
continuous line.**

The Nazca Lines are located in a remote region of southern Peru,
but can be combined with a visit to **Lima**, about 250 miles to the
north; the best time to visit is November to March. Stay on the
coast at **Hotel Paracas, a Luxury Collection Resort**, where you
can also view the **Candelabra**, another popular Nazca geoglyph,
as well as penguins and pelicans. Flights over the Nazca Lines
(mornings are recommended) depart daily from **Pisco Airport**.

The majestic Grand Canyon is so massive, a drive from the North Rim Visitor Center to the South Rim Visitor Center would take about four hours.

CHAPTER
2

Stunning
LANDSCAPES

FROM SOARING SAWTOOTH PEAKS AND BLINDING SALT FLATS
TO SPINE-TINGLING CLIFFS AND INCREDIBLE DUNES,
THESE PICTURE-PERFECT FORMATIONS STILL HAVE PLENTY
OF SURPRISES IN STORE FOR VISITORS.

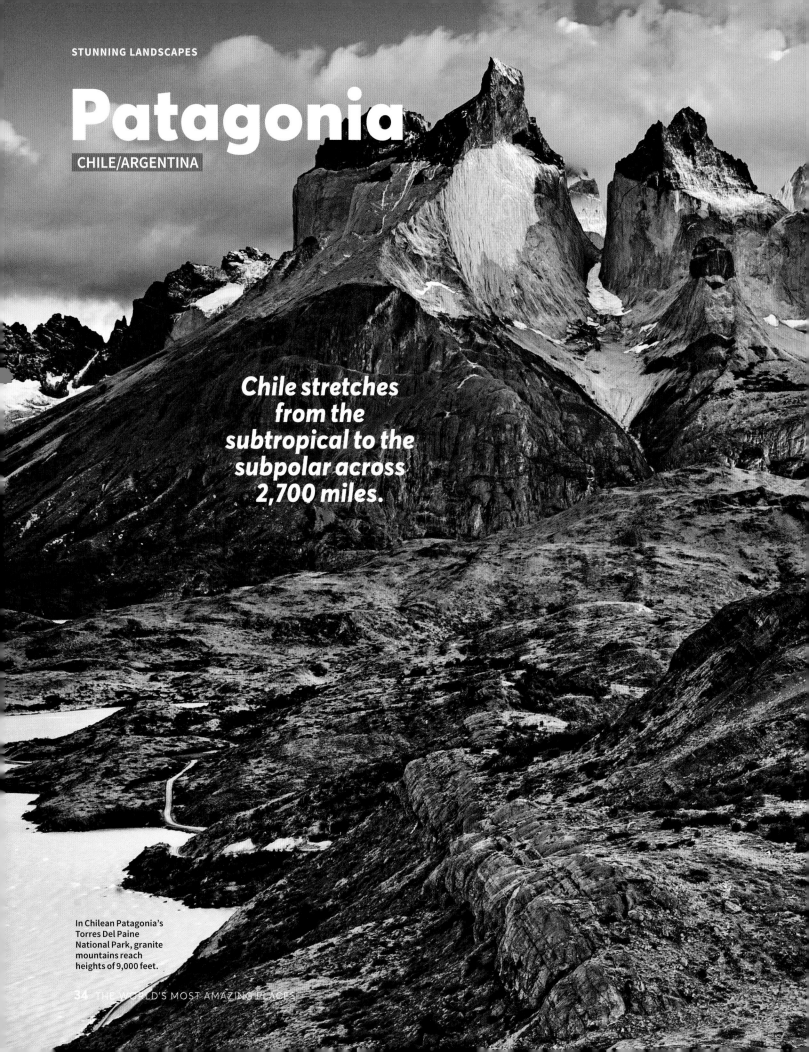

Patagonia

CHILE/ARGENTINA

Chile stretches from the subtropical to the subpolar across 2,700 miles.

In Chilean Patagonia's Torres Del Paine National Park, granite mountains reach heights of 9,000 feet.

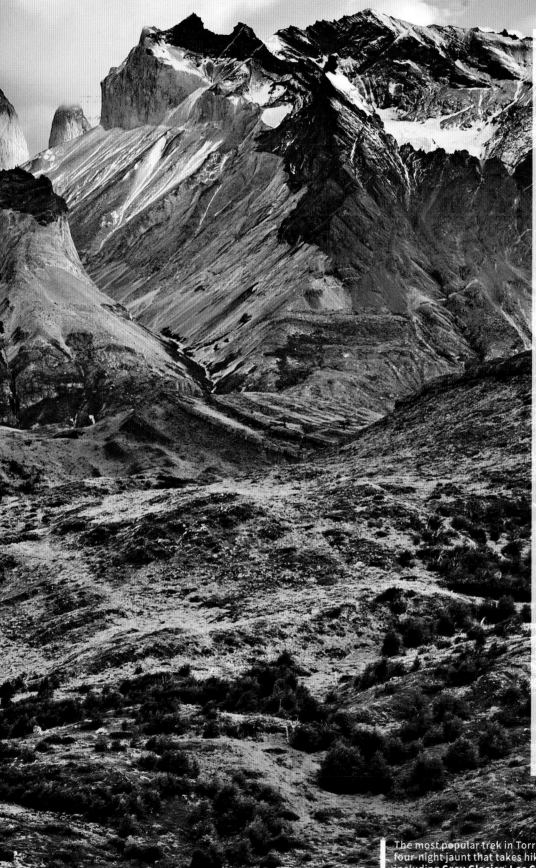

SPANNING TWO COUNTRIES AND 400,000 square miles (more than twice the size of California), the Patagonia region is an expansive wilderness at the southern tip of the New World. The very word Patagonia conjures visions of neon-blue glaciers, aqua caverns and jagged granite peaks piercing the sky.

The snow-dusted Los Cuernos del Paine (the Paine Horns) are the signature of Torres del Paine National Park, established in 1959 and declared a UNESCO World Biosphere Reserve 19 years later. Bordered by the Patagonian Steppe and the Andes Mountains in southern Chile, the 598,000-acre park attracts 100,000 visitors annually to its hiking trails, fjords, waterfalls and glacial lakes. Its distinctive mountain range was formed when tectonic collisions forced plateaus upward, and ancient glaciers eroded the terrain until only solid, resistant granite remained.

Across the border in Argentina, the Perito Moreno Glacier wows observers with its brilliant hue and magnitude: over 200 feet tall and spanning 121 square miles. Visitors behold the glacier from designated viewing platforms; those who wait long enough are often rewarded with the powerful sight of a large slice of ice splintering off and collapsing theatrically into Lake Argentino.

The remote Marble Caves hide far to the north in General Carrera lake, on the border between the two countries. Depending on the weather and season, the water in these marble grottoes, reachable only by boat, alternates from turquoise to cobalt. The phenomenon is yet another of Patagonia's wanton displays of splendor for those who make the journey.

The most popular trek in Torres del Paine is the **W Circuit**, a four-night jaunt that takes hikers past several prominent features, including **Grey Glacier**, **Los Cuernos** and the **Torres** (the three tower-like peaks from which the park gets its name). Get closer to Perito Moreno Glacier with a **boat trip** around the base or a **guided hike** on the surface of the ice itself.

35

Grand Canyon National Park

ARIZONA, USA

GREETING MORE THAN 6 MILLION visitors a year, the Grand Canyon ranks as the country's second-favorite national park. One look into the gaping gorge—one of the world's largest canyons—and it's easy to see why. Approximately 6,000 feet down at its deepest and 18 miles across at its widest, the canyon is so large that it could contain the state of Rhode Island.

But beyond the sheer size, it's the beauty of the rock—with bands of color alternating between reds, oranges, purples, greens, blacks and every shade in-between—that proves so gripping. Come sunrise and sunset, the walls reflect so much light, in such a heavenly way, that many find inspiration in this undisturbed natural place. Factor in that it contains some of the planet's oldest exposed rock, dating back almost 2 billion years, and it's hard not to be wowed.

On the popular South Rim, Yavapai and Mather points offer staggering vistas of the spectacle. But a trip down—be it hiking or rafting, lasting one day or 25 (the longest allowable time on the river with an off-season noncommercial oar-trip permit)—is one of the best ways to see the myriad color striations in the canyon walls. Likewise, both pursuits afford an intimate perspective of the canyon, giving a truer sense of the vastness. Those who venture beyond the overlooks and the last traces of civilization will be treated to a sight little changed since the 1540s, when the first European settlers laid eyes on this great natural wonder.

Carved over millions of years, the Grand Canyon became a U.S. national park in 1919.

From **Flagstaff Pulliam Airport**, it's a 100-minute drive to **Grand Canyon Village**. Most flock to the South Rim, but other areas are equally stunning, such as the West Rim, where the glass-floored **Skywalk** floats 4,000 feet over the chasm. For trekkers, try the 18-mile (round-trip) Bright Angel Trail leading to **Bright Angel Campground** at the bottom of the gorge. **Phantom Ranch** lodge is a half-mile from the campground; reservations required via online lottery.

Kirkjufell

ICELAND

The mountain is the most photographed in Iceland by professionals and amateurs.

Danish sailors originally referred to Kirkjufell as Sukkertoppen, or "The Sugar Top."

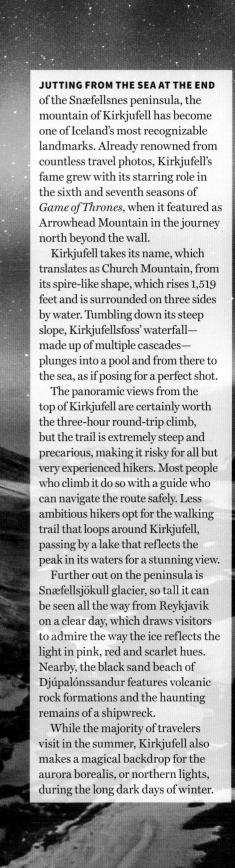

JUTTING FROM THE SEA AT THE END of the Snæfellsnes peninsula, the mountain of Kirkjufell has become one of Iceland's most recognizable landmarks. Already renowned from countless travel photos, Kirkjufell's fame grew with its starring role in the sixth and seventh seasons of *Game of Thrones,* when it featured as Arrowhead Mountain in the journey north beyond the wall.

Kirkjufell takes its name, which translates as Church Mountain, from its spire-like shape, which rises 1,519 feet and is surrounded on three sides by water. Tumbling down its steep slope, Kirkjufellsfoss' waterfall—made up of multiple cascades—plunges into a pool and from there to the sea, as if posing for a perfect shot.

The panoramic views from the top of Kirkjufell are certainly worth the three-hour round-trip climb, but the trail is extremely steep and precarious, making it risky for all but very experienced hikers. Most people who climb it do so with a guide who can navigate the route safely. Less ambitious hikers opt for the walking trail that loops around Kirkjufell, passing by a lake that reflects the peak in its waters for a stunning view.

Further out on the peninsula is Snæfellsjökull glacier, so tall it can be seen all the way from Reykjavik on a clear day, which draws visitors to admire the way the ice reflects the light in pink, red and scarlet hues. Nearby, the black sand beach of Djúpalónssandur features volcanic rock formations and the haunting remains of a shipwreck.

While the majority of travelers visit in the summer, Kirkjufell also makes a magical backdrop for the aurora borealis, or northern lights, during the long dark days of winter.

You can drive to Kirkjufell from Reykjavik in two and a half hours, making it feasible as a day trip, but you'll want to stay at least one night to see all of the peninsula's attractions. Right on the water in the tiny fishing village of Grundarfjörður, **Bjargarsteinn House of Food** serves uber-fresh seafood in a cozy house with unparalleled views. Stay in the village at **Kirkjufell Hotel** or choose more luxurious accommodation at **Hotel Búdir** half an hour away.

Zhangye Danxia

GANSU PROVINCE, CHINA

Zhangye Danxia shines from June to September, when slight rainfall boosts the colors. There is no hiking (to protect the delicate striations), so visitors must stay on the authorized paths. Nearby, the **Great Buddha Temple** houses China's largest indoor reclining Buddha.

Towers, pillars and ravines with varying colors, patterns and sizes are part of the breathtaking views.

FITTINGLY NICKNAMED THE RAINBOW Mountains of China, this colorful formation in the foothills of the Qilian Mountains stands out for its distinct striations of red, orange, yellow, green and blue. But is it really as vivid as the photos suggest? Yes and no. The dominant color is a rich red, owing to iron oxide compounds in the sandstone. Warm yellows and browns prominently feature as well, thanks to sulfur, limonite and goethite deposits. Cooler tones emerge to the patient eye, becoming more pronounced after a rare rain shower. Nevertheless, visitors agree this unique natural attraction, nestled in a relatively off-the-beaten-track northern province, is visually striking and worth a side trip.

Millions of years ago, colliding tectonic plates compressed a lake or seabed of sedimentary sandstone and siltstone, forcing it upward. The erosive forces of wind and rain continued to sculpt the stone, while rainwater runoff deposited additional trace minerals, intensifying the colors. Summits now reach heights between roughly 5,000 and 8,300 feet.

Despite bearing a resemblance to the Grand Canyon, China's "eye candy" largely flew beneath the radar until 2014, when it was officially declared Zhangye Danxia Landform Geological Park, encompassing 186 square miles (not to be confused with the China Danxia UNESCO site, in the country's southwestern subtropical zone). Newly constructed walking paths and viewing platforms began to attract up to 1,000 visitors a day.

Today, park buses shuttle tourists between the four main observation areas, which almost all have considerable stairs to climb (the highest has 666 steps that require about 30 minutes to ascend). The payoffs are sweeping panoramas of one of Mother Nature's most dazzling works of art.

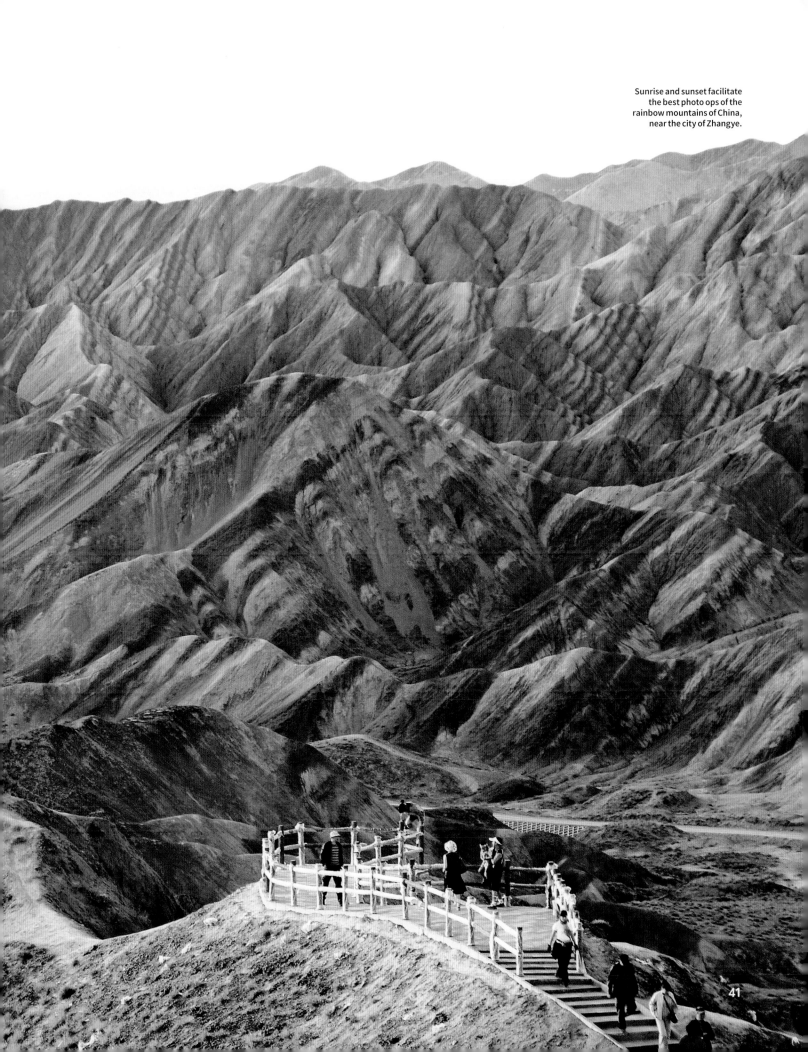

Sunrise and sunset facilitate the best photo ops of the rainbow mountains of China, near the city of Zhangye.

41

Yosemite National Park

CALIFORNIA, USA

EACH YEAR, FAMILIES RETURN TO their favorite parts of Yosemite National Park in the Sierra Nevada mountain range to witness its magic, and the sites deserve all the hype they get. Among the park's highlights: Yosemite Falls (main), a 2,425-foot, three-part waterfall that's the tallest in North America; Half Dome, an 8,842-foot granite rock with a flattened side; and El Capitan, a 7,569-foot vertical rock rising straight out of the Yosemite Valley. If that's not enough, lava flows every February over the 1,000-foot Horsetail Fall—or so it seems. The effect, dubbed Firefall, is actually an illusion created by the angle of the beams from the sunset hitting the rushing water.

Only 5 percent of the 750,000-acre park isn't designated as a wilderness, ensuring visitors truly get an all-natural experience among the granite domes, sequoia groves and sprawling valleys. But look beyond the big names and you'll also find glaciers on Mt. Maclure and Mt. Lyell, 18 peaks stretching higher than 12,000 feet and more than 90 kinds of mammals.

This Golden State gem has also been a top choice of filmmakers: The park made appearances in 1975's *Monty Python and the Holy Grail* and 1994's *Maverick* before proving it was ready for its close-up in 2018 in the Oscar-winning *Free Solo*, where rock climber Alex Honnold ascended El Capitan without ropes.

For a retro-chic camping experience, stay in one of the 80 custom-designed Airstream trailers, 15 upscale tents or three cabins at the **AutoCamp** (from $200 per night, autocamp.com), which opened in February 2019 on 35 secluded acres. Located in **Mariposa**, daily shuttles zip into the heart of Yosemite, while chill time in the campsite includes firepits, a midcentury modern clubhouse and a heated pool.

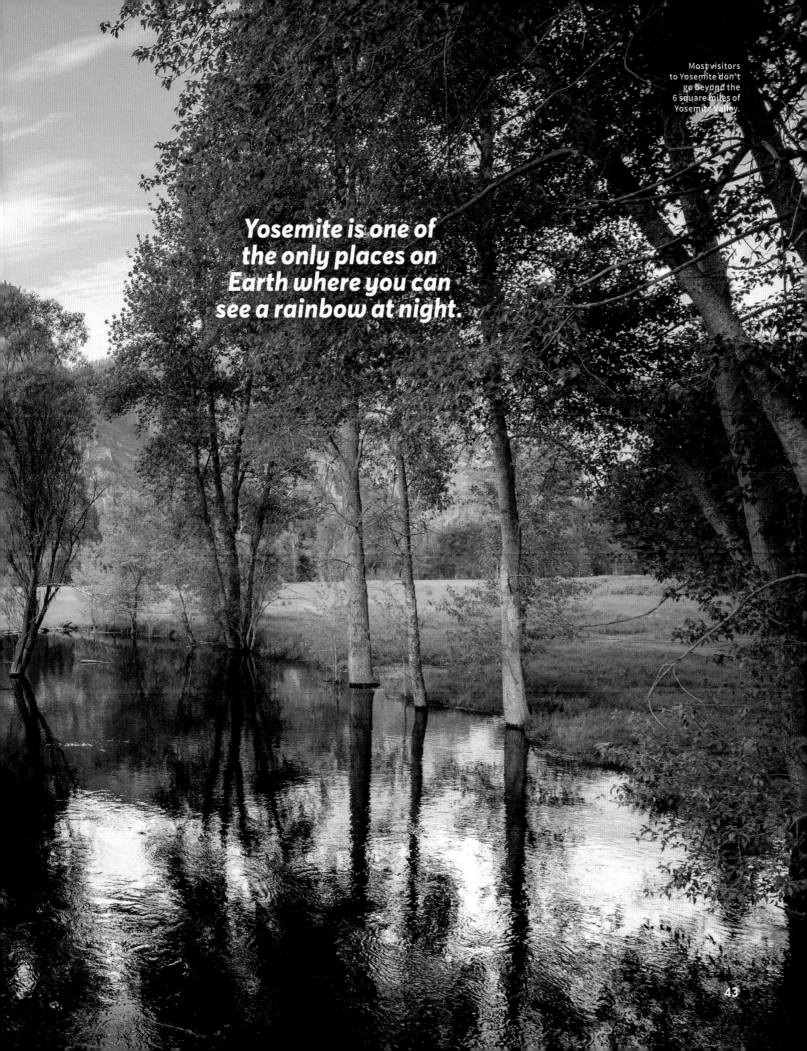

Yosemite is one of the only places on Earth where you can see a rainbow at night.

Salar de Uyuni

SOUTHWEST BOLIVIA

Tours usually last three days and two nights, and tourists stay overnight in rustic, unheated refugios (refuges) made of salt. Intrepid souls can add on a guided ascent up 17,457-foot **Volcán Tunupa**, a dormant volcano. Local lore maintains that the mountain goddess Yana Pollera filled the flats with her milk to separate the rival volcano gods Tunupa and Q'osqo, who were clashing over paternity of her child.

EVERYTHING ABOUT BOLIVIA'S VAST salt flat, which spans 4,500 square miles, is extreme. Extreme cold. Extreme isolation. Extreme beauty.

The salar's elevation—11,995 feet—on the arid plateau known as the Altiplano accounts for the biting temperatures, which creep up to the 40s during the day but plummet to the teens after dark. But the harsh climate is a small price to pay for the show of otherworldly scenery on display.

Once part of Lago Minchin, a lake that covered most of southwest Bolivia some 40,000 to 25,000 years ago, the salt flat remained when the water dried up. Most visitors depart from the wild-west town of Uyuni in 4x4 vehicles that careen haphazardly across the roadless salt desert, stopping at points of interest including a locomotive graveyard and Colchani, a tiny pueblo boasting one of the few plants that process salt from the Salar de Uyuni.

Tours typically include opportunities to explore alien geological features like the "island" of Incahuasi, spiked with cacti as tall as 30 feet, and the respectively red and blue-green lakes of Laguna Colorada and Laguna Verde, which adopt their vivid colors from sediments and microorganisms.

The epitome of the salar experience is merely setting foot on the infinite salt plain, dissected into a bleached patchwork of polygonal shapes. Creative travelers play with the perspective to compose amusing photos. In the winter wet season (November through March), a layer of water 6 to 20 inches deep floods the flats, creating a different but equally unique photo op of the ground mirroring the sky. No matter the time of year, the salar is a place truly unlike any other on the planet.

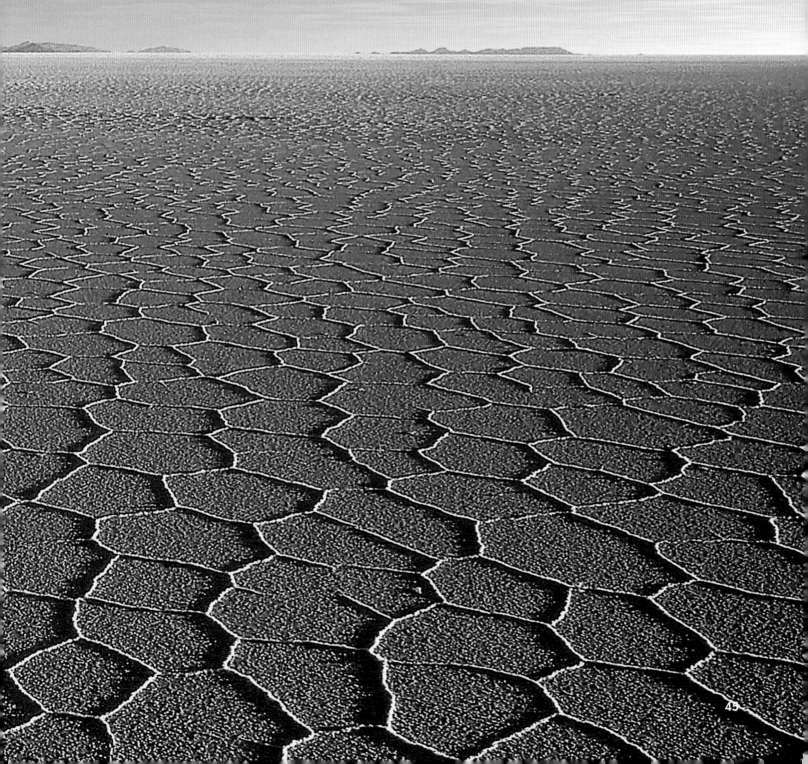

Approximately 50 percent of the world's lithium, the element used to power batteries and cellphones, lies untapped beneath the world's largest salt flat.

The salt flat, at times, is covered in very clear water, which turns it into the largest natural mirror in the world.

Antelope Canyon

ARIZONA, USA

TO THE NAVAJOS OF LONG AGO, going into Antelope Canyon was like walking into a temple. They might quiet their minds, humble their spirits and seek a divine connection to Mother Nature: Entering a place of such natural beauty was transcendent, spiritual. Today, the site lies within the LeChee Chapter of the Navajo Nation and is managed by Navajo Parks & Recreation— and visitors can still marvel at the canyon's striking splendor.

Not one slot canyon but two— Upper ("The Crack") and Lower ("The Corkscrew")—this picturesque icon has become the most visited and photographed slot canyon in the American Southwest. Formed as flash flooding eroded Navajo sandstone into smooth curves and extraordinary shapes, Antelope Canyon gives sightseers the sense of having stepped inside a dynamic art installation.

Photographers flock here, but anyone can appreciate this vermillion landmark and its 120-foot contoured walls. Upper Antelope is more accessible, spanning 660 feet of flat sand. A 15-minute drive away, Lower Antelope extends for 1,335 feet and requires navigating several sets of steel stairs. For safety, booking an authorized tour is required.

Up to 2,000 visitors a day pass through Antelope Canyon's crimson corridor. Still, despite the heavy foot traffic, both sections facilitate ethereal photos and leave observers spellbound. In this busy but sublime setting, it seems there's still plenty of opportunity for reflection and awe.

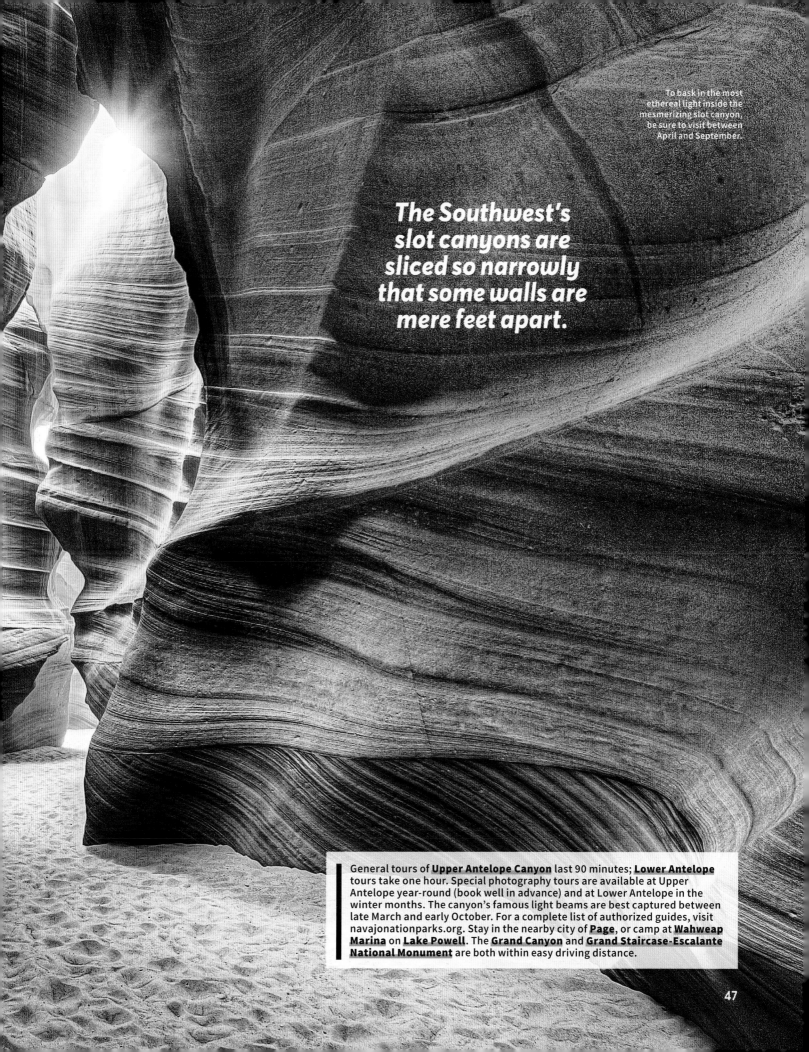

The Southwest's slot canyons are sliced so narrowly that some walls are mere feet apart.

General tours of **Upper Antelope Canyon** last 90 minutes; **Lower Antelope** tours take one hour. Special photography tours are available at Upper Antelope year-round (book well in advance) and at Lower Antelope in the winter months. The canyon's famous light beams are best captured between late March and early October. For a complete list of authorized guides, visit navajonationparks.org. Stay in the nearby city of **Page**, or camp at **Wahweap Marina** on **Lake Powell**. The **Grand Canyon** and **Grand Staircase-Escalante National Monument** are both within easy driving distance.

Riisitunturi National Park

POSIO, FINLAND

LOCATED JUST BELOW THE ARCTIC CIRCLE IN FINLAND'S northernmost Lapland region, Riisitunturi National Park is just a two-hour drive from Rovaniemi, the "official hometown" of Santa Claus. So it's no wonder the park's snow-laden spruces resemble elves, and the most common large mammal is the reindeer.

Established in 1982, Riisitunturi attracts hikers year-round, but it's the park's winter transformation into a virtual Narnia that draws photographers, cold-weather explorers and others simply looking for peace and quiet. Spanning almost 50 square miles of hills, evergreen forests and fells (upland pastures or moors), this scenic snowscape has a humid climate, which manifests on the candle-like spruce trees as a heavy layer of condensed frost.

The Riisitunturi area may have gotten its name from the Sámi word riis, meaning hay, or from the Finnish word for club

moss (riisitauti), used in folk medicine. Humans have utilized the region since prehistoric times, though relics from the past are subtle: hunting pits that indicate the Sámi practice of trap hunting; crumbling barns and lean-tos pointing to the land's bygone use in meadow agriculture.

Now the humans who snowshoe and cross-country ski across the park's sloping bogs are hunting for photo ops and powdery panoramas suspended in the hush of winter. Thirteen bare fell tops rise more than 1,300 feet, extending elevated views of Kitkajärvet Lake. And at night, there's a high chance of seeing the northern lights.

Still, Riisitunturi's whimsical snow shapes are what truly delight the imagination. It's a frozen wonderland not likely to be outdone by the North Pole itself.

Riisitunturi, where snow-crusted spruces take on elfin forms, has been called a paradise for winter hikers.

The snow loads that bend the spruce trees can weigh several thousand pounds.

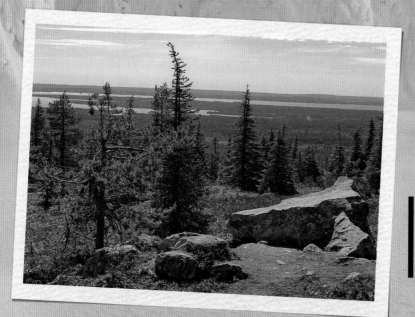

For more of a thrill, the Posio-Rovaniemi snowmobile route passes the western edge of the national park. **Polar Lights Tours** offers several dogsled excursions in the area that conclude with hot drinks and cookies. Or book a guided photography workshop tour through **Finnature** to ensure you return home with high-quality keepsake photos.

49

Yellowstone

WYOMING, MONTANA & IDAHO, USA

YELLOWSTONE'S CROWNING FEATURES— rainbow-colored hot springs, thundering waterfalls, ancient herds of roaming bison, powerful geysers spewing hundreds of feet into the air—sound like something out of a novel. In fact, when Yellowstone's earliest explorers recounted what they had witnessed, news magazines dismissed the reports as fiction.

Today, however, more than 4 million annual visitors can attest to the marvelous reality of these geologic wonders, and Yellowstone endures as the largest and most diverse virgin landscape in the contiguous U.S.

Covering 2 million acres of northwest Wyoming as well as small portions of Montana and Idaho, Yellowstone was established in 1872 as the world's first national park—a "pleasuring-ground for the benefit and enjoyment of the people." Its borders contain more than 10,000 geysers, mud pots, steam vents and hot springs.

Of the park's 300-plus geysers, its most iconic— Old Faithful—erupts every 60 to 110 minutes and reaches an average height of 130 feet. Sightseers flock to view it in the Upper Geyser Basin, but other areas of the park are equally spectacular.

It takes at least several days to absorb it all: the Grand Canyon of the Yellowstone, 20 miles long and 1,200 feet deep in places; Lower Falls, twice the height of Niagara Falls; Mammoth Hot Springs' travertine terraces, sculpted by chalky white mineral deposits. The list goes on.

As America's oldest park, Yellowstone has faced challenges, from tourists feeding bears to ranchers poisoning wolves. Such practices have since been eliminated, and at present, Yellowstone holds its full original menagerie of large mammals. Lucky tourists can spy them still, including the oldest and largest bison herd in the country—though today's visitors know to keep their distance, as Yellowstone's most amazing attractions wield tremendous power.

Yellowstone protects the greatest concentration of geothermal features on the globe.

During the summer, nine lodging options operate within park boundaries and 10 information centers serve visitors. To see the park by car, drive around the **Grand Loop**, a 140-mile figure eight that passes almost all the most famous spots. On foot, choose from more than 1,000 hiking trails. Or ply the water of **Yellowstone Lake**, the largest alpine lake in North America; guided scenic cruises depart from the **Bay Bridge Marina**.

Cappadocia

TURKEY

Two airports, **Kayseri** and **Nevsehir**, service Cappadocia with multiple daily flights from **Istanbul**, about 1.5 hours away. Stay in a fairy-chimney room at **Kelebek Special Cave Hotel** in Göreme, and they'll arrange your flight with **Butterfly Balloons**, followed by one of the best Turkish breakfasts in town. In Uchisar, the elegant **Argos** hotel boasts unbeatable views of the rising balloons from its hillside rooms and restaurant.

The ultimate Cappadocia experience is a sunrise balloon ride!

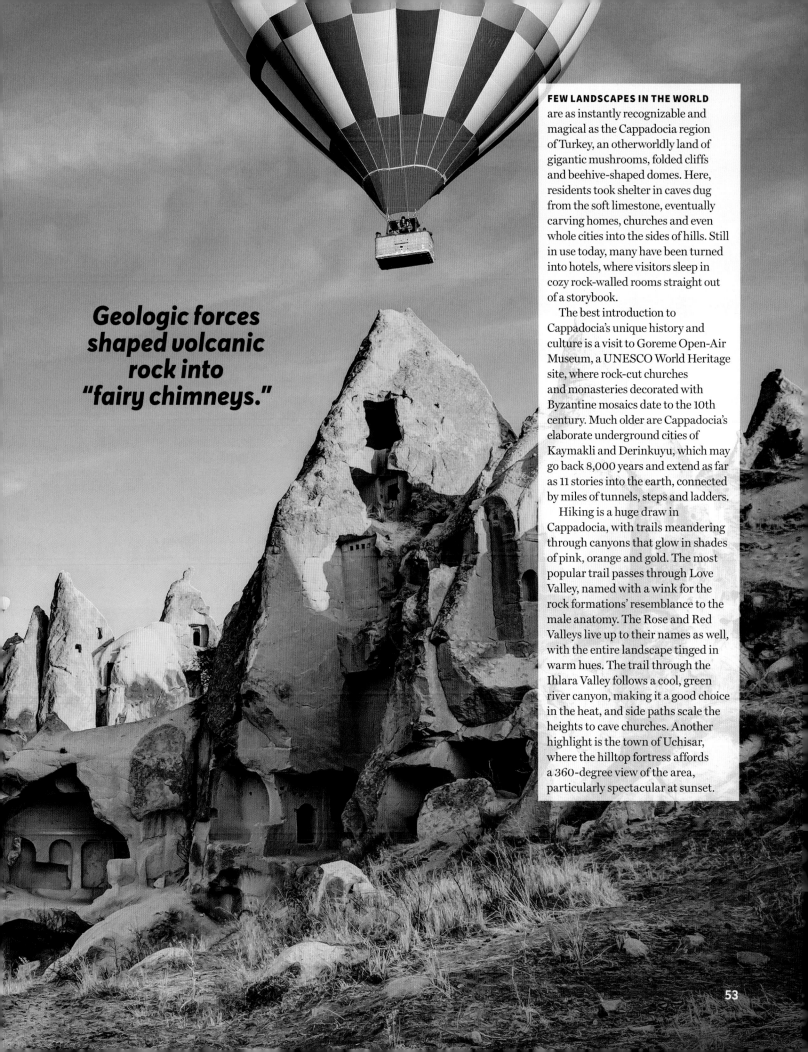

Geologic forces shaped volcanic rock into "fairy chimneys."

FEW LANDSCAPES IN THE WORLD are as instantly recognizable and magical as the Cappadocia region of Turkey, an otherworldly land of gigantic mushrooms, folded cliffs and beehive-shaped domes. Here, residents took shelter in caves dug from the soft limestone, eventually carving homes, churches and even whole cities into the sides of hills. Still in use today, many have been turned into hotels, where visitors sleep in cozy rock-walled rooms straight out of a storybook.

The best introduction to Cappadocia's unique history and culture is a visit to Goreme Open-Air Museum, a UNESCO World Heritage site, where rock-cut churches and monasteries decorated with Byzantine mosaics date to the 10th century. Much older are Cappadocia's elaborate underground cities of Kaymakli and Derinkuyu, which may go back 8,000 years and extend as far as 11 stories into the earth, connected by miles of tunnels, steps and ladders.

Hiking is a huge draw in Cappadocia, with trails meandering through canyons that glow in shades of pink, orange and gold. The most popular trail passes through Love Valley, named with a wink for the rock formations' resemblance to the male anatomy. The Rose and Red Valleys live up to their names as well, with the entire landscape tinged in warm hues. The trail through the Ihlara Valley follows a cool, green river canyon, making it a good choice in the heat, and side paths scale the heights to cave churches. Another highlight is the town of Uchisar, where the hilltop fortress affords a 360-degree view of the area, particularly spectacular at sunset.

Uluru

CENTRAL AUSTRALIA

Learn about Uluru's rich anthropological importance at the **Cultural Centre**. A helicopter tour offers another perspective—the bird's-eye view. **Longitude 131**'s luxury safari tents are the closest lodging to the Rock, while the popular **Sounds of Silence** dinner at **Ayers Rock Resort** offers moonlit views of Uluru, along with local gourmet food and a presentation by the hotel's "resident star talker."

ULURU (FORMERLY CALLED AYERS Rock), the 1,142-foot monolith that rises starkly from the desert in Australia's remote Red Centre, has no fossils. Its arkose sandstone mass—molded from compacted sediments on the ocean floor—formed some 600 million years ago, at the genesis of life on Earth.

The iconic red rock does, however, have ancient paintings and carvings by the Anangu aboriginal people, the traditional custodians of Uluru for perhaps 20,000 years. The Anangu attribute deep spiritual significance to the Rock but lost official ownership of the land in 1958, when the Australian government established Ayers Rock–Mount Olga National Park—later renamed Uluru–Kata Tjuta National Park. But the Anangu were again recognized as the rightful owners of the land in 1985 and currently manage the park jointly with Parks Australia.

A journey to Uluru and its nearby sister rock, Kata Tjuta, is equal parts geological discovery and cultural immersion. Visitors can observe Anangu people dot-painting, storytelling, performing traditional song and dance and gathering bush tucker (food native to Australia).

Even the 7-mile Uluru Base Walk is laced with glimpses into aboriginal heritage, as guides share creation stories and other folklore along the way.

Though climbing on the Rock has been officially halted, Uluru's visual bounty is more than ample at its ground level. Bird and reptile species flourish, and lucky sightseers even spot kangaroos and wallabies. Sunset is the zenith of the experience, when Uluru's rust-colored face catches fire. It is this spectacular light show that best helps Westerners grasp the primal, sacred essence of this crimson giant.

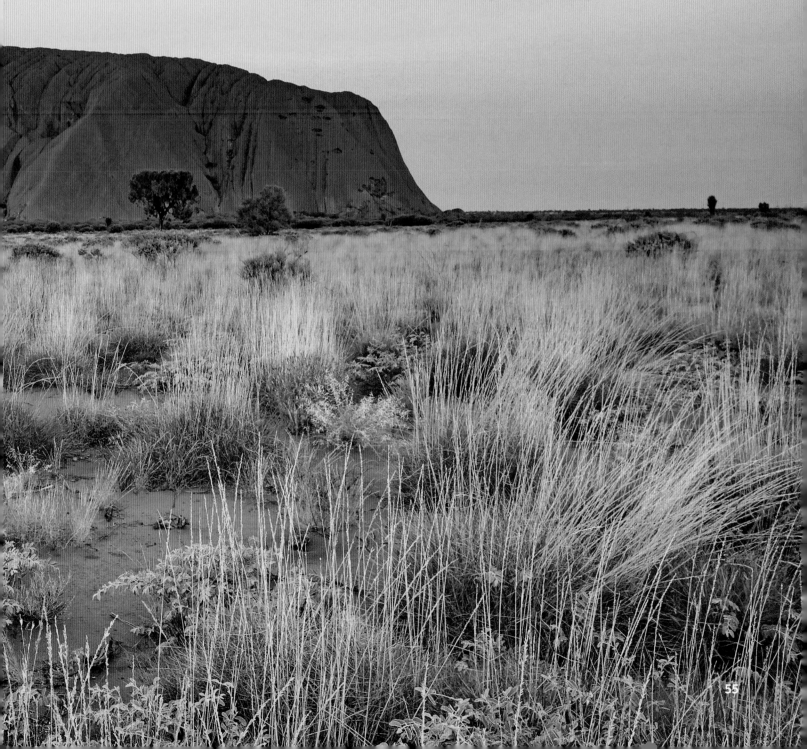

Climbs on Uluru were stopped in 2019 out of respect for the site and the Anangu people.

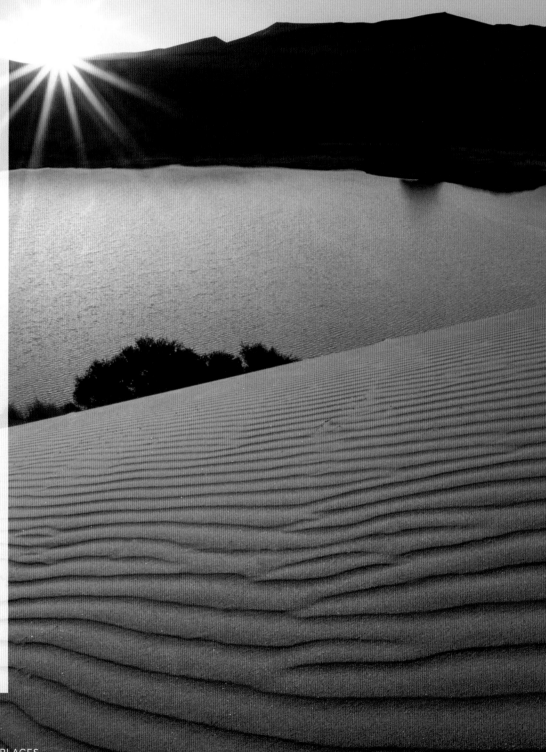

Sossusvlei Dunes

NAMIBIA

THE SCULPTURAL BEAUTY OF sand dunes has long intrigued painters, photographers and filmmakers—see Claude Monet's 1882 landscape, *Beach at Pourville*; Ansel Adams' ethereal 1948 image, *Sand Dunes, Sunrise, Death Valley National Monument, California*; and Japanese New Wave director Hiroshi Teshigahara's moody 1964 film, *Woman in the Dunes*. But perhaps the most dramatic expression of Mother Nature's artistry—the fiery red contours of Sossusvlei Sand Dunes in the African nation of Namibia—inspires awe when simply snapped on a smartphone and posted to Instagram.

Located in Namib-Naukluft National Park, the dunes at Sossusvlei rank among the highest in the world, reaching more than 1,250 feet. They have names such as Big Daddy (which tops out at 1,066 feet) and Dune 45 (a less-strenuous 560 feet). The reward for scaling Big Daddy's elegantly curved spine (it takes two hours, a good deal of balance and plenty of water) is a panorama of Deadvlei, a stark salt pan with scorched 800-year-old camel thorn trees set against white earth.

Timing is critical. Most guided tours depart before sunrise and arrive just as the first rays of daylight envelop the dunes, coloring certain slopes a molten red and creating dramatic shadows and swirls. This is also the best time to climb: The early bird gets the view.

Since the area's primary source of water is fog, the reptiles and mammals inhabiting the region had to become desert-adapted in order to survive on limited water supplies.

Sand carried by the wind from Namibia's Atlantic coast formed these impressive dunes.

Namibia borders South Africa and Botswana, and reaching Sossusvlei is a journey: You'll need to fly into **Windhoek** and then take a charter flight to an airstrip near the dunes. What the country lacks in easy access, it more than makes up for in visual splendor. Stay at **&Beyond Sossusvlei Desert Lodge**, where the all-inclusive pricing covers a guided excursion to the dunes, as well as morning and evening safari excursions to spot wildlife such as spiral-horned kudu, hypnotic zebra and graceful springbok.

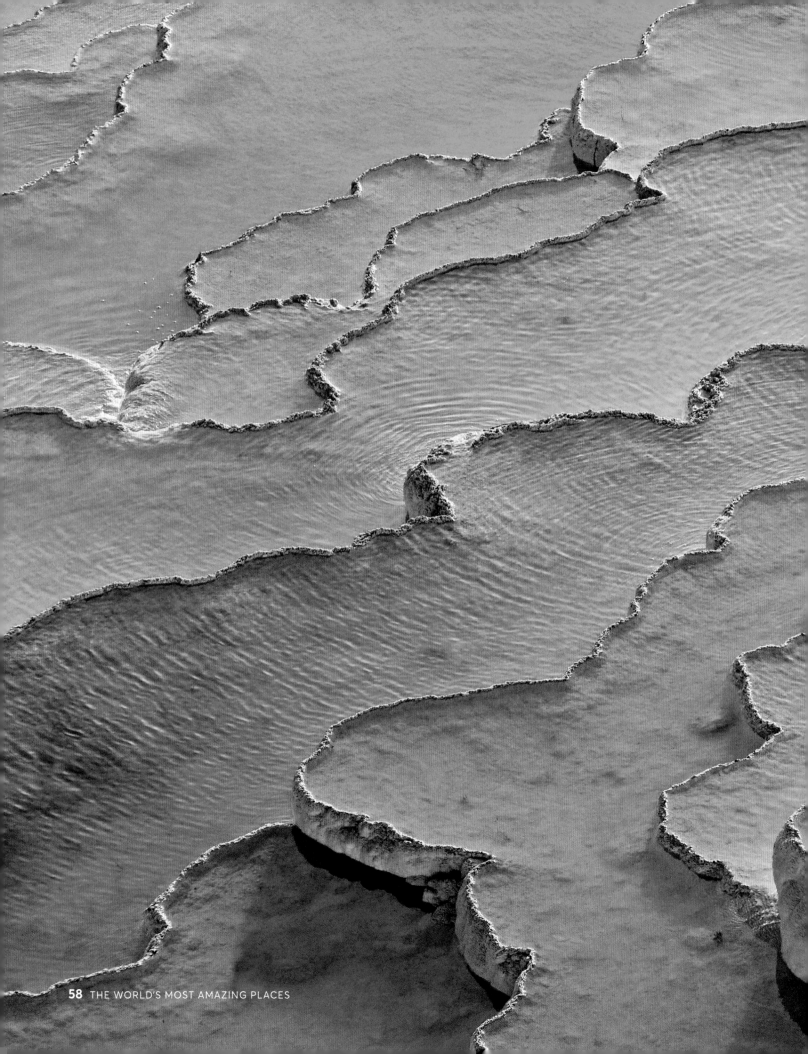

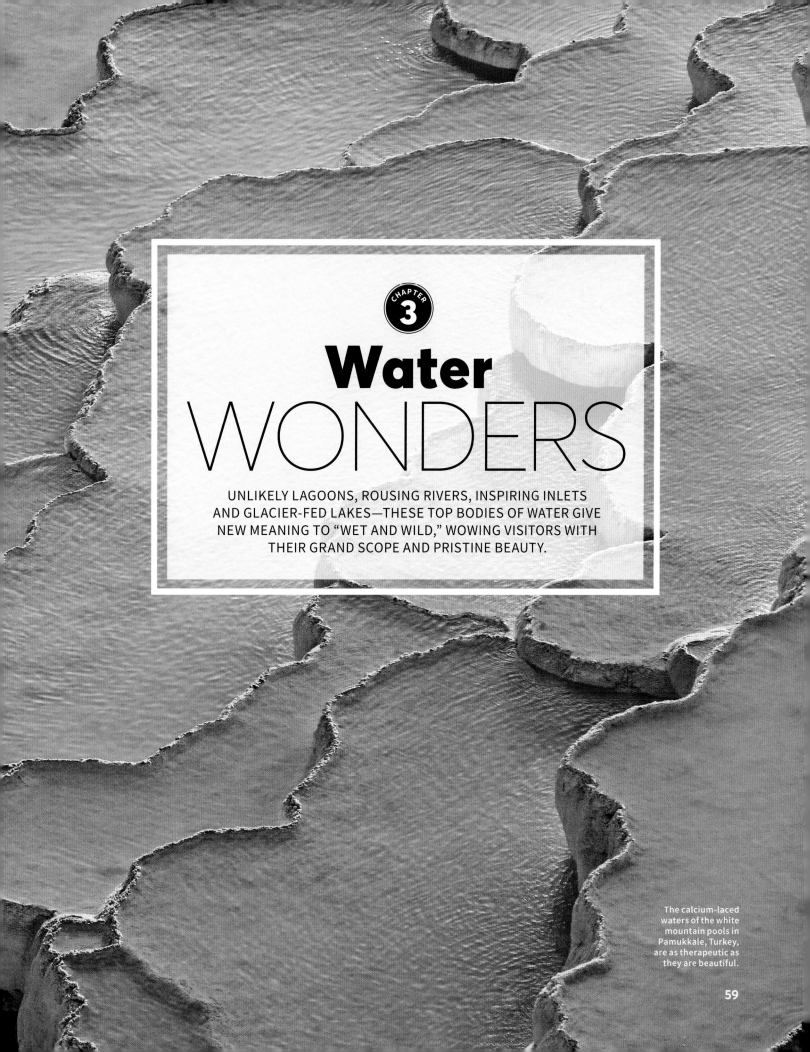

CHAPTER 3

Water
WONDERS

UNLIKELY LAGOONS, ROUSING RIVERS, INSPIRING INLETS
AND GLACIER-FED LAKES—THESE TOP BODIES OF WATER GIVE
NEW MEANING TO "WET AND WILD," WOWING VISITORS WITH
THEIR GRAND SCOPE AND PRISTINE BEAUTY.

The calcium-laced
waters of the white
mountain pools in
Pamukkale, Turkey,
are as therapeutic as
they are beautiful.

Blue Lagoon

GRINDAVÍK, ICELAND

Time the visit just right, and you may glimpse the **Northern Lights** dazzling the sky over the Blue Lagoon. Peak viewing season is during autumn and winter (September through March), when Iceland experiences longer nights. As an added bonus, booking an evening visit to the Blue Lagoon—which stays open until at least 9 p.m., depending on the season—is generally less expensive than daytime visits. (As a general rule, all visits should be booked online, in advance.)

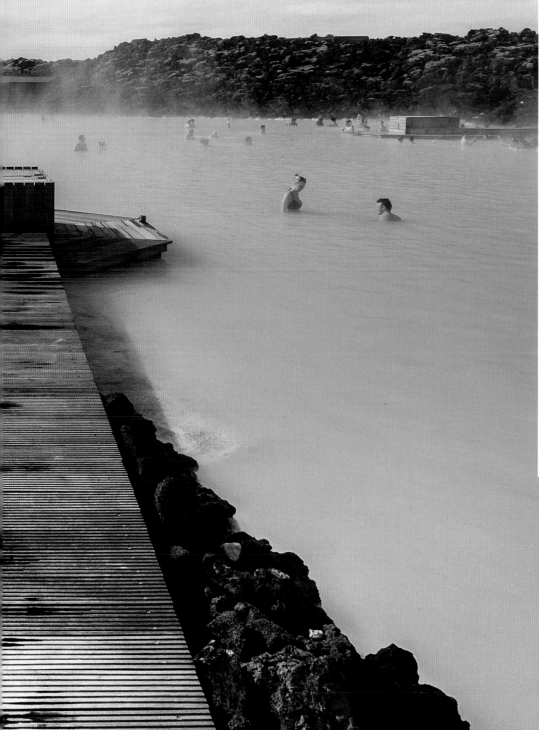

An accidental discovery led to one of Iceland's most iconic experiences.

ACCORDING TO LOCAL LORE, Iceland's Blue Lagoon was first discovered in the mid-1970s by a construction worker who had been building the geothermal plant nearby. The man began bathing in the warm, bright-blue water, and within months, his psoriasis cleared up. Word got out about the water's supposed healing powers, and within the next few decades, it went from a secretive spot to one of the planet's most iconic places.

Encompassed by a jet-black UNESCO-listed lava landscape, the 94,000-square-foot complex now features an extensive spa facility, featuring saunas, steam rooms and a swim-up bar. And, of course, there's the lagoon itself, with its stunning shade of steaming water, geothermally heated to a soothing 104°F. Rich in algae and minerals like silica, both the water and the white mud scraped from the bottom of the spa are said to rejuvenate and moisturize the skin. Visitors can opt for a simple soak and a mud mask or add on spa treatments, like in-water massages, and perks, like access to a private section of the lagoon.

While most people choose to make the Blue Lagoon a day-trip destination—it is just a 15-minute drive from Keflavík airport and 30 minutes from the capital city of Reykjavík—the 62-suite Retreat Hotel opened on-site in 2018 for overnight stays. The perk: From some of the hotel's lower-level suites, guests can leap right into the lagoon from their own private balcony!

It's estimated that up to 4,000 people visit the milky blue waters of Iceland's Blue Lagoon each day.

Great Barrier Reef

AUSTRALIA

Some 1,500 species of tropical fish call the Great Barrier Reef home.

Most liveaboards—including **Mike Ball Dive Expeditions** and **Taka Dive Tours**—depart from **Cairns**, a city that warrants a night or two so you can acclimate to the time change and visit nearby attractions, including the rainforest village of **Kuranda**. Guided walks, riverboat trips and hikes allow you to witness the colorful and bizarre birds of the continent, such as the 6-foot-tall, blue-faced southern cassowary. The weather is mild, with less rainfall June through October.

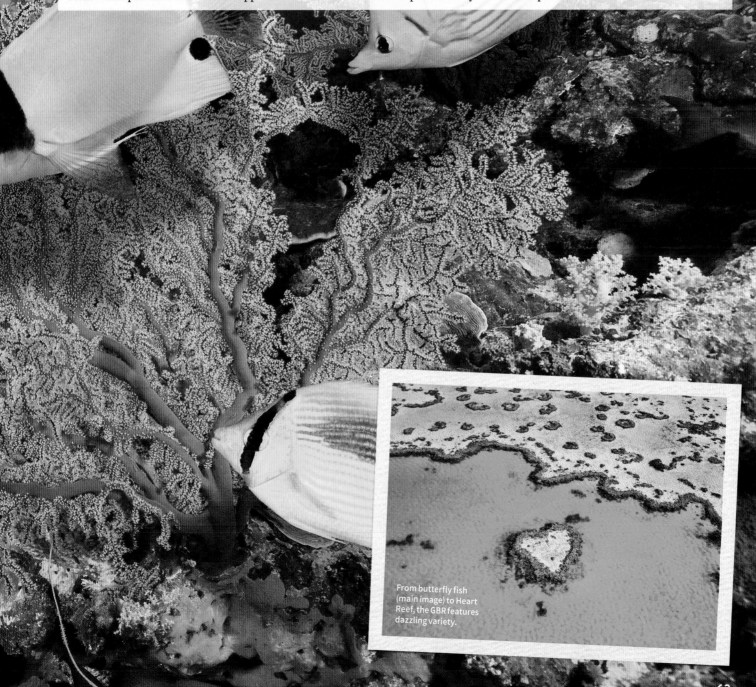

ONLY SO MUCH MAGIC CAN BE CONVEYED through aerial photos of Australia's Great Barrier Reef. To really grasp the splendor, you should dive into it firsthand.

Surrounded by deep blue water, the Ribbon Reefs are the jewels of the world's largest barrier reef. Numbered 1 through 10 and found roughly 146 miles north of the western coastal city of Cairns, these coral atolls and their bright turquoise lagoons are the reasons this destination has become legendary for its beauty.

Outside each atoll are walls made of coral—411 species in total—that support the only biomass that's visible from space. American travelers tend to be most wowed by the clownfish, anthias and 4-foot giant clams with purple or cobalt fleshy centers—none of which can be found in the waters off North America or the Caribbean. Another favorite is the 6-foot potato cod that noses up to divers for intimate meet-and-greets. In June and July, visitors may even come face to face with migrating minke whales.

To encounter the best of the GBR, travelers have several options. A day boat from Cairns, the most popular choice, gives a taste of snorkeling or scuba diving the reefs, but doesn't fully allow guests to experience the vastness of this underwater Serengeti, a place where schools of 3-foot green humphead parrotfish and whitetip reef sharks cruise by.

One of the best ways to see it all is on a "liveaboard" boat. Operators give guests the option of diving or snorkeling for multiple nights, making it much more affordable to experience the most remote and pristine stretches of reef.

From butterfly fish (main image) to Heart Reef, the GBR features dazzling variety.

63

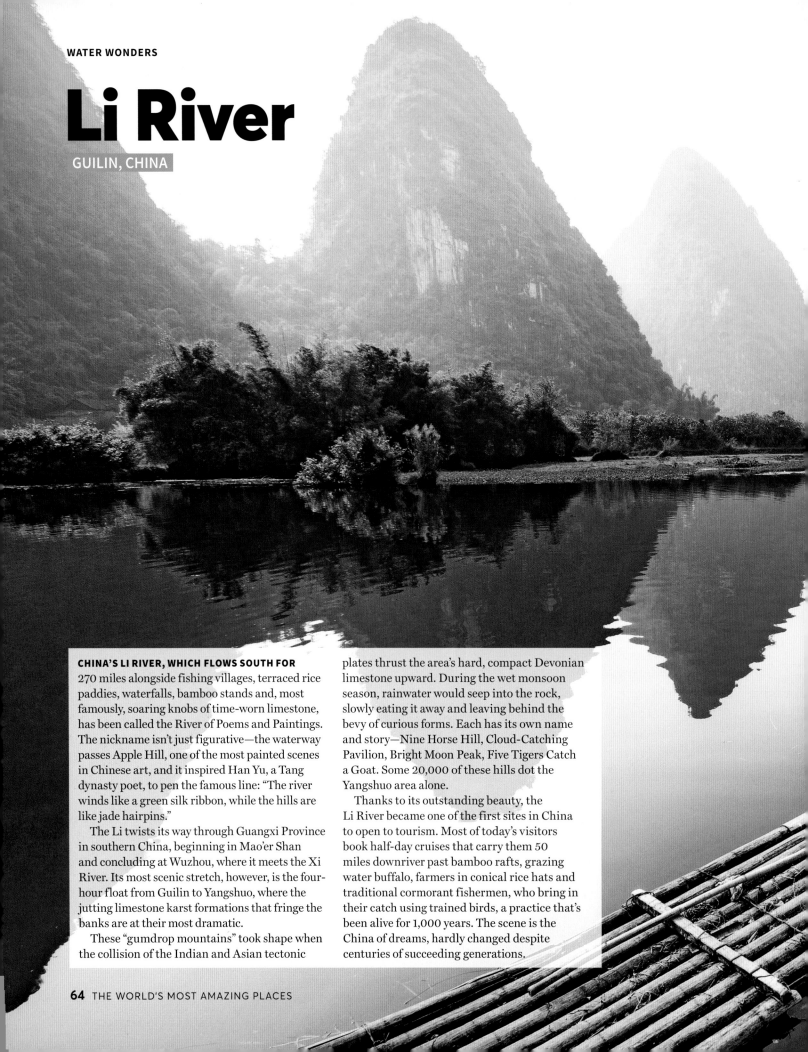

Li River

GUILIN, CHINA

CHINA'S LI RIVER, WHICH FLOWS SOUTH FOR 270 miles alongside fishing villages, terraced rice paddies, waterfalls, bamboo stands and, most famously, soaring knobs of time-worn limestone, has been called the River of Poems and Paintings. The nickname isn't just figurative—the waterway passes Apple Hill, one of the most painted scenes in Chinese art, and it inspired Han Yu, a Tang dynasty poet, to pen the famous line: "The river winds like a green silk ribbon, while the hills are like jade hairpins."

The Li twists its way through Guangxi Province in southern China, beginning in Mao'er Shan and concluding at Wuzhou, where it meets the Xi River. Its most scenic stretch, however, is the four-hour float from Guilin to Yangshuo, where the jutting limestone karst formations that fringe the banks are at their most dramatic.

These "gumdrop mountains" took shape when the collision of the Indian and Asian tectonic plates thrust the area's hard, compact Devonian limestone upward. During the wet monsoon season, rainwater would seep into the rock, slowly eating it away and leaving behind the bevy of curious forms. Each has its own name and story—Nine Horse Hill, Cloud-Catching Pavilion, Bright Moon Peak, Five Tigers Catch a Goat. Some 20,000 of these hills dot the Yangshuo area alone.

Thanks to its outstanding beauty, the Li River became one of the first sites in China to open to tourism. Most of today's visitors book half-day cruises that carry them 50 miles downriver past bamboo rafts, grazing water buffalo, farmers in conical rice hats and traditional cormorant fishermen, who bring in their catch using trained birds, a practice that's been alive for 1,000 years. The scene is the China of dreams, hardly changed despite centuries of succeeding generations.

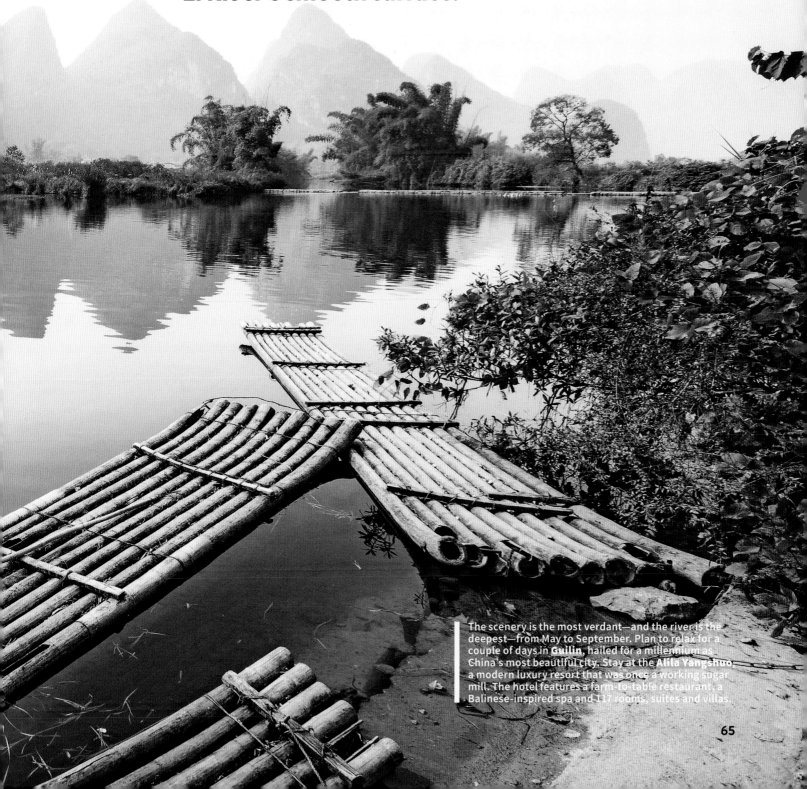

When the sun is shining, visitors can view the mirror image of the mountains on both sides on the Li River's smooth surface.

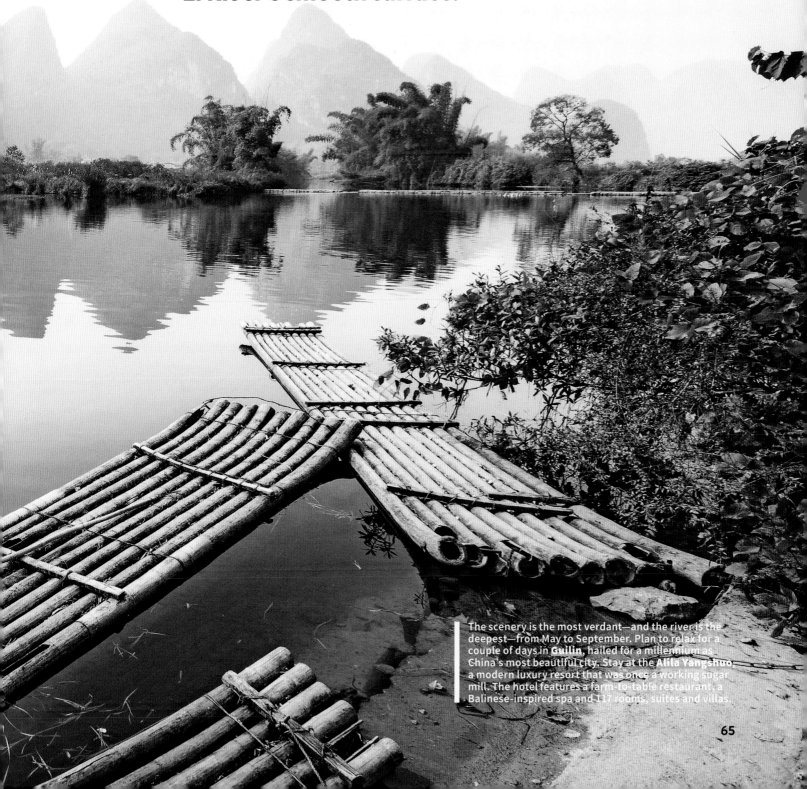

You can paddle your own bamboo raft down the Li, but most people hire guides or take a motorized boat.

The scenery is the most verdant—and the river is the deepest—from May to September. Plan to relax for a couple of days in **Guilin**, hailed for a millennium as China's most beautiful city. Stay at the **Alila Yangshuo**, a modern luxury resort that was once a working sugar mill. The hotel features a farm-to-table restaurant, a Balinese-inspired spa and 117 rooms, suites and villas.

Niagara Falls

NEW YORK, USA, AND ONTARIO, CANADA

HOLDING A RIGHTFUL SPOT on many tourists' bucket lists, Niagara Falls doesn't disappoint. During peak season, nearly 650,000 gallons of water tumble over the falls each second—and with a vertical drop spanning more than 165 feet, Niagara has the highest flow rate of any waterfall in the world.

Lying between New York and Canada, Niagara Falls is a collection of three cascades: American Falls, Horseshoe Falls and Bridal Veil Falls. When it originally formed, Niagara's wall of water was about 7 miles downstream from its current location, and erosion continues to push the falls farther upstream at a rate of about a foot a year.

With an unmistakable roar that can be heard from miles away, Niagara Falls and its surrounding region played roles in the War of 1812 and the Underground Railroad before becoming a vital source of hydroelectric power. Today, the falls represent 20 percent of the drinking-water supply for the United States and Canada—continuing to be, as British author Arthur Young once said, "the key to the whole continent."

Eight million people a year descend on this 400-acre state park to see the falls and explore the surrounding area. A trip on *Maid of the Mist*, which has been towing passengers to the base of the falls since 1846, is a must. There's nothing quite like feeling the spray of the water coming off Horseshoe Falls as the rapids of the Niagara River churn below.

Back on land, spots like Goat Island, with its straight-down views into the deluge, offer Instagram-worthy photo ops for days. Other exceptional viewpoints range from a helicopter and an observation tower to the "Hurricane Deck," accessed via a cave elevator and a series of wooden walkways.

No matter the angle, Niagara Falls is a once-in-a-lifetime spectacle and deserves a big check mark on the travel wish list.

Be advised that you will get drenched on the *Maid of the Mist* boat ride. The tour operator provides souvenir ponchos, but make sure to wear shoes that can get wet. Also remember that while many of the iconic sights lie on the American side of the falls, there's plenty to explore in **Canada** as well—so bring your passport.

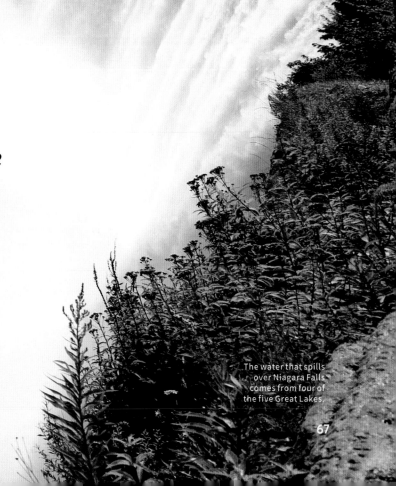

Niagara Falls State Park is the oldest state park in the U.S.

The water that spills over Niagara Falls comes from four of the five Great Lakes.

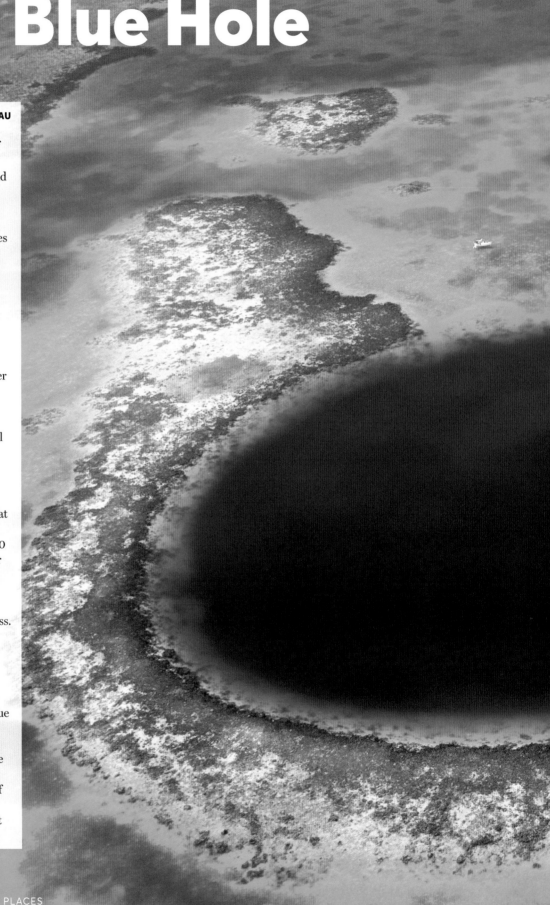

Great Blue Hole

BELIZE

EVER SINCE JACQUES-YVES COUSTEAU plunged into the Great Blue Hole in 1972 while filming an episode of the TV show *The Undersea World*, divers have been longing to visit and explore this natural wonder.

Sea conditions must be flat enough to allow boats passage and easy anchor at this location 60 miles from the coast of Belize.

From San Pedro, a town on the island of Ambergris Cay, the run time to the site, inside Lighthouse Reef atoll, is 2.5 hours each way, making this a full-day trip with departure times typically around 5:30 a.m.

Inside Lighthouse Reef, the water is still. For divers, this UNESCO World Heritage site—stretching nearly 1,000 feet across—is the chance to go deep. The recreational limit for scuba is 130 feet, and the bottom of the Great Blue Hole is dizzyingly deeper, at 394 feet.

Around 60 feet down, snorkelers and divers can witness stalactites, fat as torpedoes, which reveal this site was once a dry cave, formed 153,000 years ago. The stalactites date as far back as 60,000 years. Then, as the sea level rose, the roof of the cave collapsed, creating the feature that 200,000 annual visitors now witness.

Down around 90 feet, it's quite possible for divers to encounter sharks: Several species of the awe-inspiring fish can be sighted here on a regular basis.

Following a dip here, the only blue hole visible from space, most day-trip operators then include time at Half Moon Cay, which ranks as one of the best wall dives in the world.

Altogether, the trip offers a bit of everything underwater, including reefs, walls and wonder—and most of all, self-satisfaction.

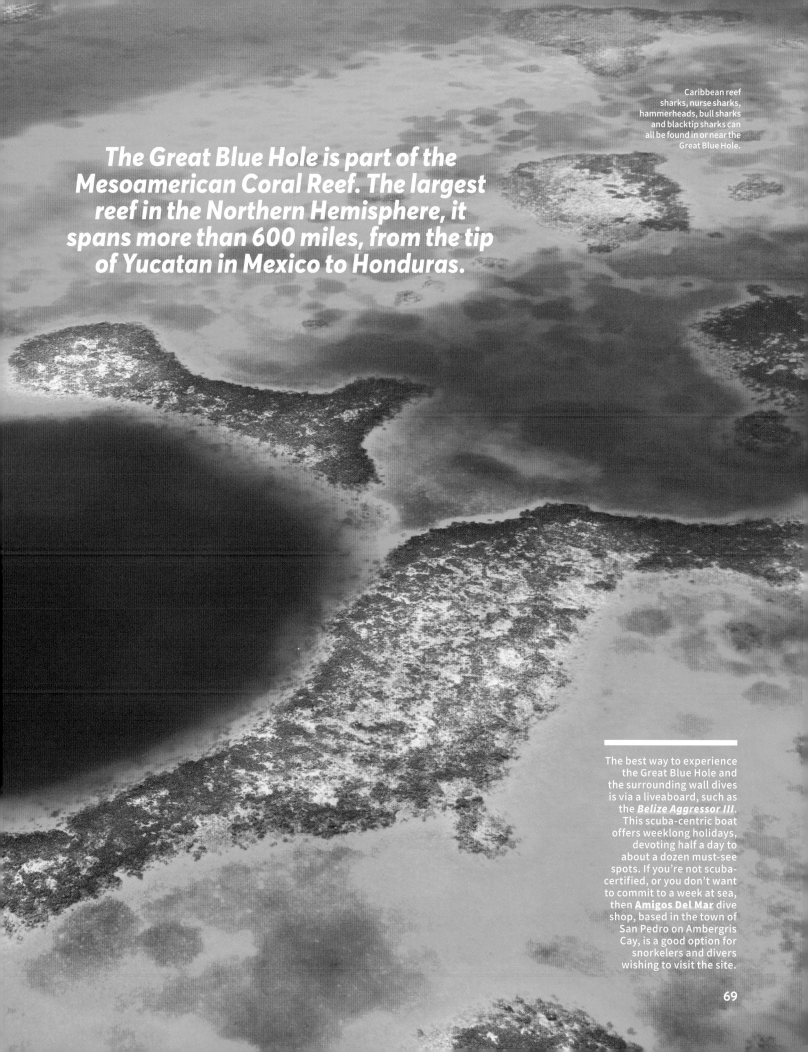

The Great Blue Hole is part of the Mesoamerican Coral Reef. The largest reef in the Northern Hemisphere, it spans more than 600 miles, from the tip of Yucatan in Mexico to Honduras.

Caribbean reef sharks, nurse sharks, hammerheads, bull sharks and blacktip sharks can all be found in or near the Great Blue Hole.

The best way to experience the Great Blue Hole and the surrounding wall dives is via a liveaboard, such as the *Belize Aggressor III*. This scuba-centric boat offers weeklong holidays, devoting half a day to about a dozen must-see spots. If you're not scuba-certified, or you don't want to commit to a week at sea, then **Amigos Del Mar** dive shop, based in the town of San Pedro on Ambergris Cay, is a good option for snorkelers and divers wishing to visit the site.

Lençóis Maranhenses

MARANHÃO, BRAZIL

The small town of **Barreirinhas** is the gateway to the lagoons. Most visitors opt for guided day tours to attractions like **Azul** and **Bonita** lakes, the largest in the park. Some operators provide sandboards or opportunities to visit with the local villagers. Get more extreme with an aerial tour, trekking or kiteboarding. July, August and September are the optimal months to go, with full lakes but less wind and rain.

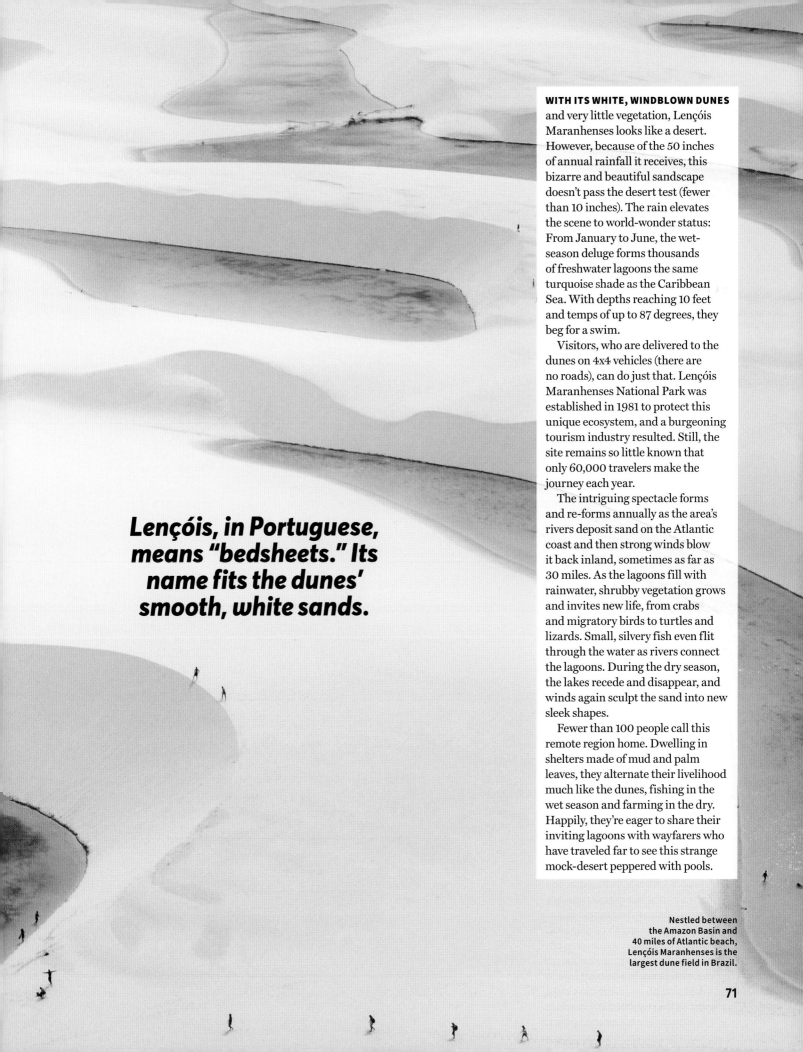

WITH ITS WHITE, WINDBLOWN DUNES and very little vegetation, Lençóis Maranhenses looks like a desert. However, because of the 50 inches of annual rainfall it receives, this bizarre and beautiful sandscape doesn't pass the desert test (fewer than 10 inches). The rain elevates the scene to world-wonder status: From January to June, the wet-season deluge forms thousands of freshwater lagoons the same turquoise shade as the Caribbean Sea. With depths reaching 10 feet and temps of up to 87 degrees, they beg for a swim.

Visitors, who are delivered to the dunes on 4x4 vehicles (there are no roads), can do just that. Lençóis Maranhenses National Park was established in 1981 to protect this unique ecosystem, and a burgeoning tourism industry resulted. Still, the site remains so little known that only 60,000 travelers make the journey each year.

The intriguing spectacle forms and re-forms annually as the area's rivers deposit sand on the Atlantic coast and then strong winds blow it back inland, sometimes as far as 30 miles. As the lagoons fill with rainwater, shrubby vegetation grows and invites new life, from crabs and migratory birds to turtles and lizards. Small, silvery fish even flit through the water as rivers connect the lagoons. During the dry season, the lakes recede and disappear, and winds again sculpt the sand into new sleek shapes.

Fewer than 100 people call this remote region home. Dwelling in shelters made of mud and palm leaves, they alternate their livelihood much like the dunes, fishing in the wet season and farming in the dry. Happily, they're eager to share their inviting lagoons with wayfarers who have traveled far to see this strange mock-desert peppered with pools.

Lençóis, in Portuguese, means "bedsheets." Its name fits the dunes' smooth, white sands.

Nestled between the Amazon Basin and 40 miles of Atlantic beach, Lençóis Maranhenses is the largest dune field in Brazil.

Victoria Falls

ZAMBIA AND ZIMBABWE

SWIM AT THE TOP OF THE LARGEST waterfall in the world? It's possible—and safer than it looks. Visitors to the Devil's Pool at Victoria Falls can float right up to the edge of the 350-foot drop and lean over. Only accessible when Zambezi River levels are lower (August through January), the planet's scariest infinity pool keeps tourists from falling thanks to an underwater rock lip.

Tucked between the countries of Zambia and Zimbabwe, the UNESCO site has plenty to offer those who prefer to stay dry as well. Two national parks border the falls on either side, both lined with paths offering many different vantage points of the cascade and its accompanying rainbows. Hikers may spot native species including African elephants, lions, antelope and zebra. A more romantic view can be had via sunset cruise, when hippos and rhinos are common sights, or on board a luxury steam train, the same way travelers arrived in the early 1900s.

The destination also attracts adrenaline junkies for white-water rafting (with expert-level Grade 5 rapids), bungee jumping off Victoria Falls Bridge and microlight flights over the sheet of falling water.

Death-defying feats aside, the falls themselves literally boom with raw natural power. While Scottish explorer David Livingstone named the site after the queen of Britain in 1855, the moniker given to it by the local Kololo tribe, Mosi-oa-Tunya, translates to "the smoke that thunders," referring to the mists that can be spotted—and heard—from miles away.

Tumbling over a wide basalt cliff, Victoria Falls spans more than 1.25 miles.

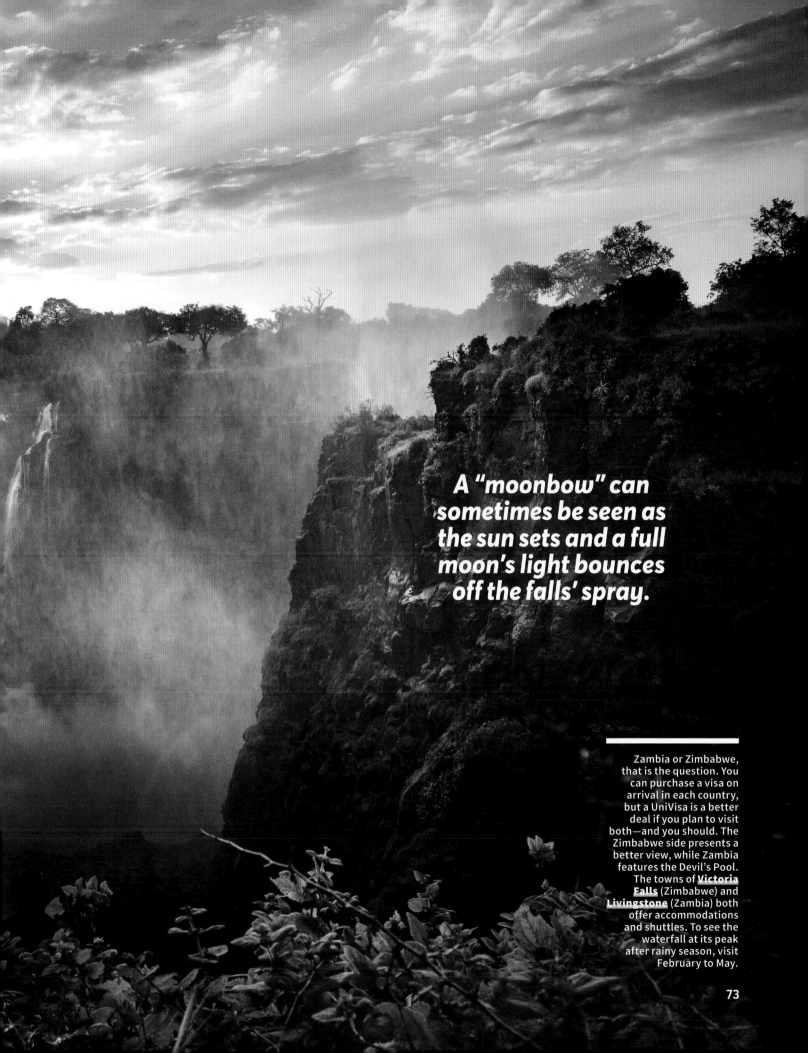

A "moonbow" can sometimes be seen as the sun sets and a full moon's light bounces off the falls' spray.

Zambia or Zimbabwe, that is the question. You can purchase a visa on arrival in each country, but a UniVisa is a better deal if you plan to visit both—and you should. The Zimbabwe side presents a better view, while Zambia features the Devil's Pool. The towns of **Victoria Falls** (Zimbabwe) and **Livingstone** (Zambia) both offer accommodations and shuttles. To see the waterfall at its peak after rainy season, visit February to May.

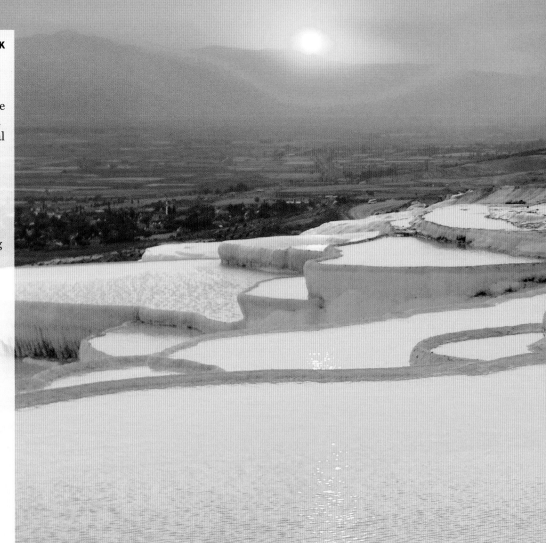

Pamukkale

TURKEY

TURKEY'S MOST BELOVED LANDMARK is not an archaeological ruin or a Byzantine cathedral, but a white mountain of natural tiered pools— so white that the name given the site by the ancients translates as "Cotton Castle." Here, calcium-laden thermal water cascades over each terrace edge, creating petrified waterfalls and stalactites that have been a favorite of local spa-seekers since at least the second century B.C.

Late spring through early fall allows the best weather for enjoying a soak in the shallow water inside the travertine pools, which are fed by five hot springs and range from 95 to 97 degrees. Year-round, the view over the 525-foot-tall plateau leaves visitors in awe.

UNESCO has recognized the site for the pools, as well as for the elaborate Greco-Roman system of canals that brought the mineral water to villages and fields close by. Also in the area are the centuries-old structures of Hierapolis, considered a holy city.

Just a few minutes' drive to the north lies the Roman theater, built during the reign of Hadrian sometime after the earthquake of A.D. 60. This grand undertaking is well-preserved, from the 50 rows of seating to the columns and statues of the stage. Those who climb to the highest perch will be granted a far-reaching overlook of the surrounding desert and an understanding of just why this area has been so highly prized then and now.

Pamukkale is more than 600 feet tall, from top to bottom.

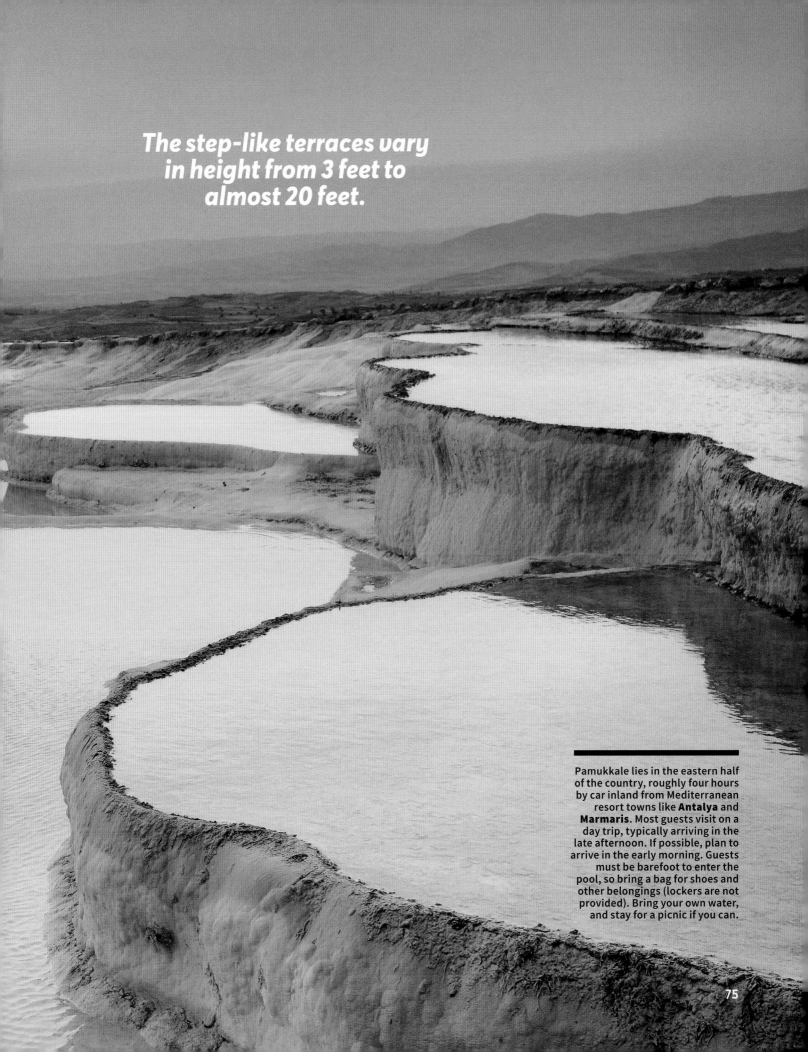

The step-like terraces vary in height from 3 feet to almost 20 feet.

Pamukkale lies in the eastern half of the country, roughly four hours by car inland from Mediterranean resort towns like **Antalya** and **Marmaris**. Most guests visit on a day trip, typically arriving in the late afternoon. If possible, plan to arrive in the early morning. Guests must be barefoot to enter the pool, so bring a bag for shoes and other belongings (lockers are not provided). Bring your own water, and stay for a picnic if you can.

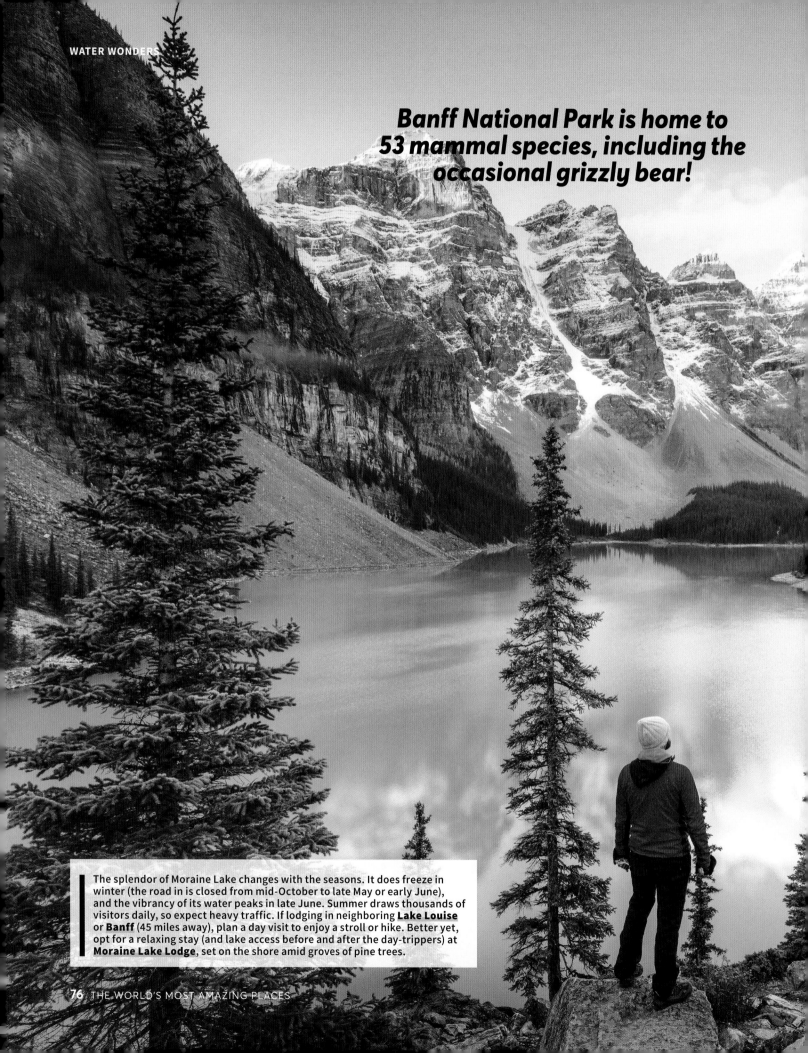

Banff National Park is home to 53 mammal species, including the occasional grizzly bear!

The splendor of Moraine Lake changes with the seasons. It does freeze in winter (the road in is closed from mid-October to late May or early June), and the vibrancy of its water peaks in late June. Summer draws thousands of visitors daily, so expect heavy traffic. If lodging in neighboring **Lake Louise** or **Banff** (45 miles away), plan a day visit to enjoy a stroll or hike. Better yet, opt for a relaxing stay (and lake access before and after the day-trippers) at **Moraine Lake Lodge**, set on the shore amid groves of pine trees.

Moraine Lake

LAKE LOUISE MAY GET MORE HYPE, but among the glacier-fed lakes that draw millions of visitors to the Canadian province of Alberta each year, it's Moraine Lake that's likely to leave them breathless. The reason? Not only is its water a surreal shade of turquoise (created by fine particles of light-refracting rock flour), but its setting amid the Valley of the Ten Peaks is panoramic perfection. And unlike Lake Louise, 9 miles away, there isn't a massive "château" hotel at one end. The sole lodge here is designed to blend in rather than to impress.

Located inside Banff National Park at an elevation of 6,183 feet, Moraine Lake is considered so beautiful that a drawing of it appeared on the back of Canadian 20-dollar bills issued in 1969 and 1979. This inspired the phrase "Twenty-dollar view"—more like 20-million-dollar view—and it's easily enjoyed, along with the invigorating aroma of fresh pine, by taking the popular 1,000-foot switchback path known as the Rockpile Trail.

A second easy option is the Moraine Lake Lakeshore Trail, which follows the water's contours and offers stellar views. Canoeing makes for another serene pastime. Those looking for a more challenging hike can tackle the Sentinel Pass or Larch Valley trails, the latter known for its brilliant autumn colors. And yet the true star is always Moraine Lake's vivid tint. Once seen, it's not easily forgotten.

Douglas firs, lodgepole pines and aspen trees contrast with Moraine Lake's bright-blue hue.

Antarctica

WHY IS ANTARCTICA—A CONTINENT—
here among Water Wonders? A
good question with a perfectly good
answer: Water is at the very heart
of the Antarctic experience. Here,
amid the frigid seas of the Southern
Ocean, hardy penguins, seals and
seabirds survive and thrive against
all odds, and regiments of Windex-
blue icebergs stoke the imagination
(ooh...this one resembles a circus tent,
and that one looks like a castle!), even
as they inspire a level of healthy fear
and awe.

A visit to this frozen wonderland
requires a journey by ship that's
not for the faint of heart. Crossing
the Drake Passage from the tip of
South America to the 300-mile-
long curved land chain known as
the South Shetland Islands is so
unpredictable, it's known as either the
Drake Lake (clear, cold and serene)
or the Drake Shake (so windy and
rough that seasickness is guaranteed).
Unfortunately, it's often the latter.

Those who chance it are rewarded
with unforgettable spectacles unlike
anywhere else on Earth: a 360-degree
view of icebergs for as far as the eye
can see; the wobbly theatricality of
a penguin parade that gives way to
speed-demon acrobatics in the water;
and knowing that Antarctica, for as
long as it can survive climate change,
is hostile to most life-forms but life-
affirming for those who traverse it.

Antarctica holds about 70 percent of the planet's fresh water, and 90 percent of its freshwater ice.

Experiencing the waters of Antarctica generally requires an expedition cruise, which is only scheduled during the Southern Hemisphere's summer and early fall (December to March). Expedition cruises, by polar specialists such as **Hurtigruten** and **Lindblad Expeditions**, are longer, more in-depth and more expensive. Some leisure cruise lines (**Princess**, **Holland America**, **Azamara**) can get you to the South Shetland Islands for a day or two for less money.

Whitsunday Islands

AUSTRALIA

ALONG THE GREAT BARRIER REEF, on the Queensland coast of Australia, lies an archipelago of 74 tropical islands featuring glorious coastlines with diverse and spectacular beaches. One of the most magnificent, and most photographed, is Whitehaven Beach (main), a large, sandy shore located on the chain's biggest and namesake Whitsunday Island.

Stretching 4.5 miles, Whitehaven Beach is known for its brilliant white sand and sparkling aquamarine waters. The beach is protected land and remains pristine because it is accessible only by ferry, boat, seaplane or helicopters that depart from nearby Airlie Beach or Hamilton Island.

The unique glowing sand on Whitehaven is some of the purest silica in the world. Geologists have surmised that tides likely carried the special grains here millions of years ago, since none of the surrounding rocks are silica-based.

Of the 74 Whitsundays, just five are inhabited and feature resorts. The rest remain as green and undeveloped as they were in 1770 when Captain James Cook arrived, finding tribes of local Aborigines known as the Ngaro people.

Another selling point of the area? From Hamilton Island, the largest inhabited isle of the Whitsundays, it's only a two-hour sail to another world-famous water wonder, the Great Barrier Reef.

The Australian summer runs from September to December, with the rainiest season in January to February. Most visitors to Whitsunday Island also trek to **Hill Inlet**, on the northern end of Whitehaven Beach, where the sea and sand swirl together to create a breathtaking blend of startling white, sapphire blue and emerald green. **Tongue Point**, just a short walk from Hill Inlet, offers a great view of this magnificent area.

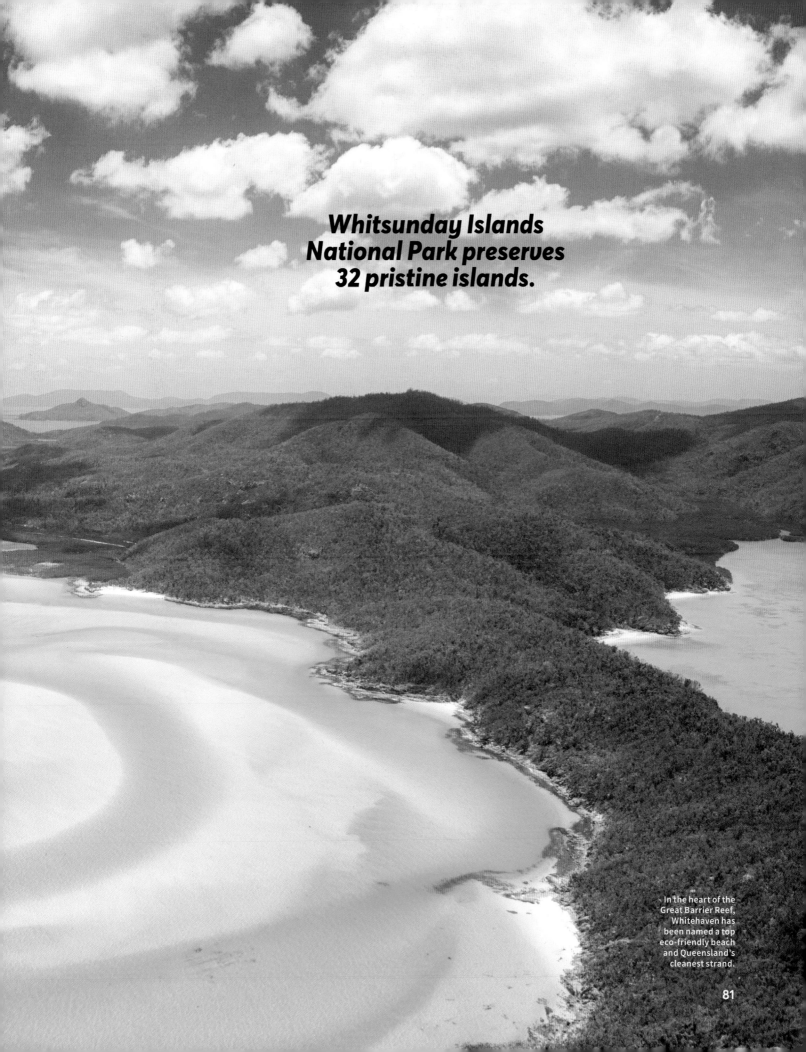

Whitsunday Islands National Park preserves 32 pristine islands.

In the heart of the Great Barrier Reef, Whitehaven has been named a top eco-friendly beach and Queensland's cleanest strand.

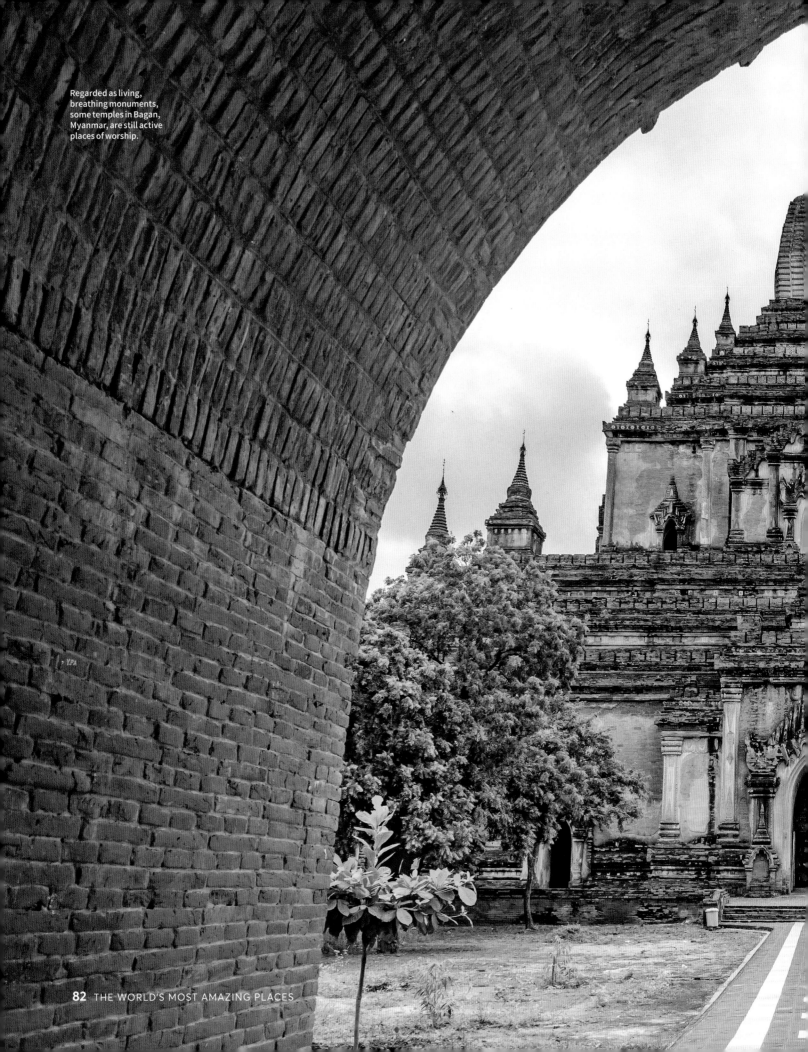

Regarded as living, breathing monuments, some temples in Bagan, Myanmar, are still active places of worship.

CHAPTER

4

Sacred
SITES

MANKIND'S SEARCH FOR TRANSCENDENCE SHINES AT
THESE INTRICATE TEMPLES, CEREMONIAL PLATFORMS,
MOUNTAINTOP SANCTUARIES AND MYSTICAL STATUES THAT
SPEAK TO OUR SOULS AND BRING US CLOSER TO HEAVEN.

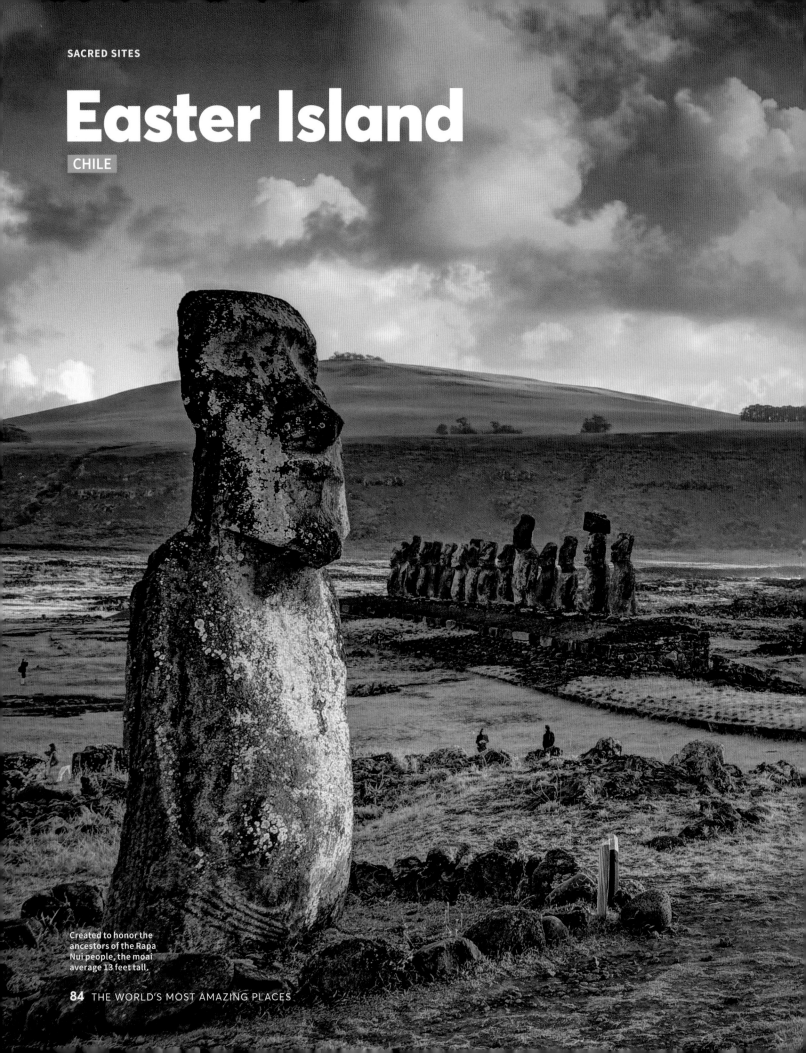

Easter Island

CHILE

Created to honor the ancestors of the Rapa Nui people, the moai average 13 feet tall.

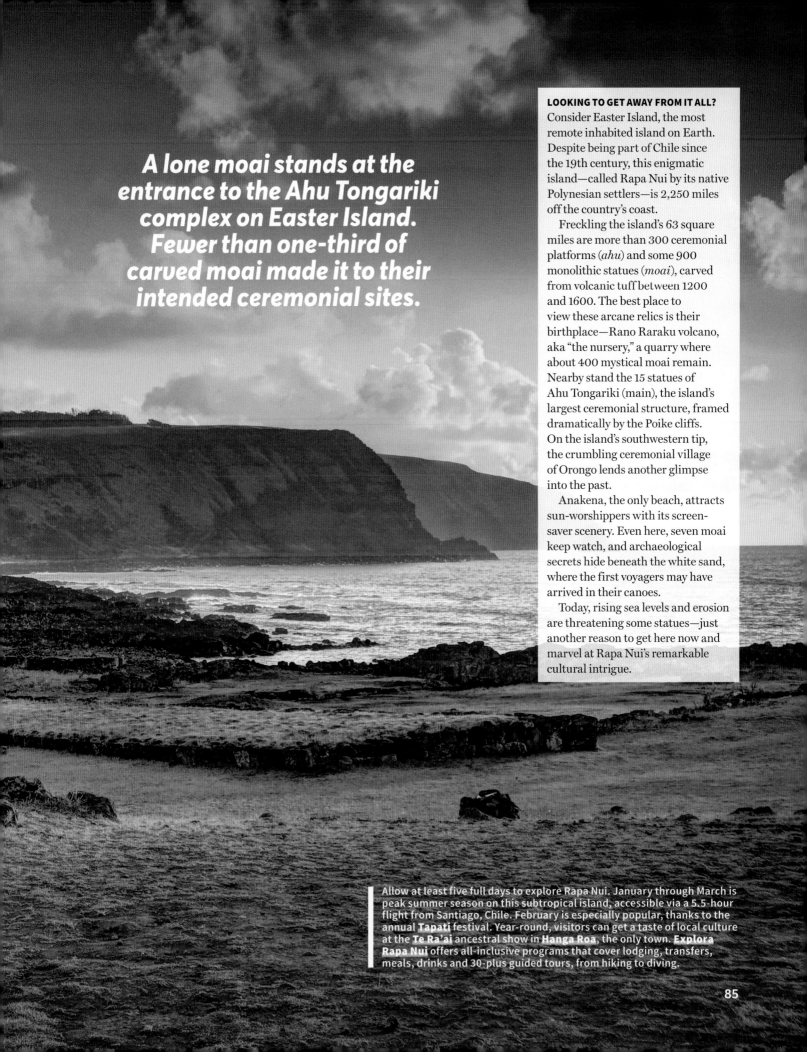

A lone moai stands at the entrance to the Ahu Tongariki complex on Easter Island. Fewer than one-third of carved moai made it to their intended ceremonial sites.

LOOKING TO GET AWAY FROM IT ALL?
Consider Easter Island, the most remote inhabited island on Earth. Despite being part of Chile since the 19th century, this enigmatic island—called Rapa Nui by its native Polynesian settlers—is 2,250 miles off the country's coast.

Freckling the island's 63 square miles are more than 300 ceremonial platforms (*ahu*) and some 900 monolithic statues (*moai*), carved from volcanic tuff between 1200 and 1600. The best place to view these arcane relics is their birthplace—Rano Raraku volcano, aka "the nursery," a quarry where about 400 mystical moai remain. Nearby stand the 15 statues of Ahu Tongariki (main), the island's largest ceremonial structure, framed dramatically by the Poike cliffs. On the island's southwestern tip, the crumbling ceremonial village of Orongo lends another glimpse into the past.

Anakena, the only beach, attracts sun-worshippers with its screen-saver scenery. Even here, seven moai keep watch, and archaeological secrets hide beneath the white sand, where the first voyagers may have arrived in their canoes.

Today, rising sea levels and erosion are threatening some statues—just another reason to get here now and marvel at Rapa Nui's remarkable cultural intrigue.

Allow at least five full days to explore Rapa Nui. January through March is peak summer season on this subtropical island, accessible via a 5.5-hour flight from Santiago, Chile. February is especially popular, thanks to the annual **Tapati** festival. Year-round, visitors can get a taste of local culture at the **Te Ra'ai** ancestral show in **Hanga Roa**, the only town. **Explora Rapa Nui** offers all-inclusive programs that cover lodging, transfers, meals, drinks and 30-plus guided tours, from hiking to diving.

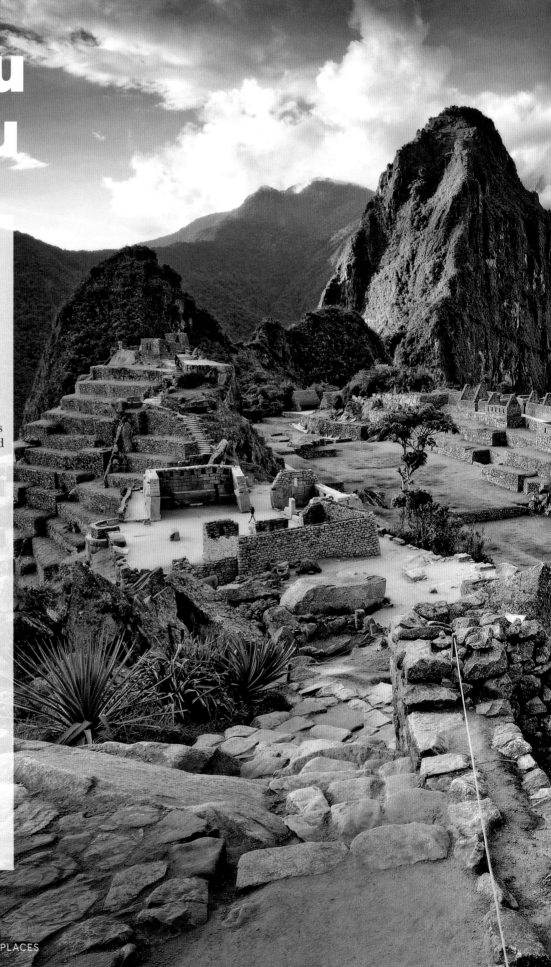

Machu Picchu

PERU

VISITING THE ICONIC INCAN archaeological site is like being drawn through a beautiful picture book roughly 8,000 feet above sea level. From a wide path that looks over a deep green valley marbled with wispy fogbanks, the massive centuries-old sanctuary appears around a bend. The buildings, walled terraces, plazas and staircases are completely constructed from stone. Alpacas—tiny white pinpricks in the distance—give scale to the scene as they graze on terraces once planted with corn and potatoes.

For many, Machu Picchu's magic lies in its mystery: It was constructed in the 1400s by the Incas, who performed this feat of engineering without the aid of wheels to move the massive boulders, or iron tools to chisel chunks of granite into building blocks so perfectly matched, no mortar was required to hold them together. The site is also filled with cosmic alignments—openings carved into stones that, during the solstice, would allow bolts of sunlight to illuminate specific spots.

Less than 100 years after creating this wondrous complex, the Incas abandoned it to the elements, where it was soon completely engulfed by jungle vegetation so thick, it obscured any evidence of the place. Machu Picchu lay hidden until 1911, when Hiram Bingham, an American explorer, literally uncovered it.

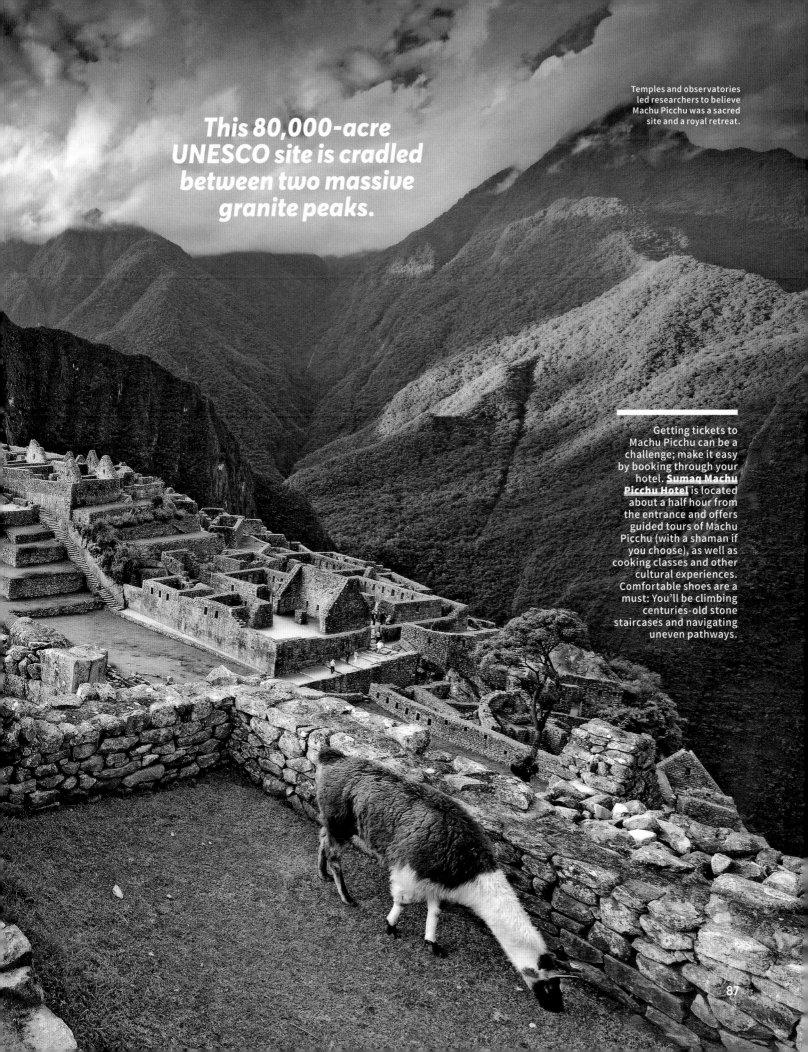

This 80,000-acre UNESCO site is cradled between two massive granite peaks.

Temples and observatories led researchers to believe Machu Picchu was a sacred site and a royal retreat.

Getting tickets to Machu Picchu can be a challenge; make it easy by booking through your hotel. **Sumaq Machu Picchu Hotel** is located about a half hour from the entrance and offers guided tours of Machu Picchu (with a shaman if you choose), as well as cooking classes and other cultural experiences. Comfortable shoes are a must: You'll be climbing centuries-old stone staircases and navigating uneven pathways.

Jerusalem

ISRAEL

PASSIONS RUN HIGH IN THE HOLIEST city in the world. Pilgrims from the three great monotheistic religions—Judaism, Christianity and Islam—flock to Jerusalem. And while the region makes headlines for conflict and division, these devotees share an ardent veneration for this hallowed ground.

Across the Old City—a UNESCO listing historically divided into Armenian, Christian, Jewish and Muslim quarters—significant sites are marked by shrines and churches, including the Church of the Holy Sepulcher, regarded as the location of Jesus' crucifixion, burial and resurrection. But the area's religious history stretches back much further—to the time of the biblical King David, who established Jerusalem as the capital of the kingdom of Israel three millennia ago.

Now the capital of the modern state of Israel, the ancient city has been repeatedly razed and rebuilt. Nowhere is this more evident than the Temple Mount, a walled compound where the Prophet Muhammad ascended to the "Divine Presence," according to Muslim belief. Jewish tradition maintains the First and Second temples once stood in this spot. Today, all that remains of the Second Temple, destroyed in A.D. 70 by the Romans, is the Western Wall (inset). Here, the faithful still leave written prayers in the cracks between the stones—a solemn and moving expression of their deep-felt beliefs.

Jerusalem's name comes from a word of Semitic origin meaning "Foundation of God."

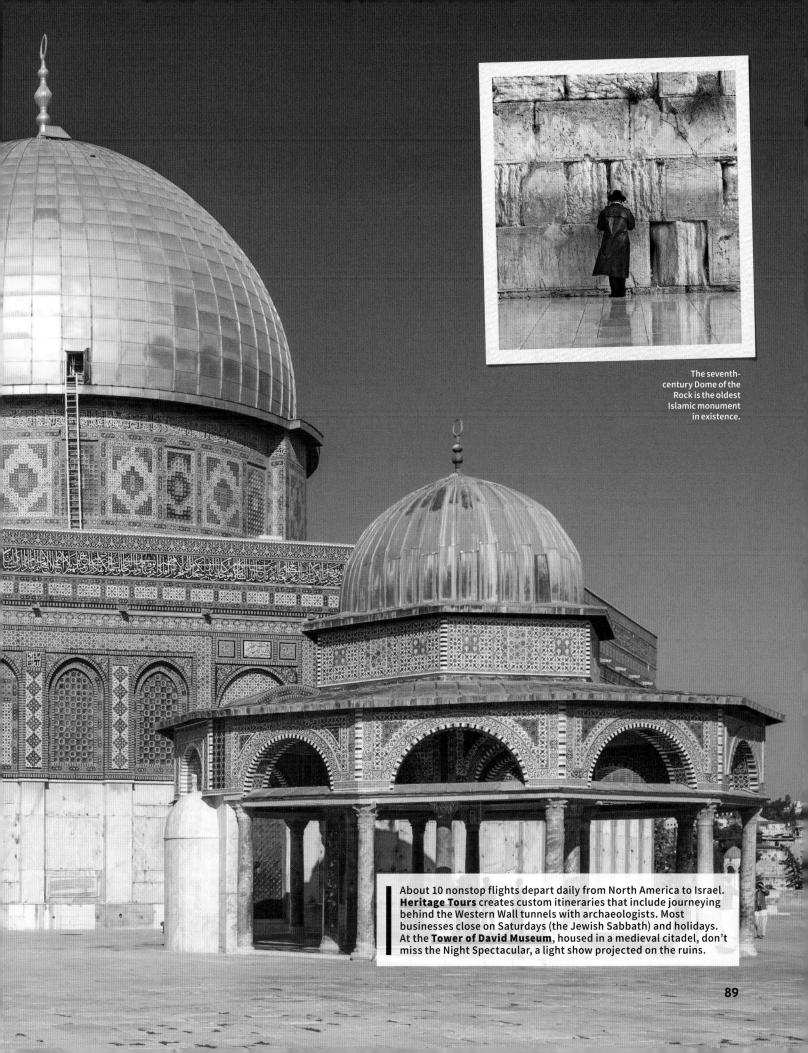

The seventh-century Dome of the Rock is the oldest Islamic monument in existence.

About 10 nonstop flights depart daily from North America to Israel. **Heritage Tours** creates custom itineraries that include journeying behind the Western Wall tunnels with archaeologists. Most businesses close on Saturdays (the Jewish Sabbath) and holidays. At the **Tower of David Museum**, housed in a medieval citadel, don't miss the Night Spectacular, a light show projected on the ruins.

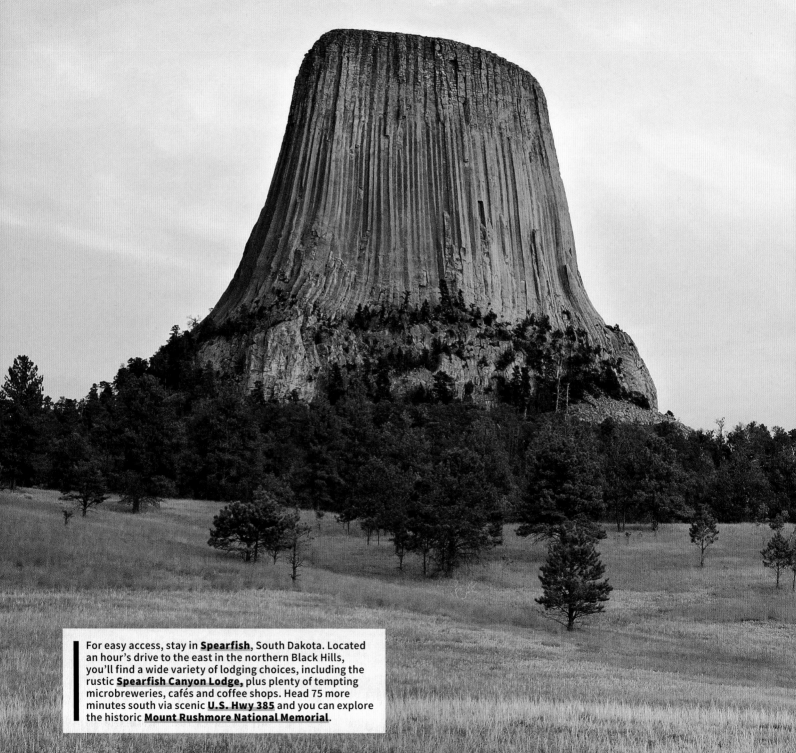

Some Northern Plains Native American tribes still hold sacred rituals, such as sun dances and sweat lodges, at Devil's Tower.

For easy access, stay in **Spearfish**, South Dakota. Located an hour's drive to the east in the northern Black Hills, you'll find a wide variety of lodging choices, including the rustic **Spearfish Canyon Lodge,** plus plenty of tempting microbreweries, cafés and coffee shops. Head 75 more minutes south via scenic **U.S. Hwy 385** and you can explore the historic **Mount Rushmore National Memorial**.

Devil's Tower

IN THE COWBOY STATE, THE WEST IS still wild, and the scenery seems to jump straight off a painter's canvas.

Devil's Tower is a prime example. Located near the city of Hulett, Wyoming, it's an impressive geologic feature that majestically protrudes out of the landscape of the prairie that surrounds the Black Hills. The Tower is a popular destination for rock climbers, and it's easy to see why—the dark, deeply grooved spire of volcanic rock rises a stark 867 feet above the nearby Belle Fourche River.

The landmark, though, is still considered deeply sacred by the indigenous people of the Lakota, Kiowa and other Native tribes, and it remains a stirring reminder that in this rugged part of the country, nature is both untamed and unfathomable. Each tribe has passed down its own oral history of the Tower through the years, and these sacred narratives are still recounted today with the same reverence to the beliefs and people of the past.

Just 30 miles away, Grand Teton National Park makes a perfect pairing if you're visiting. Far fewer people explore its 13,500-foot, glacier-covered peaks and pristine alpine lakes. Reflecting the entire range in its glassy waters, Jenny Lake is a favorite stop. And the Snake River, like the Yellowstone River, is popular with rafters.

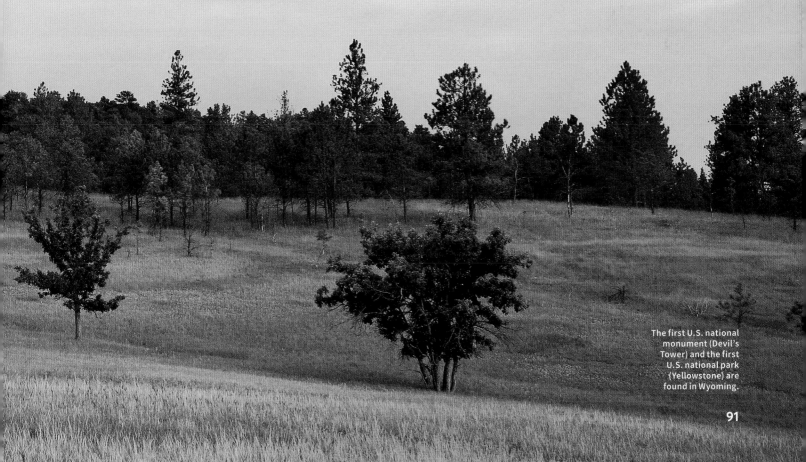

The first U.S. national monument (Devil's Tower) and the first U.S. national park (Yellowstone) are found in Wyoming.

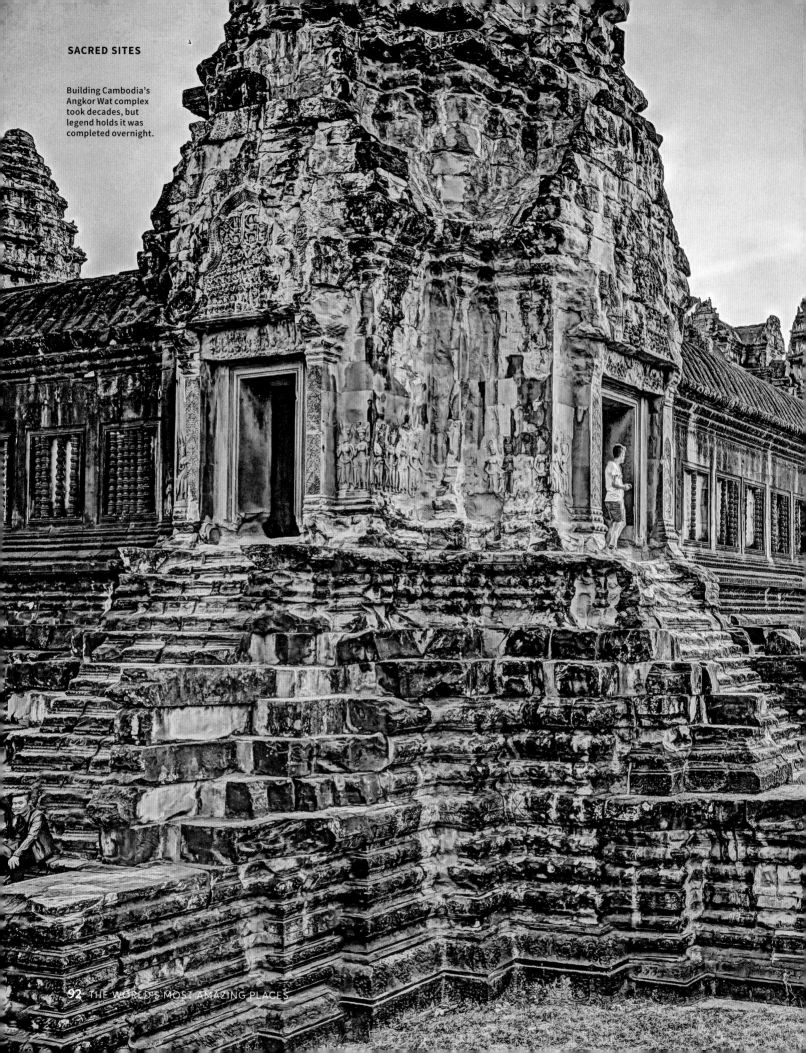

Building Cambodia's
Angkor Wat complex
took decades, but
legend holds it was
completed overnight.

Angkor Wat

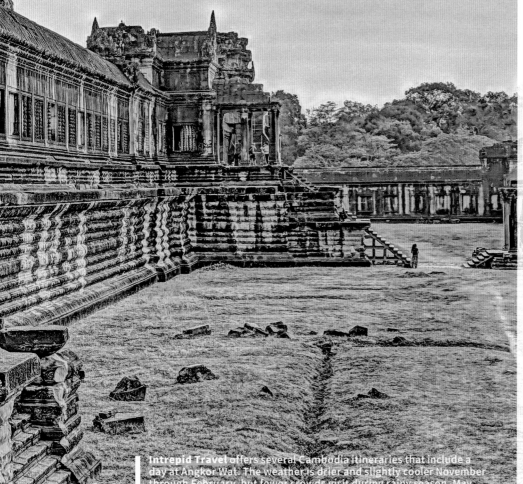

Angkor Wat is the largest religious monument in the world.

DEEP IN THE JUNGLE OF CAMBODIA'S Siem Reap province lies the sprawling Angkor complex, a group of temples constructed in the 12th century by the Khmer empire. Of these, Angkor Wat is the most beloved—the temple is the emblem on the Cambodia flag.

Although the "City of Temples" is now Buddhist, it was built to honor the Hindu god Vishnu and was modeled to be the earthly representation of Mount Meru, which houses gods in Hindu mythology. Near the western entrance, visitors still leave offerings like flowers and locks of hair at an eight-armed Vishnu statue to thank the god for good fortune.

Intricate sculptures dot the three-story temple complex, telling tales of historical events and religious mythology. More than 3,000 *apsaras* (heavenly spirits) and *devatas* (goddesses) are carved into the sandstone.

A set of deliberately steep stairs, meant to mimic the difficulty of reaching heaven, lead to Bakan Sanctuary. Open to a limited number of visitors per day, the upper level is the most sacred place within the complex and offers views of the surrounding river valley.

Another Angkor attraction is Ta Prohm, which served as a backdrop for the movie *Lara Croft: Tomb Raider*. The beauty of this temple is nature's aim to reclaim it: Massive strangler-fig tree roots weave artistically through the structure.

When Angkor Archaeological Park was added to UNESCO's World Heritage list in 1992, it was also flagged as in danger. A campaign to restore the complex and make it safe for travelers addressed theft, illegal excavations and land mines. Thanks to these efforts, the modern wonder now welcomes more than 2 million visitors per year.

Intrepid Travel offers several Cambodia itineraries that include a day at Angkor Wat. The weather is drier and slightly cooler November through February, but fewer crowds visit during rainy season, May through October. Arrive early to witness the iconic sunrise, and avoid the masses by watching from the south reflection pool instead of the north. This is a sacred place, so dress modestly; don't touch, sit on or climb structures; avoid restricted areas; and be respectful of monks.

Vatican

VATICAN CITY

THE SMALLEST COUNTRY IN THE WORLD packs a big punch. With a population of 800 and annual visitors numbering 5.5 million, Vatican City sees more tourists per resident than any other country. Which makes sense, given this sacred site is not only the spiritual and governing center of the Roman Catholic Church, but also stands as testimony to a storied history that dates back two millennia.

Popes have resided in the Vatican since the 14th century, but it wasn't until 1929 that Vatican City was established as an independent sovereign state, uniquely autonomous from surrounding Rome. Famed Italian architect Gian Lorenzo Bernini designed St. Peter's Square—its two semicircular colonnades representing what he coined "the motherly arms of the church"—as the graceful guardian of St. Peter's Basilica. Beneath the famous church lies the tomb of St. Peter, along with the remains of the original basilica built by Constantine on the site in the fourth century.

From there, it's one *pièce de résistance* after another. Entering the intimate Sistine Chapel, Michelangelo's hallowed ceiling comes into view, depicting frescoes of the book of Genesis and his magnum opus, "The Last Judgment." A glance just beneath Christ shows St. Bartholomew holding his own flayed skin. Ostensibly, in the face of the skin is a self-portrait of Michelangelo, its crestfallen expression hinting at the artist's struggle with faith.

Other revered Vatican relics include the Raphael Rooms, the Vatican Library and epic works like Caravaggio's "The Entombment of Christ." No matter one's religious leanings, wandering through this holy place invites contemplation, inspires generosity, sparks wonder and feeds the soul.

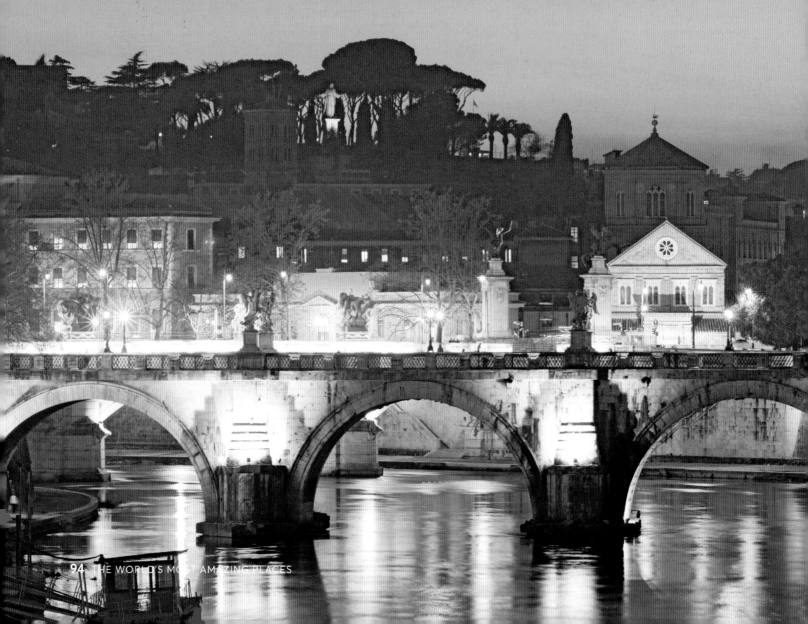

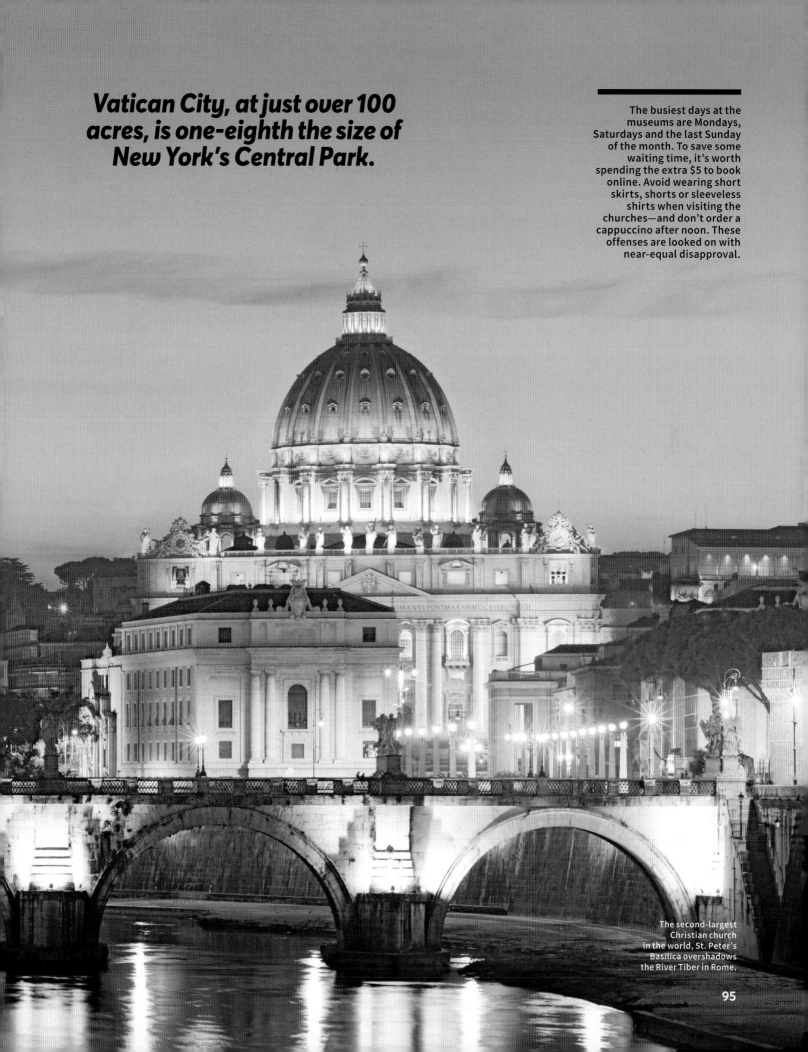

Vatican City, at just over 100 acres, is one-eighth the size of New York's Central Park.

The busiest days at the museums are Mondays, Saturdays and the last Sunday of the month. To save some waiting time, it's worth spending the extra $5 to book online. Avoid wearing short skirts, shorts or sleeveless shirts when visiting the churches—and don't order a cappuccino after noon. These offenses are looked on with near-equal disapproval.

The second-largest Christian church in the world, St. Peter's Basilica overshadows the River Tiber in Rome.

Sagrada Família

BARCELONA, SPAIN

THE CITY OF BARCELONA resembles a Dr. Seuss book thanks to one modernist Catalan architect: Antoni Gaudí. Of the landmarks he designed here (seven of which are grouped as the Works of Antoni Gaudí UNESCO site), the crown jewel is the Sagrada Família, a Catholic church that has been under construction for more than 138 years.

A year after the foundation was laid in 1882, Gaudí took the helm of the project and devoted the rest of his life to the masterpiece. Before his death in 1926, he was only able to complete the church's crypt and a majority of the Nativity facade—a mere fraction of the overall project. Knowing the church would not be finished in his lifetime, Gaudí created numerous drawings and models so his vision could be carried out.

Poor funding significantly hindered construction until the late 20th century. But thanks to an influx of tourism, entry fees have bankrolled the basilica's progress.

While the intricate carvings on the building's exterior are impressive, the central nave is the church's shining star. The vaults rise 150 feet, with stone pillars designed to look like trees and branches stretching to the dreamlike ceiling.

Currently, the projected completion date is 2026, which will mark the centennial of Gaudí's death. But visitors should not wait to plan a visit—after all, the price of admission will ensure this labor of love is preserved for many more generations to come.

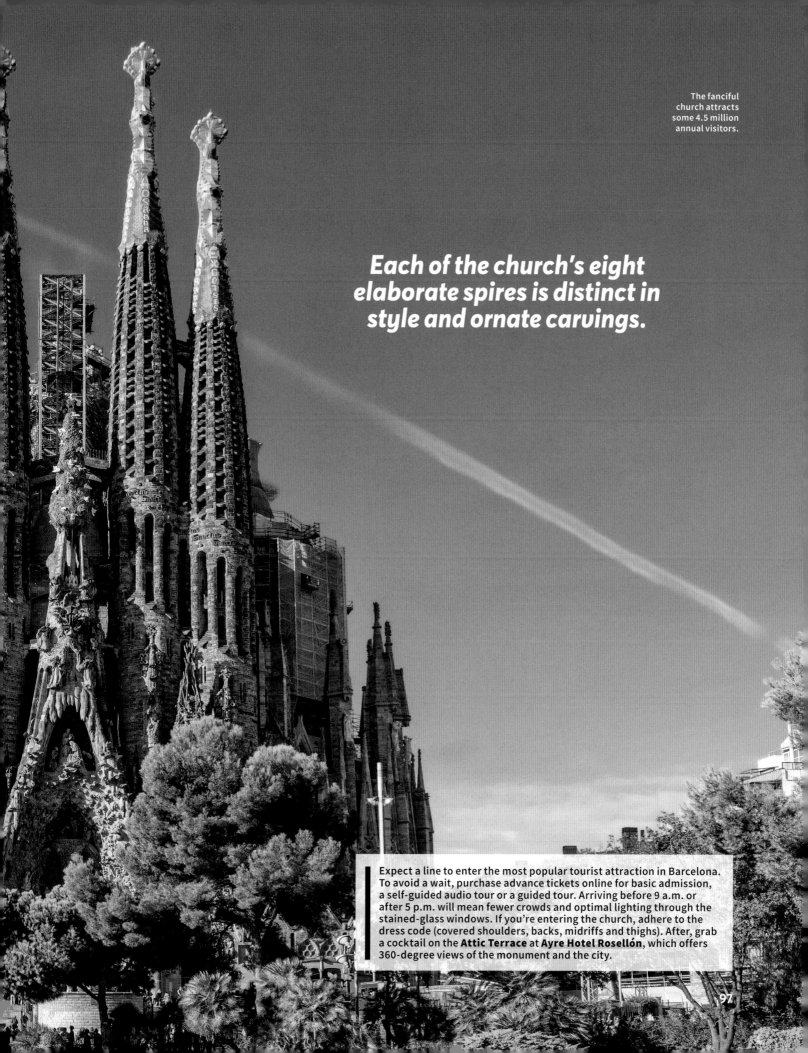

The fanciful church attracts some 4.5 million annual visitors.

Each of the church's eight elaborate spires is distinct in style and ornate carvings.

Expect a line to enter the most popular tourist attraction in Barcelona. To avoid a wait, purchase advance tickets online for basic admission, a self-guided audio tour or a guided tour. Arriving before 9 a.m. or after 5 p.m. will mean fewer crowds and optimal lighting through the stained-glass windows. If you're entering the church, adhere to the dress code (covered shoulders, backs, midriffs and thighs). After, grab a cocktail on the **Attic Terrace** at **Ayre Hotel Rosellón**, which offers 360-degree views of the monument and the city.

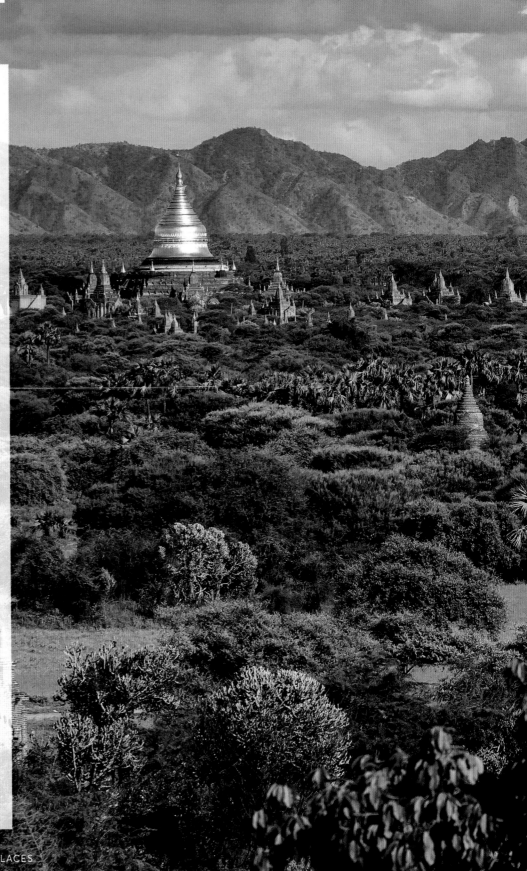

Bagan

MYANMAR

WITH MORE THAN 2,000 BUDDHIST- temple ruins dotting a 26-square-mile plain along the Irrawaddy River, the Bagan Archaeological Zone has been likened to Angkor Wat without the crowds. Inaccessible for decades due to military rule, Bagan now entices with exotic settings, ancient temples and the chance to visit one of the cradles of Buddhism long closed to the outside world.

At least 4,000 monuments once stood in this temple town, erected between 1057 and 1287 by Bagan kings who believed building these shrines would garner them eternal merit. New construction ended as earthquakes and Mongol invaders brought an end to the kingdom.

Located on a seismic fault, Bagan has been plagued by centuries of earthquakes. One in 2016 wreaked havoc, damaging 389 pagodas and breaking the spire of Pyathatgyi temple, whose rooftop is a popular sunset-viewing spot. Still, as nature takes its toll on the site, visitors find the ruins ever more spellbinding. Highlights include Sulamani, which displays some of the most extensive frescoes in the complex; Shwezigon, with its gilded stupa (dome); Ananda, the first of the temples at Bagan; and Dhammayangyi, the biggest and best-preserved of Bagan's pagodas.

Restoration began on earthquake-damaged pagodas shortly after 2016's quake. "We are halfway through repairing the major damages," the deputy director of the Bagan branch of the Department of Archaeology said in 2018, adding he hoped the endeavors would be completed by 2020. As this archaeological wonder continues to rise on the world stage, now is the time to wander its dusty lanes, behold its weathered monasteries and contemplate your own eternity.

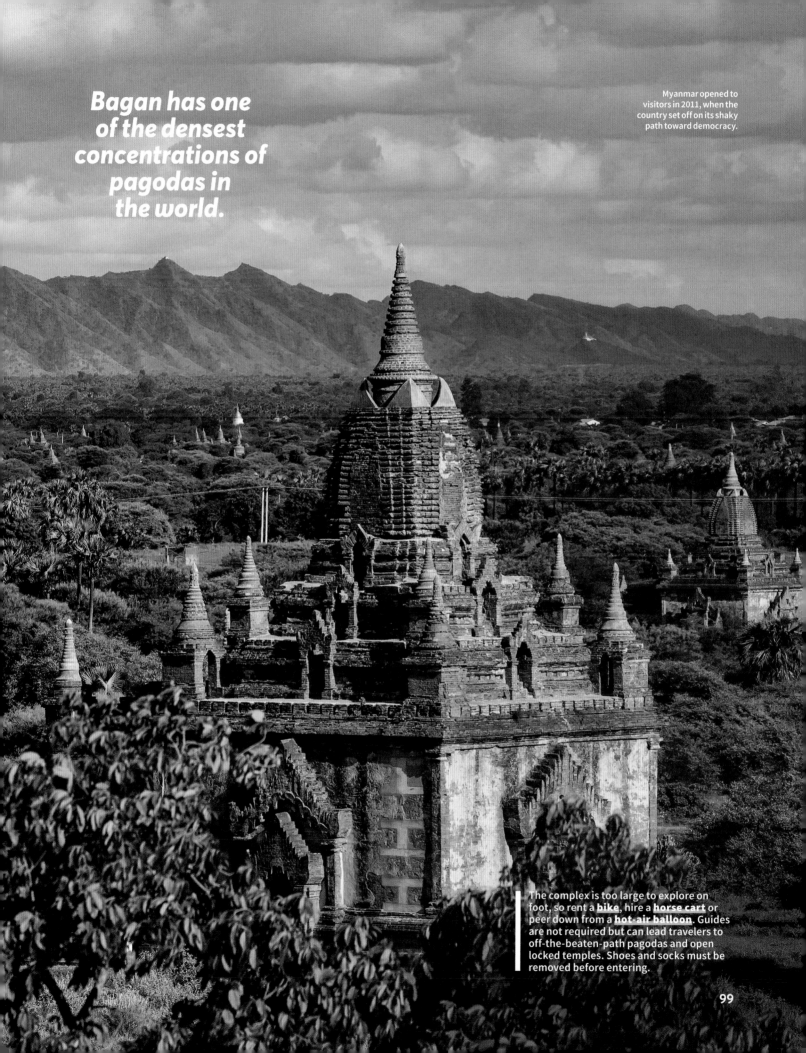

Bagan has one of the densest concentrations of pagodas in the world.

Myanmar opened to visitors in 2011, when the country set off on its shaky path toward democracy.

The complex is too large to explore on foot, so rent a **bike**, hire a **horse cart** or peer down from a **hot-air balloon**. Guides are not required but can lead travelers to off-the-beaten-path pagodas and open locked temples. Shoes and socks must be removed before entering.

Temples of Kyoto

JAPAN

The cultural center of Japan and its imperial capital for more than a thousand years, **Kyoto** is a bonanza of **teahouses**, **geishas**, **Japanese gardens** and **wooden temples**. Kiyomizu-dera, the most visited, enjoys a festive ambience. The site recently underwent extensive repair work that was scheduled to conclude in March 2020, right in time for the **2020 Tokyo Olympic Games**, which start in July.

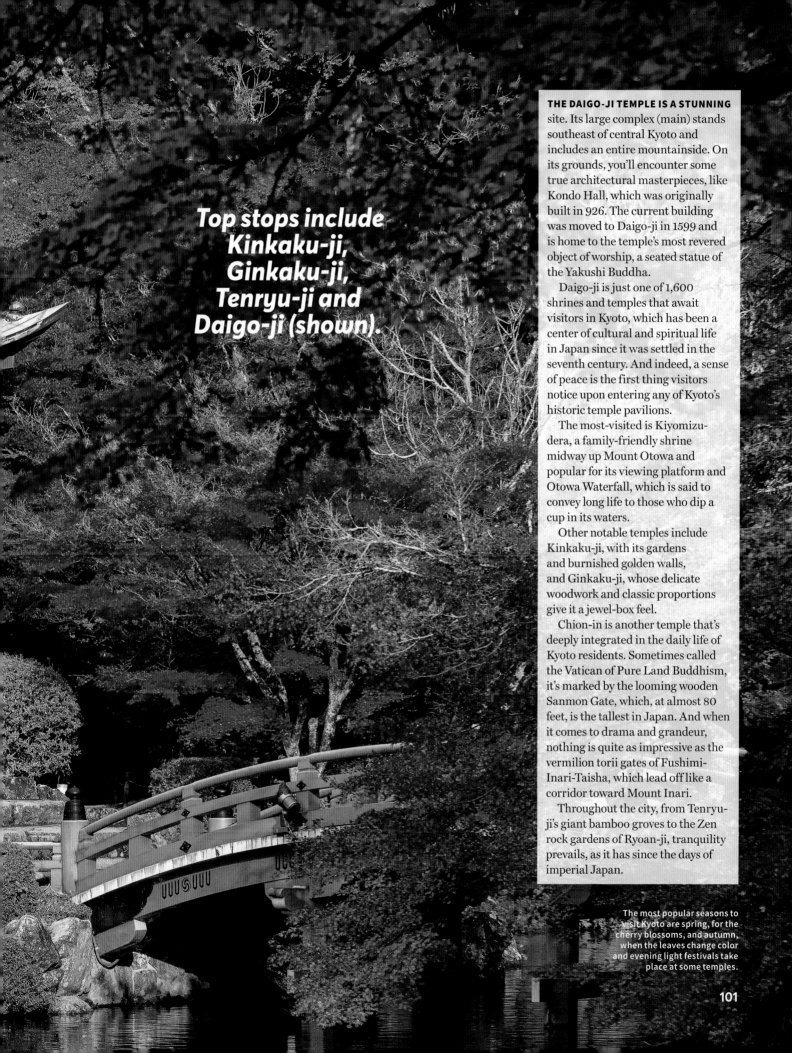

Top stops include Kinkaku-ji, Ginkaku-ji, Tenryu-ji and Daigo-ji (shown).

THE DAIGO-JI TEMPLE IS A STUNNING site. Its large complex (main) stands southeast of central Kyoto and includes an entire mountainside. On its grounds, you'll encounter some true architectural masterpieces, like Kondo Hall, which was originally built in 926. The current building was moved to Daigo-ji in 1599 and is home to the temple's most revered object of worship, a seated statue of the Yakushi Buddha.

Daigo-ji is just one of 1,600 shrines and temples that await visitors in Kyoto, which has been a center of cultural and spiritual life in Japan since it was settled in the seventh century. And indeed, a sense of peace is the first thing visitors notice upon entering any of Kyoto's historic temple pavilions.

The most-visited is Kiyomizu-dera, a family-friendly shrine midway up Mount Otowa and popular for its viewing platform and Otowa Waterfall, which is said to convey long life to those who dip a cup in its waters.

Other notable temples include Kinkaku-ji, with its gardens and burnished golden walls, and Ginkaku-ji, whose delicate woodwork and classic proportions give it a jewel-box feel.

Chion-in is another temple that's deeply integrated in the daily life of Kyoto residents. Sometimes called the Vatican of Pure Land Buddhism, it's marked by the looming wooden Sanmon Gate, which, at almost 80 feet, is the tallest in Japan. And when it comes to drama and grandeur, nothing is quite as impressive as the vermilion torii gates of Fushimi-Inari-Taisha, which lead off like a corridor toward Mount Inari.

Throughout the city, from Tenryu-ji's giant bamboo groves to the Zen rock gardens of Ryoan-ji, tranquility prevails, as it has since the days of imperial Japan.

The most popular seasons to visit Kyoto are spring, for the cherry blossoms, and autumn, when the leaves change color and evening light festivals take place at some temples.

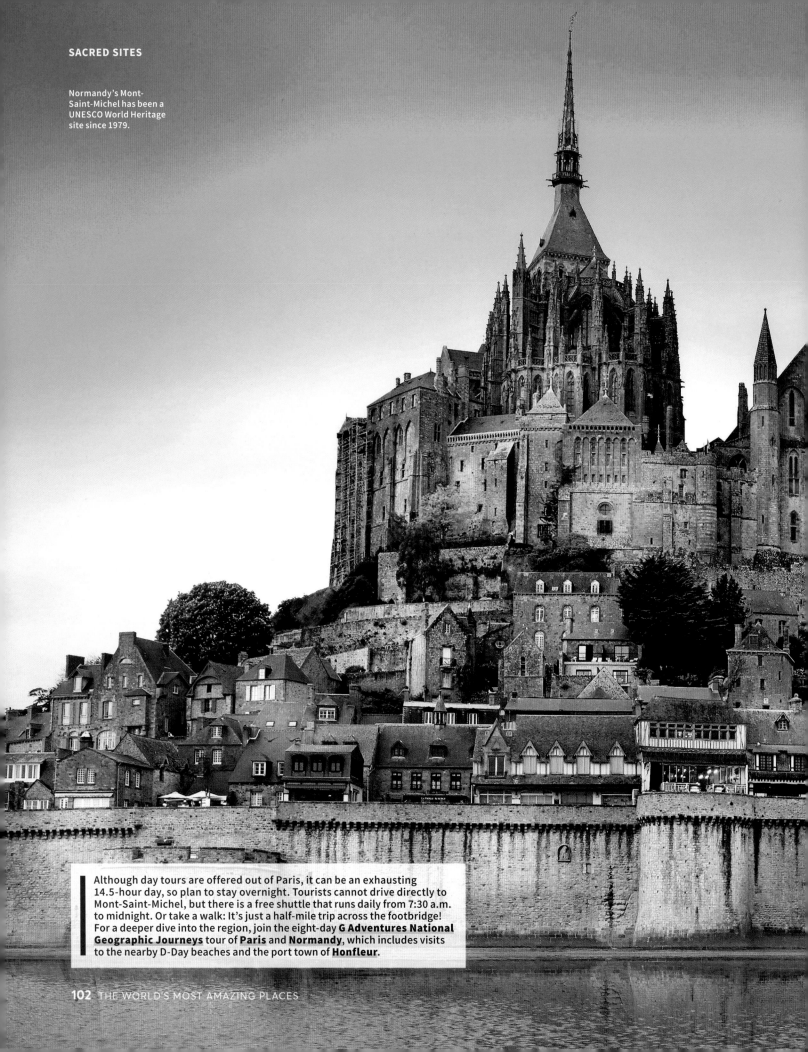

Normandy's Mont-
Saint-Michel has been a
UNESCO World Heritage
site since 1979.

Although day tours are offered out of Paris, it can be an exhausting
14.5-hour day, so plan to stay overnight. Tourists cannot drive directly to
Mont-Saint-Michel, but there is a free shuttle that runs daily from 7:30 a.m.
to midnight. Or take a walk: It's just a half-mile trip across the footbridge!
For a deeper dive into the region, join the eight-day **G Adventures National
Geographic Journeys** tour of **Paris** and **Normandy**, which includes visits
to the nearby D-Day beaches and the port town of **Honfleur**.

Mont-Saint-Michel

In the Middle Ages, the monastery became a pilgrimage site and earned the isle the moniker "City of the Books."

FROM AFAR, MONT-SAINT-MICHEL glistens like a castle straight out of a Disney fairy tale. After all, it did inspire the royal palace in 2010's animated film *Tangled*. The Gothic-style abbey sits atop a rocky isle in the bay between Normandy and Brittany and was built in the eighth century by Bishop Aubert of Avranches in dedication to the Archangel Michael.

Less than half a mile from the French coast, the island was once part of the mainland. But in 709, a tidal wave isolated the area. Quicksand and ever-changing tides kept it at bay until 1879, when a causeway was built. But the tides' natural ebb and flow caused a silt buildup. So in 2014, it was finally replaced with a modern, 2,500-foot bridge and footpath.

Today, the tides are still unpredictable. At high tide, the monastery appears to be floating above water, creating a magical reflection in the water. Come low tide, visitors are able to walk the surrounding sandy perimeter.

Though Mont-Saint-Michel has a population of just 50 residents, which mostly consists of monks and nuns, more than 2.5 million tourists flock to one of UNESCO's first world heritage sites.

Chichén-Itzá

YUCATÁN PENINSULA, MEXICO

THE GRAND TEMPLE-CITY OF
Chichén-Itzá was established near
freshwater-filled sinkholes called
cenotes, which supplied water to
the settlement—and served as a
locus for human sacrifice. Believing
Chaac, the Maya rain god, dwelled
in the depths of these cavities, the
pre-Columbian Maya dropped in
offerings such as gold, jade, pottery
and shells. Eerily, archaeologists
have even retrieved human bones.

Though this area was a place
of pilgrimage during the first
millennium B.C., the Maya-Toltec
city of Chichén-Itzá wasn't first
developed until sometime in the
fifth century. Considered sacred,
its temples and other structures are
marked by *chacmools* (sculptures
holding sacrificial basins),
tzompantli (skull walls) and
ceremonial incense burners.

The Mesoamerican urban center
flourished between 750 and 1200,
but was abandoned in the 15th
century. Even so, a number of
monuments, including El Caracol
observatory and the Grand Ball
Court, still stand on the 6-square-
mile site. Most iconic is the 90-foot-
tall Temple of Kukulkán, the
Feathered Serpent God. Its cryptic
design manifests the Maya calendar,
and its orientation delineates the
solstices and equinoxes (on the latter,
a snake-shaped shadow appears on
the steps). Soberingly, the pyramid
almost certainly hosted human
sacrifices on its uppermost terrace.

Excavated in 1841, Chichén-Itzá
is now the second-most-visited
archaeological site in Mexico, after
Teotihuacan. Its monumental
architecture, cosmic symbolism,
historic significance and, yes, grisly
rituals, readily captivate travelers
who roam these hallowed grounds.

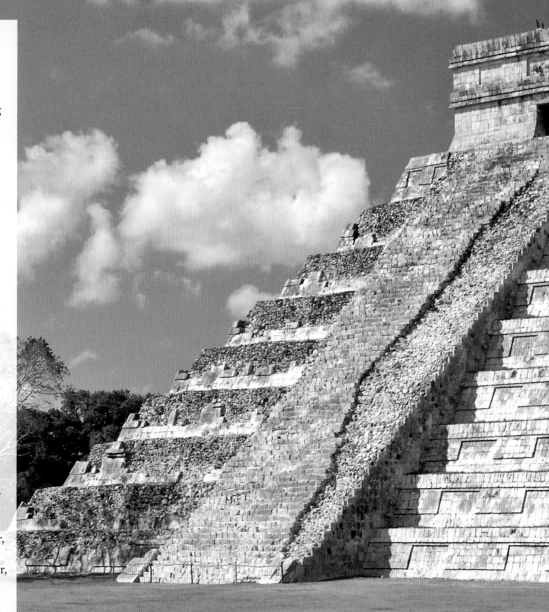

The Kukulkán Pyramid actually sits on top of the site of another much older temple.

Just two hours by road from **Cancun**, Chichén-Itzá is a popular day trip for vacationers in the Riviera Maya. Renting a car allows you to arrive early, before large tour groups descend on the site, and stay late for the nightly light-and-sound show, a 45-minute spectacle featuring projections on the pyramid's facade (apply for tickets at nochesdekukulkan.com). No climbing is allowed on the structures. Combine a visit to the site with a swim in a cenote such as **Ik Kil**.

Taj Mahal

AGRA, INDIA

AS IF THE TAJ MAHAL—A shimmering white-marble layer cake of arched windows, domes and towers rising above a serene reflecting pool—wasn't stunning enough at first view, it becomes even more wondrous when admired close-up. That's when visitors discover almost every surface is decorated in *pietra dura,* an inlay technique that involves fitting tiny pieces of lapis, malachite and other semiprecious stones into the marble in elaborate patterns of flowers and geometric designs. Considered the pinnacle of Mughal architecture and artisanship, this gigantic jewel box is also almost perfectly symmetrical—even the gardens are divided into quadrants—creating a sense of harmony and balance.

The backstory of the Taj triggers strong emotions as well: The majestic structure is a testament to eternal love, built by the Mughal emperor Shah Jahan as a mausoleum for his beloved third wife, Mumtaz, who died in childbirth. The two are buried inside the Taj Mahal, but not in the octagonal chamber displaying their elaborately carved symbolic cenotaphs (tombs)—their actual sarcophagi are on the simpler lower level, in accordance with Muslim law, which prohibits vanity in the decoration of graves.

One of the seven modern wonders of the world as well as a UNESCO World Heritage site, the Taj took 20,000 workers, 1,000 elephants and over 22 years to build. Sadly, Shah Jahan was overthrown soon after and imprisoned in Agra Fort, where he spent the rest of his life looking across at the Taj but unable to visit it. A stop at Agra Fort is a worthy side trip, enhancing a tour of the Taj.

Visits to the Taj Mahal are limited to three hours. You can make a day trip from **Delhi,** but you'll miss one of its super-impressive features: the way the changing light turns the stone from pink to white to sunset gold. Dine at the rooftop restaurant of **Hotel Kamal** or **Hotel Saniya Palace,** and you'll have a front-row seat. Or stay at the **Oberoi Amarvilas,** where every room has a Taj view.

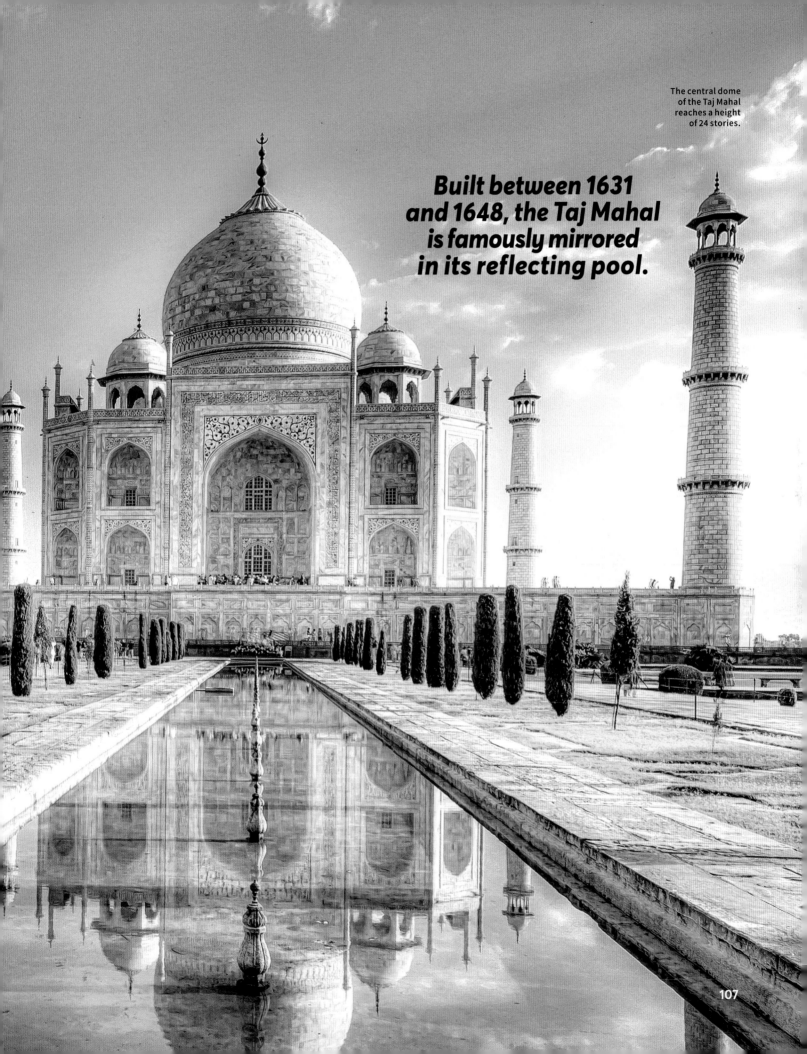

The central dome of the Taj Mahal reaches a height of 24 stories.

Built between 1631 and 1648, the Taj Mahal is famously mirrored in its reflecting pool.

Meteora

GREECE

To reach Meteora, trains and buses run from **Athens** to the nearby village of **Kalambaka**, which is where to find hotels, shops and restaurants. Check monastery hours before visiting, as each one is closed on a different day of the week. Dress conservatively to enter—no short sleeves or shorts are permitted. To learn more about the history of the monasteries and the surrounding area (including spotting the caves where hermits used to hide), hire a guide or book a day tour.

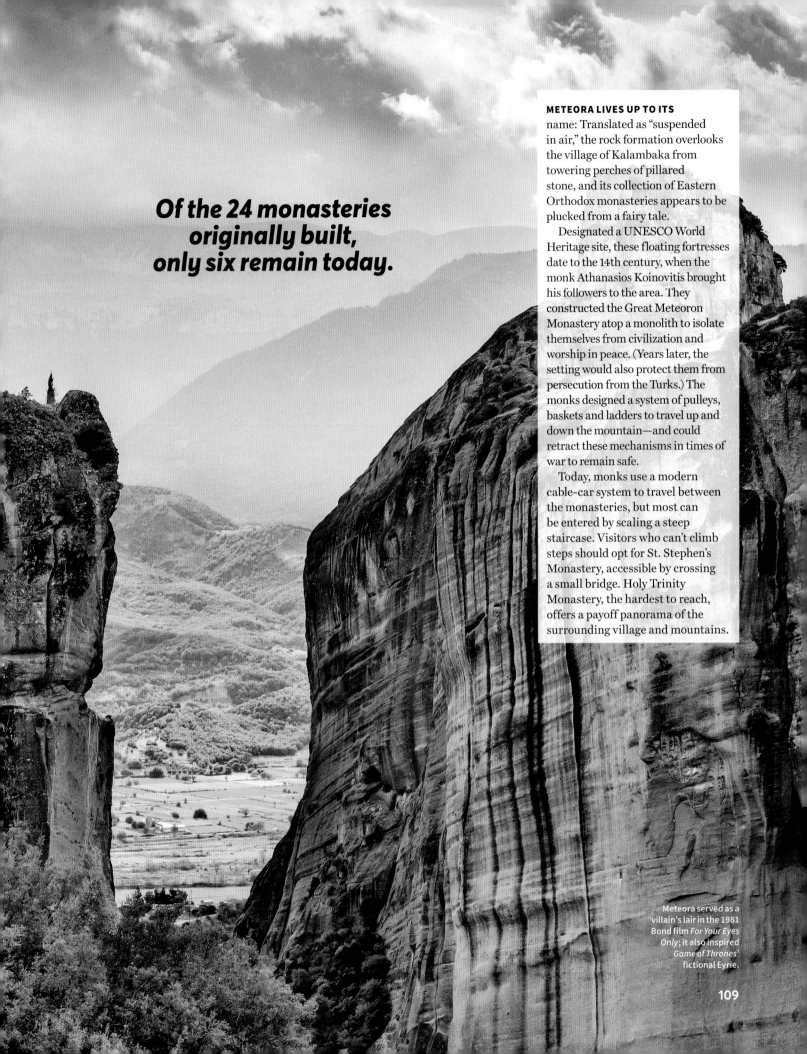

Of the 24 monasteries originally built, only six remain today.

METEORA LIVES UP TO ITS name: Translated as "suspended in air," the rock formation overlooks the village of Kalambaka from towering perches of pillared stone, and its collection of Eastern Orthodox monasteries appears to be plucked from a fairy tale.

Designated a UNESCO World Heritage site, these floating fortresses date to the 14th century, when the monk Athanasios Koinovitis brought his followers to the area. They constructed the Great Meteoron Monastery atop a monolith to isolate themselves from civilization and worship in peace. (Years later, the setting would also protect them from persecution from the Turks.) The monks designed a system of pulleys, baskets and ladders to travel up and down the mountain—and could retract these mechanisms in times of war to remain safe.

Today, monks use a modern cable-car system to travel between the monasteries, but most can be entered by scaling a steep staircase. Visitors who can't climb steps should opt for St. Stephen's Monastery, accessible by crossing a small bridge. Holy Trinity Monastery, the hardest to reach, offers a payoff panorama of the surrounding village and mountains.

Meteora served as a villain's lair in the 1981 Bond film *For Your Eyes Only*; it also inspired *Game of Thrones'* fictional Eyrie.

109

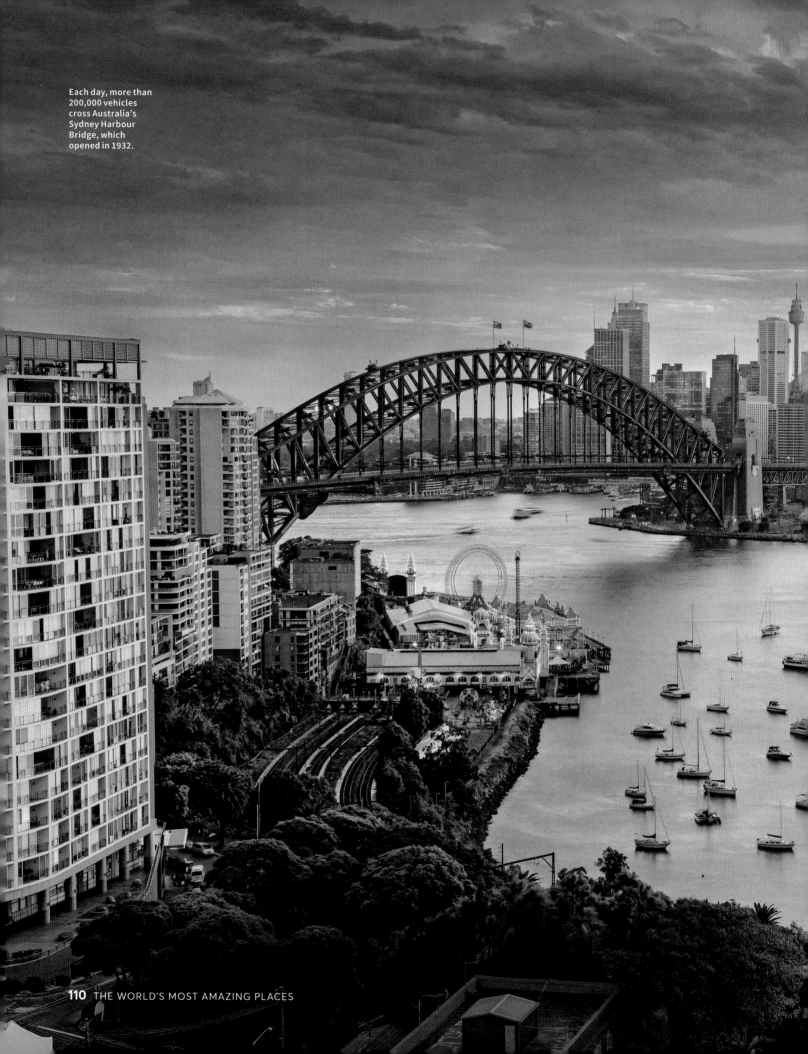

Each day, more than
200,000 vehicles
cross Australia's
Sydney Harbour
Bridge, which
opened in 1932.

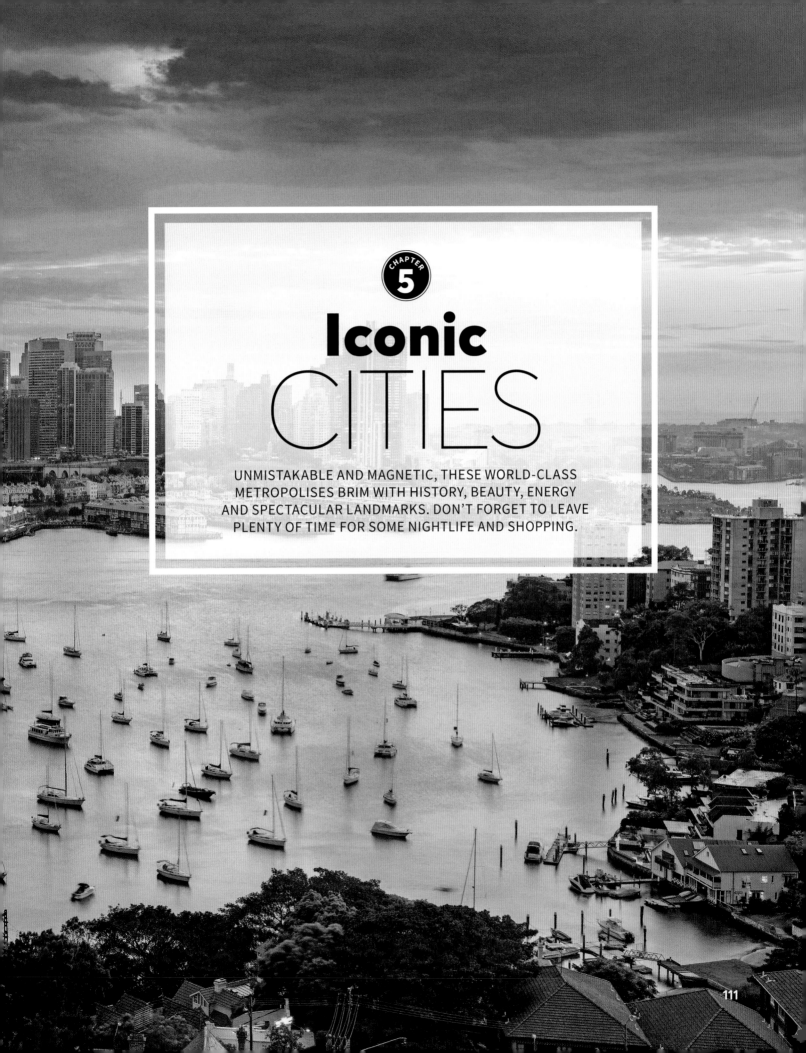

Iconic
CITIES

UNMISTAKABLE AND MAGNETIC, THESE WORLD-CLASS
METROPOLISES BRIM WITH HISTORY, BEAUTY, ENERGY
AND SPECTACULAR LANDMARKS. DON'T FORGET TO LEAVE
PLENTY OF TIME FOR SOME NIGHTLIFE AND SHOPPING.

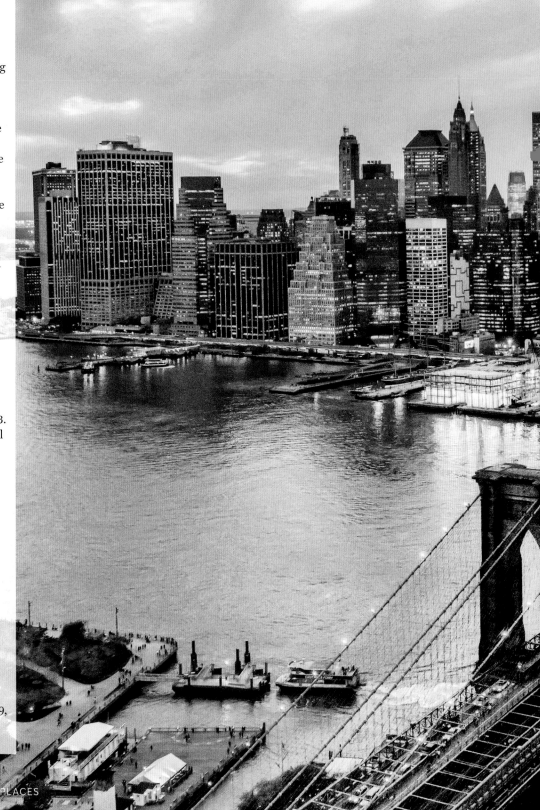

New York City

NEW YORK, USA

THE BIG APPLE EXUDES AN ENERGY that's incomparable to any other urban area on Earth. And, thanks to the magic of movies, the city manages to feel familiar to its throng of 62.8 million annual visitors.

Few skylines are as recognizable as that of NYC, which has been an important U.S. trade center since the early 1800s. Its literal and figurative anchor is the Statue of Liberty, whose presence near the southern tip of Manhattan has been welcoming immigrants to American shores since she was gifted by France in 1885.

The 102-story, Art Deco Empire State Building (long rumored to have been built as a zeppelin airship-docking station) has been a symbol of the city since 1931. Here, the 86th-floor observation deck has stolen scenes in countless films (including 1933's *King Kong*, and 1993's *Sleepless in Seattle*), and its sweeping 360-degree vistas take on an ethereal quality after dark.

Just to the north stands Grand Central Terminal, completed in 1913. A celebration of the gilded age of rail travel, the ornate beaux arts–style station was built by the Vanderbilt family. The main concourse, with its sparkling astrological muraled ceiling, is inspiring.

The Metropolitan Museum of Art, founded in 1870, is the largest art institution in the country. It houses works that span 5,000 years of history. Meanwhile, nature is on display in Central Park, opened in 1859. America's first landscaped public park sparked an urban-park movement across the nation.

The city that doesn't sleep doesn't stop evolving, either. Don't miss two newer tourist hot spots on your visit: the High Line, which opened in 2009, and the World Trade Center Oculus, which opened in 2016.

The 1.3-mile walk across the famed Brooklyn Bridge is perfect for photo ops.

The Big Apple comprises more than 200 buildings reaching 500 feet or taller.

The subway is the cheapest, easiest way to get around NYC; if you're staying for a week, purchase a seven-day unlimited MetroCard. Guided hop-on/hop-off bus tours stop at the major attractions and may include admission to some. The **Hudson Yards' Vessel**, a web of 154 staircases, 80 landings and 2,500 steps, is a huge tourist draw and photo op. The complex also recently opened the **Edge**, the highest outdoor deck in the Western Hempisphere, complete with a glass floor to look down 1,100 feet on the city streets.

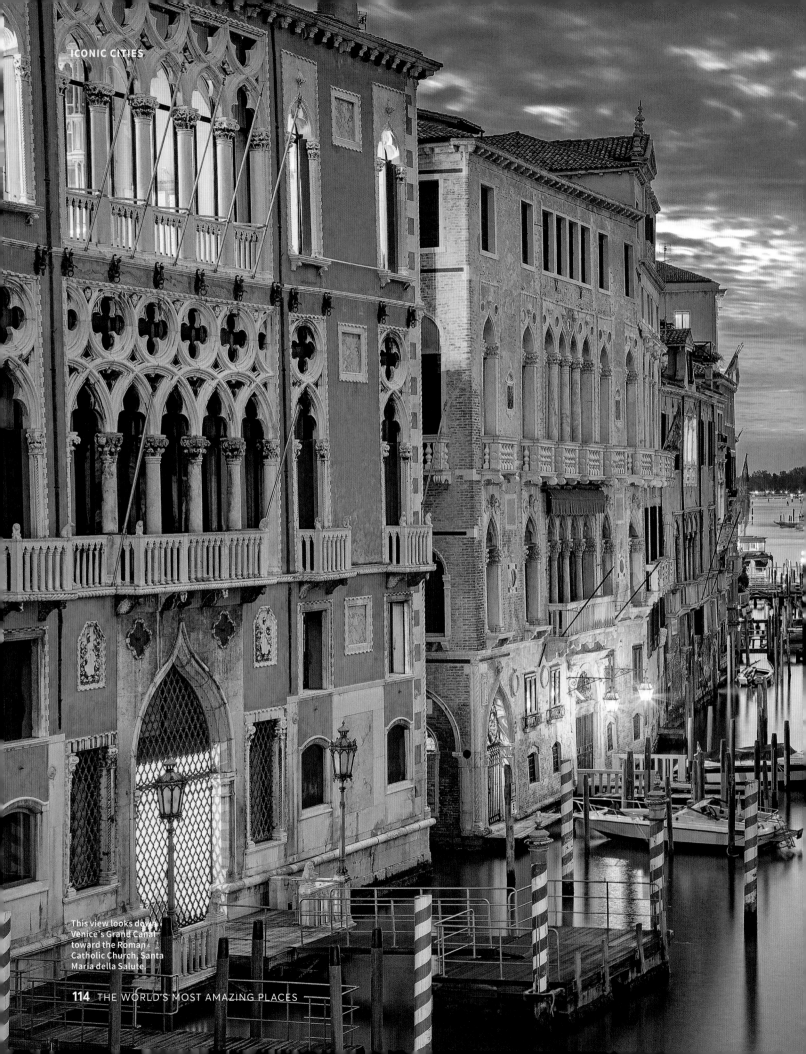

This view looks down Venice's Grand Canal toward the Roman Catholic Church, Santa Maria della Salute.

Venice
ITALY

Venice has been fondly referred to as "La Dominante," "Queen of the Adriatic" and "City of Bridges."

VENICE IS MORE THAN A city. It's a dream. The island city seems to rise out of the Adriatic Sea's northwestern section, mixing together all the most fantastical elements imaginable: whimsical architecture, historic roots and, of course, waterfront views that go on for miles—26 miles of canal waterways to be exact.

The Laguna Veneta (Venice Lagoon) traces its earliest settlers back before Roman times, but truly came into its current form around the seventh century when migrants started moving into the Rialto area and linking together the 118 islands into one unified city. Today, more than 400 bridges dance across the city on water.

The Grand Canal—a reverse S-shaped 2-mile stretch—serves as Venice's heart, floating from San Marco Basilica to Santa Chiara Church and dividing the city into two sections. Along its course are buildings from various architectural eras, including Romanesque, Gothic and Renaissance. And at just about its halfway point, the 16th-century stone-arch Rialto Bridge traverses the canal at its narrowest point.

Both visitors and pigeons alike also flock to Piazza San Marco, right in front of the cathedral, which was first constructed in 829. Napoleon is rumored to have referred to it as "The Drawing Room of Europe."

With all its charms, plus festivals big and small and tasty gelato to boot, it's no wonder that visitors have been wandering around Venice since the 18th century. Today, there are more than 25 million tourists trying to capture their own piece of the Italian "bella vita."

Recent entrance fees and fines have been implemented to prevent overcrowding, especially from the 14 million annually who are day-trippers. To best experience the city—and lessen your footprint—visit during the off-season from November through March and spend a few days there to give back to the economy. One place to really make an impact is the **Rialto Fish Market**, which opened on the edge of the canal in 1097, and is in danger of closing since so many visitors walk through to take selfies, but don't buy any fish.

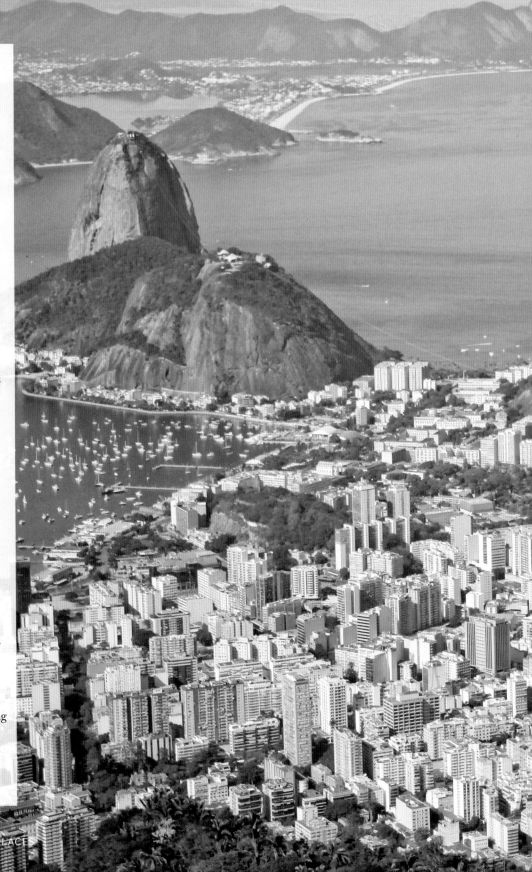

Rio de Janeiro

BRAZIL

LEGEND CLAIMS THAT RIO DE Janeiro, which means January River, was named by Portuguese explorers who arrived on Jan. 1, 1502, and mistook the entrance of the bay for the mouth of a river. Locals refer to their beloved home as Cidade Maravilhosa, or Marvelous City. By any name, Rio draws more than 5 million visitors each year to its sun-soaked shores.

Steamy, sexy and spirited, Rio satiates the senses. The sounds of samba fill the streets as white-sand beaches ring the interior and jungle-cloaked mountains rise tall against the bluest sky in the world (yes, it's been proven). Nobody parties like the Cariocas, Rio's native-born residents, whose annual Carnival celebration trumps all others in size and splendor. Bodies scantily clad in colorful costumes crusted in sequins shake and swing to electrifying samba beats, stopping only to swig a few sips of coconut water between ice-cold caipirinhas.

Beyond the party scene, Rio has more on tap. The statue of Christ the Redeemer stands 98 feet high, its arms spanning wide to protect all who dwell in the Marvelous City. Rio's must-see beaches include Copacabana, often referred to as the world's most famous; Ipanema, where all the beautiful people flock come summer; and Prainha, a remote, crescent-shaped spot known for surfing. Just yards from the city center sprawls the Floresta da Tijuca, the largest urban forest in the world, whose year-round residents include iguanas, monkeys and sloths.

In a place where revelry exists right alongside religion, and where gleaming high-rises tower against a verdant backdrop of rain forest, life in Rio unfolds at a pace all its own. With so much to see, smell, touch and taste, sleep here is for the birds.

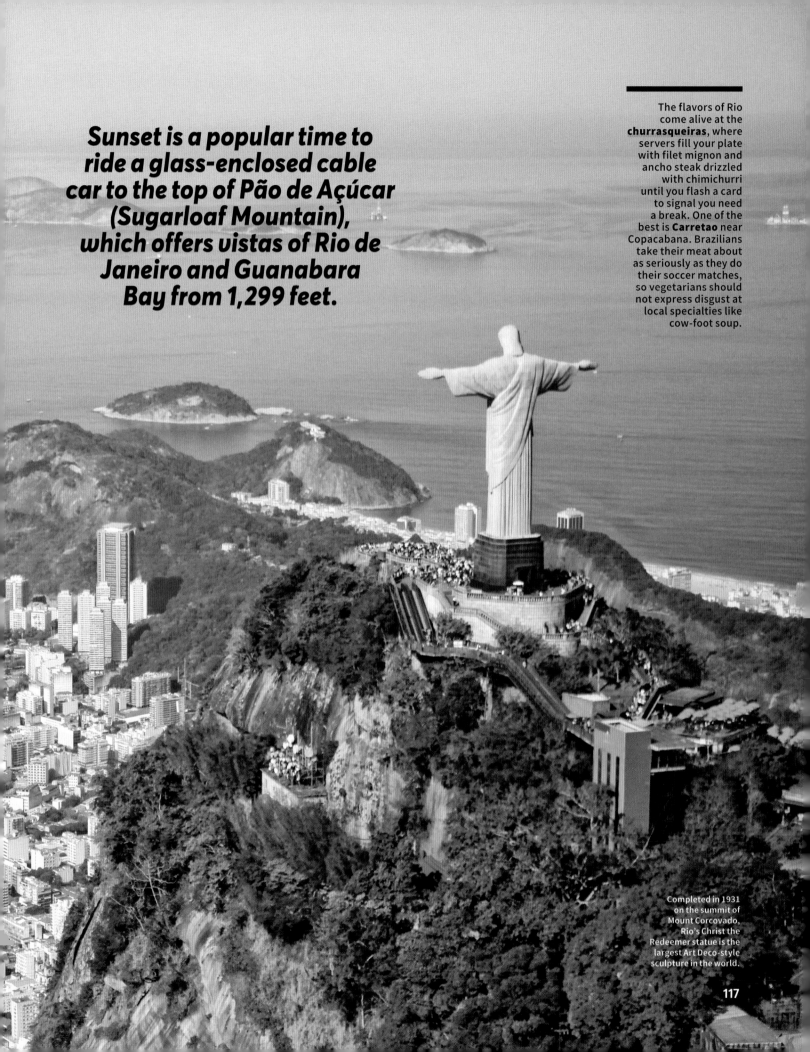

Sunset is a popular time to ride a glass-enclosed cable car to the top of Pão de Açúcar (Sugarloaf Mountain), which offers vistas of Rio de Janeiro and Guanabara Bay from 1,299 feet.

The flavors of Rio come alive at the **churrasqueiras**, where servers fill your plate with filet mignon and ancho steak drizzled with chimichurri until you flash a card to signal you need a break. One of the best is **Carretao** near Copacabana. Brazilians take their meat about as seriously as they do their soccer matches, so vegetarians should not express disgust at local specialties like cow-foot soup.

Completed in 1931 on the summit of Mount Corcovado, Rio's Christ the Redeemer statue is the largest Art Deco-style sculpture in the world.

Hong Kong

CHINA

THE 7.4 MILLION RESIDENTS of Hong Kong are spread throughout the Kowloon Peninsula, Hong Kong Island, Lantau Island Peninsula and the New Territories, which includes 262 islands—all which sit in the South China Sea. So here, urban living is synonymous with the marine lifestyle. While the global impact of Hong Kong is large, the 427 square miles it occupies are actually relatively compact since less than a quarter of that space is developed.

Zipping back and forth between the central points of Kowloon and Hong Kong Island is common on the *Star Ferry*, running since 1888. A first-class ticket on the upper deck is still less than 50 cents in U.S. dollars.

Hong Kong's centerpiece is Victoria Harbour, which sits between the two sides. After all, it's the strategic waterfront locale that brought prosperity to the city as a trading port. Leisure cruises, like the Duk Ling Harbour Cruise on a historic Chinese junk sailing ship, offer an immersive look at the busy waterway. But the real spectacle comes when night falls and the Symphony of Lights casts multicolored light displays onto the skyscrapers, as it has every night since 2004.

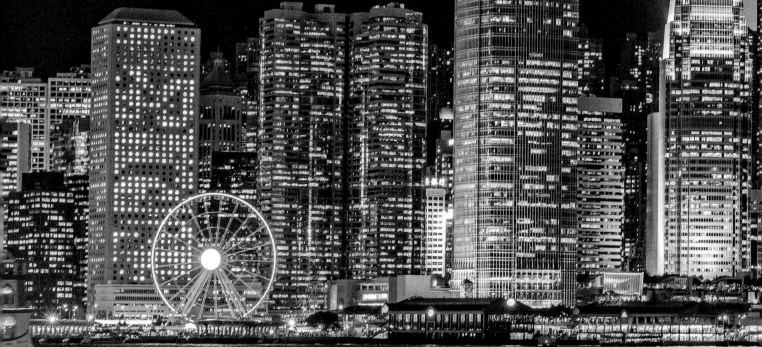

To get an aerial view of the region, head uphill to **Victoria Peak**, about 1,800 feet above sea level. The Peak Tram Cableway funicular can carry up to 120 riders to the top in about seven minutes along its 27-degree climb. At the top is the **Sky Terrace 428** (named because it's 428 meters, or about 1,400 feet, above sea level) viewing platform. Combination tickets for the tram and terrace are about $13 round trip.

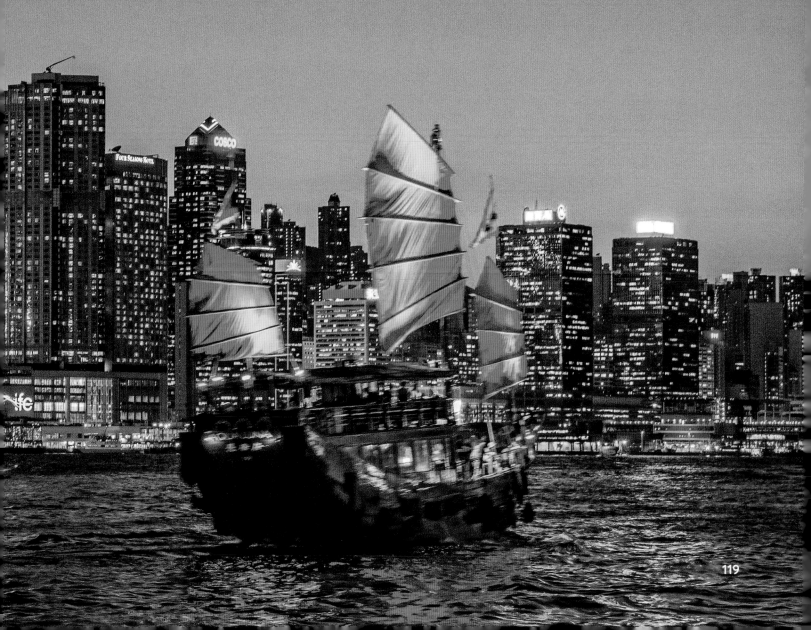

Hong Kong boasts the world's largest concentration of skyscrapers.

Paris

FRANCE

The city of Paris, despite its busy streets, doesn't have any stop signs.

IT'S IMPOSSIBLE TO FIND A "world's most romantic cities" list that doesn't include Paris. The City of Light is so captivating, even the most cynical skeptics are wooed by its tree-lined boulevards, corner cafés, 19th-century facades and, of course, dazzling monuments.

The 1,063-foot Eiffel Tower, erected for the Exposition Universelle of 1889, stands as the symbol of the city while the most-visited landmark, Notre-Dame, is being rebuilt after a 2019 fire that led to its temporary closure. The circa-1919 Sacré-Coeur basilica, atop the Butte Montmarte, extends vistas from its 426-foot dome, and the Arc de Triomphe—the biggest arch in the world—overlooks the sparkling Champs-Élysées and beyond.

Behind the walls of Paris' world-class museums wait other iconic sights: Impressionist masterpieces at the Musée d'Orsay; the Louvre's 38,000 works, including Venus de Milo, The Winged Victory of Samothrace and Mona Lisa.

First a 12th-century fortress, then a royal residence, the Louvre museum opened in 1793, and its modern glass pyramid was added in 1989. The monument is a poignant illustration of Paris' layered history. The city's origins trace to 250 B.C., when a Gallic tribe called the Parisii established an island settlement (the present-day Île de la Cité) in the Seine River. After a period of Roman occupation, Paris became France's capital in 987.

But it was in the 1800s that the city took on its modern veneer. A civic planner named Georges-Eugène Haussmann, commissioned by Napoleon III, transformed Paris with the features modern crowds now adore: stone edifices, wide cobbled avenues, public parks and squares. As today's visitors stroll and play in the City of Light, they can't help but fall in love.

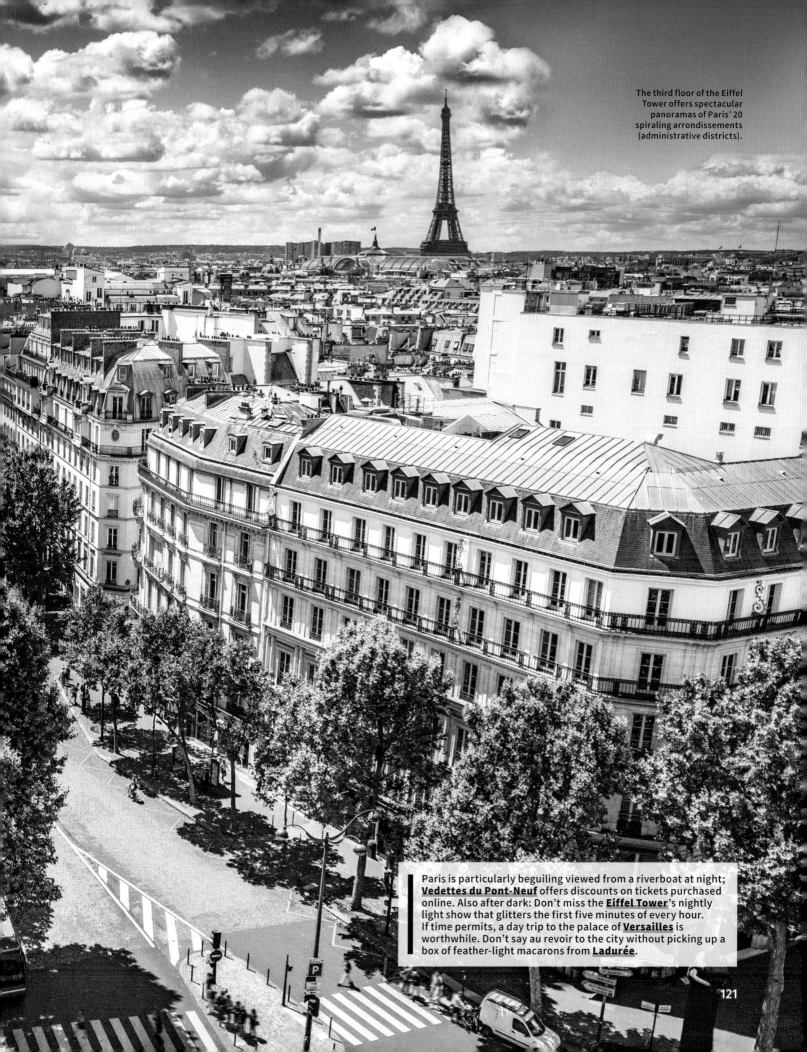

The third floor of the Eiffel Tower offers spectacular panoramas of Paris' 20 spiraling arrondissements (administrative districts).

Paris is particularly beguiling viewed from a riverboat at night; **Vedettes du Pont-Neuf** offers discounts on tickets purchased online. Also after dark: Don't miss the **Eiffel Tower**'s nightly light show that glitters the first five minutes of every hour. If time permits, a day trip to the palace of **Versailles** is worthwhile. Don't say au revoir to the city without picking up a box of feather-light macarons from **Ladurée**.

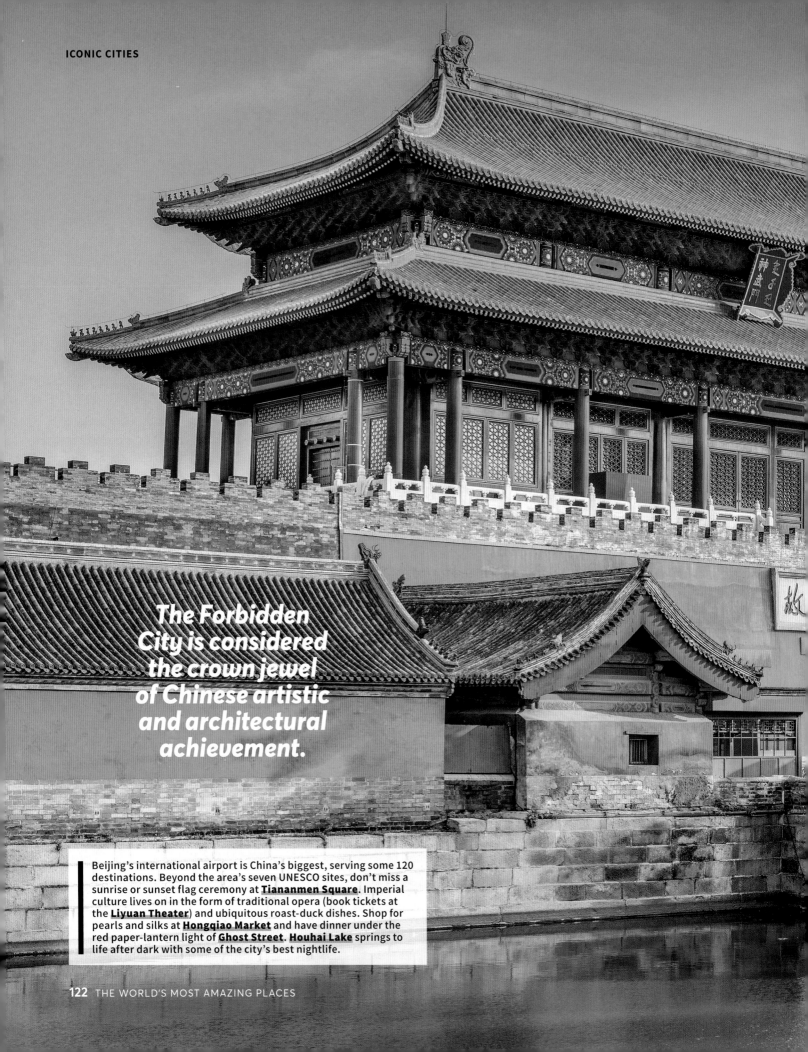

The Forbidden City is considered the crown jewel of Chinese artistic and architectural achievement.

Beijing's international airport is China's biggest, serving some 120 destinations. Beyond the area's seven UNESCO sites, don't miss a sunrise or sunset flag ceremony at **Tiananmen Square**. Imperial culture lives on in the form of traditional opera (book tickets at the **Liyuan Theater**) and ubiquitous roast-duck dishes. Shop for pearls and silks at **Hongqiao Market** and have dinner under the red paper-lantern light of **Ghost Street**. **Houhai Lake** springs to life after dark with some of the city's best nightlife.

Beijing

IN CHINA'S CAPITAL—AMID SOARING skyscrapers and avant-garde venues, rectangular apartment blocks and austere public buildings—persists a more timeworn but indelible Beijing: an ancient city, a seat of imperial power, a sacred center.

For more than 800 years, Beijing functioned as the capital of six dynasties, including the Ming dynasty (1368–1644) and the Qing dynasty (1644–1912). It comprises the most exceptional relics of China's imperial history, including a section of China's iconic Great Wall called Badaling—the most complete, popular and representative portion.

In the center of Beijing stands the Forbidden City, the biggest palace complex on the planet. Home to 14 Ming and 10 Qing emperors over the centuries, the compound was off-limits to the public for 500 years. Today, millions of visitors pour in to marvel at its halls, gardens, courtyards and galleries.

In contrast to the might and grandeur of the Forbidden City, the Summer Palace exudes tranquility and welcome. Built in 1750, the exquisite royal retreat is one of the best-preserved imperial gardens in the world.

Of course, Beijing's modern marvels—the CCTV Building, the Olympic Stadium, Galaxy Soho, the NCPA concert hall—also inspire travelers. But the city's ancient sites tell the most compelling story: one of greatness, conflict, power and intrigue.

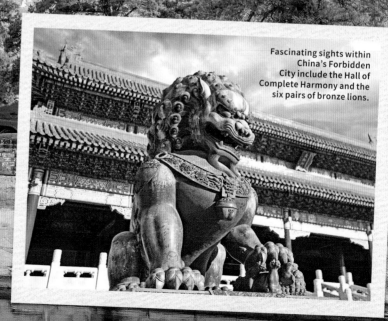

Fascinating sights within China's Forbidden City include the Hall of Complete Harmony and the six pairs of bronze lions.

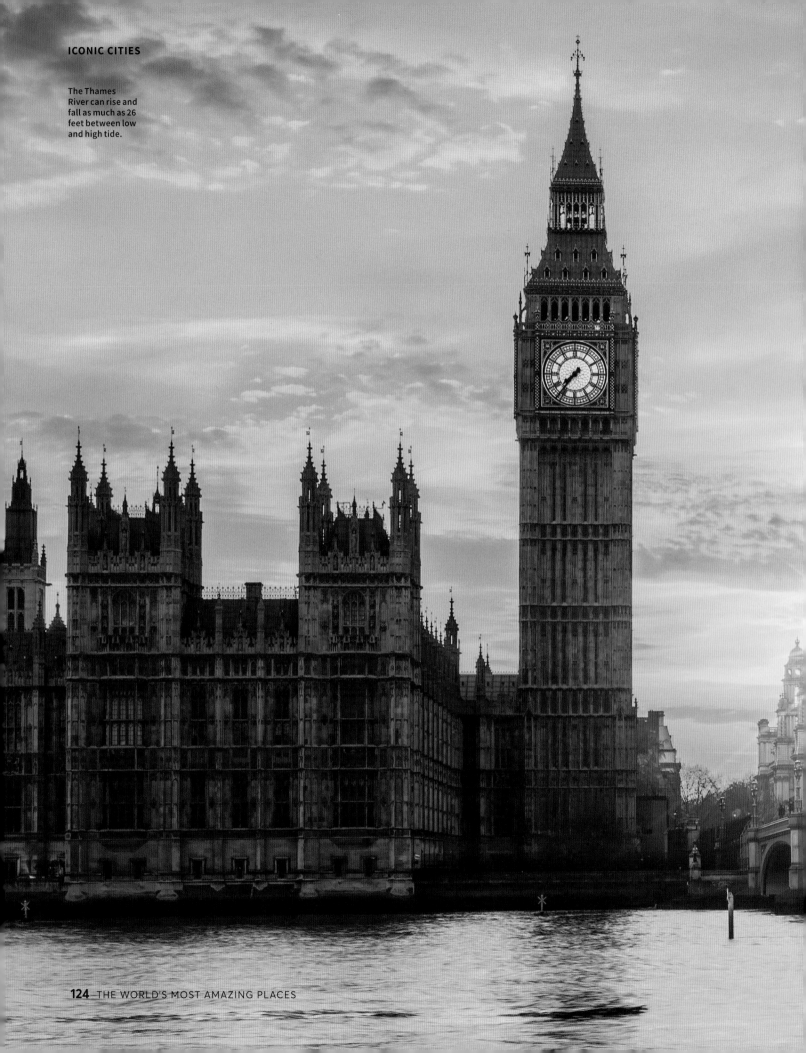

The Thames River can rise and fall as much as 26 feet between low and high tide.

London

The landmark tower at the Houses of Parliament is known as Big Ben, which first chimed on July 11, 1859.

ROLL CALL: THE TOWER OF LONDON, the Globe Theater, London Bridge, Tate Modern and London Eye. Not only are these among London's most notable landmarks, but each one of them also lines the shore of the 205-mile-long Thames River, as it passes through the British capital.

With a population of about 8.8 million, London is a juxtaposition of formal traditions and modern marvels, as the riverfront sights reflect. The stone Tower of London was built by William the Conqueror in the 1070s and the Globe Theatre was commissioned by William Shakespeare and has been hosting performances of his works since 1599! In more recent times, the Tate Modern, built on the former site of the Bankside Power Station, opened in 2000, while the 443-foot observational wheel, the London Eye, started spinning the same year. And multiple versions of the London Bridge have arched over the Thames, with the first dating back to 1176 and the current one built between 1968 and 1972.

A waterfront stroll along the south bank in the city passes by lively restaurants and public spaces, but the pathway is actually just part of the 184-mile Thames Path that goes from the Cotswolds hills to the sea. For a quieter section within London's city limits, head over to Kew Gardens, a UNESCO World Heritage site with more than 50,000 plants.

Soak in London's most stunning scenery while dining along the **Thames**. Snag a private transparent igloo on the rooftop of the **Coppa Club Tower Bridge**. Decked out with lights, the scene is straight out of an Instagram dream. But plan early: Reservations have been known to be booked up months in advance. Other riverfront restaurants with a view: **Le Pont de la Tour**, **Oxo Tower Restaurant** and **Sea Containers**. Or for a more casual experience, pick up food at the 1,000-year-old **Borough Market** and have a waterfront picnic.

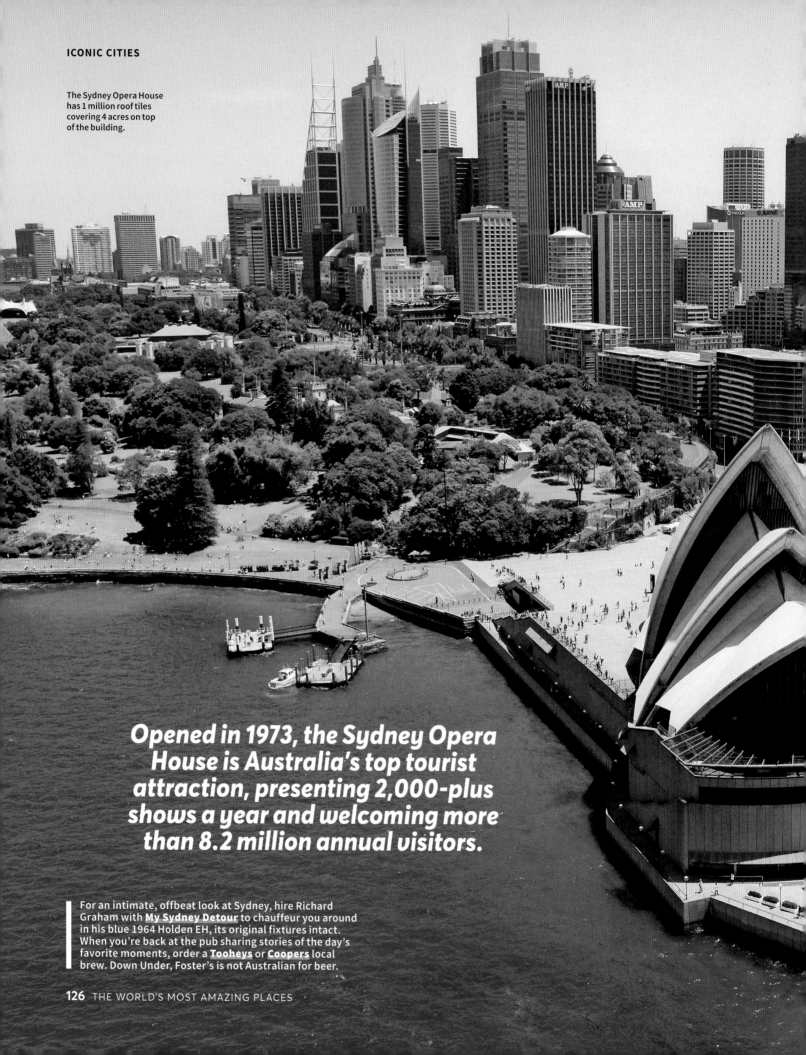

The Sydney Opera House has 1 million roof tiles covering 4 acres on top of the building.

Opened in 1973, the Sydney Opera House is Australia's top tourist attraction, presenting 2,000-plus shows a year and welcoming more than 8.2 million annual visitors.

For an intimate, offbeat look at Sydney, hire Richard Graham with **My Sydney Detour** to chauffeur you around in his blue 1964 Holden EH, its original fixtures intact. When you're back at the pub sharing stories of the day's favorite moments, order a **Tooheys** or **Coopers** local brew. Down Under, Foster's is not Australian for beer.

Sydney

AUSTRALIA'S LARGEST AND MOST urbane city is also refreshingly quirky, a bit brash, rather laid-back and exceedingly welcoming. Sydneysiders say "no worries" as much as they do "g'day," but perhaps not as often as "mate." A city that was originally established by the British in 1788 as a penal colony pressed on through drought and disease, war and the Great Depression, to become the 5-million–strong international hub of culture and finance it is today.

The Circular Quay is Sydney's main terminal and the best jumping-off point for exploring the surrounding city, where fragrant frangipani blooms give way to tall eucalyptus stalks, and outdoor pools flank sprawling national parks. Walkable highlights include the iconic Sydney Opera House, its white walls arcing out like giant fins from the world's deepest natural harbor; the Sydney Harbour Bridge (BridgeClimb leads brave sightseers to the 440-foot apex); and The Rocks, the site of the first European settlement. Wandering the cobblestone streets reveals sandstone buildings—held together by crushed cockle shells—that house museums, cafés, shops and long-held secrets of a mischievous past.

Transportation to other points of interest is easy from the Circular Quay. Ferries, buses and trains depart all day long to spots like Taronga Zoo, where Tasmanian devils and gorillas live alongside koalas and hairy-nosed wombats, and to Bondi Beach, whose golden sands draw billionaires and backpackers alike.

Sydney seduces visitors with 338 days of sunshine a year, 100 golden beaches and a mix of 180 nationalities. It's no wonder that the city itself is as vibrant and awash in wonder as its world-famous New Year's Eve fireworks spectacle.

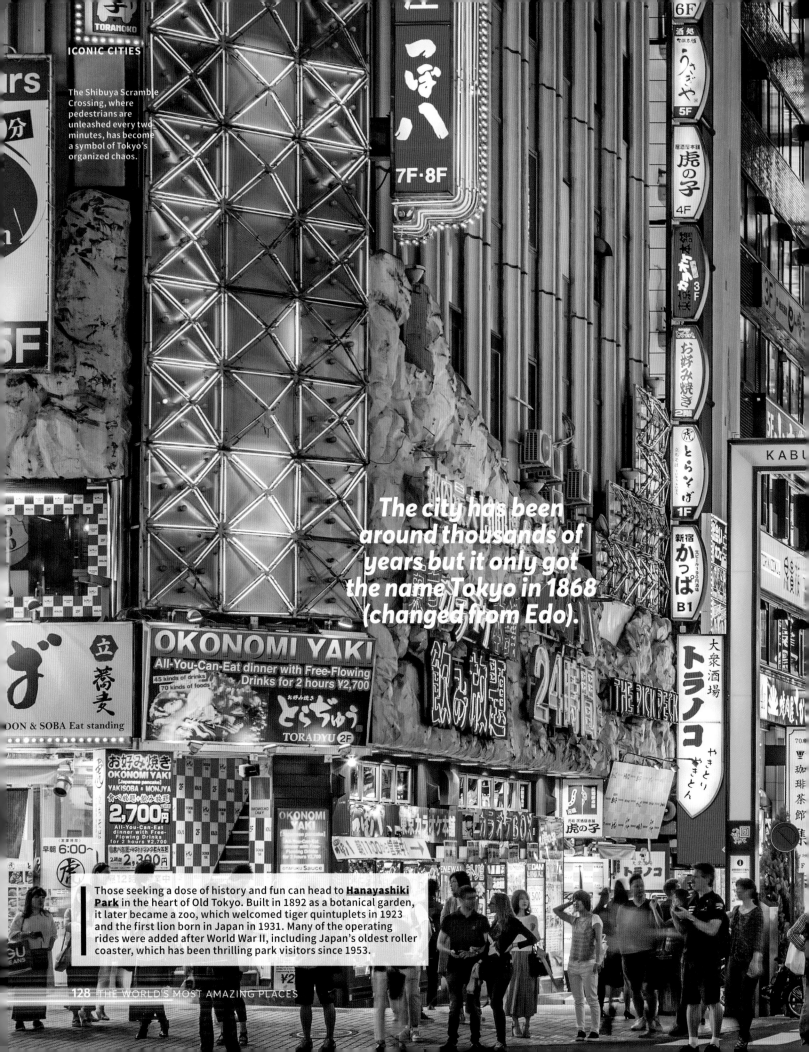

The Shibuya Scramble Crossing, where pedestrians are unleashed every two minutes, has become a symbol of Tokyo's organized chaos.

The city has been around thousands of years but it only got the name Tokyo in 1868 (changed from Edo).

Those seeking a dose of history and fun can head to **Hanayashiki Park** in the heart of Old Tokyo. Built in 1892 as a botanical garden, it later became a zoo, which welcomed tiger quintuplets in 1923 and the first lion born in Japan in 1931. Many of the operating rides were added after World War II, including Japan's oldest roller coaster, which has been thrilling park visitors since 1953.

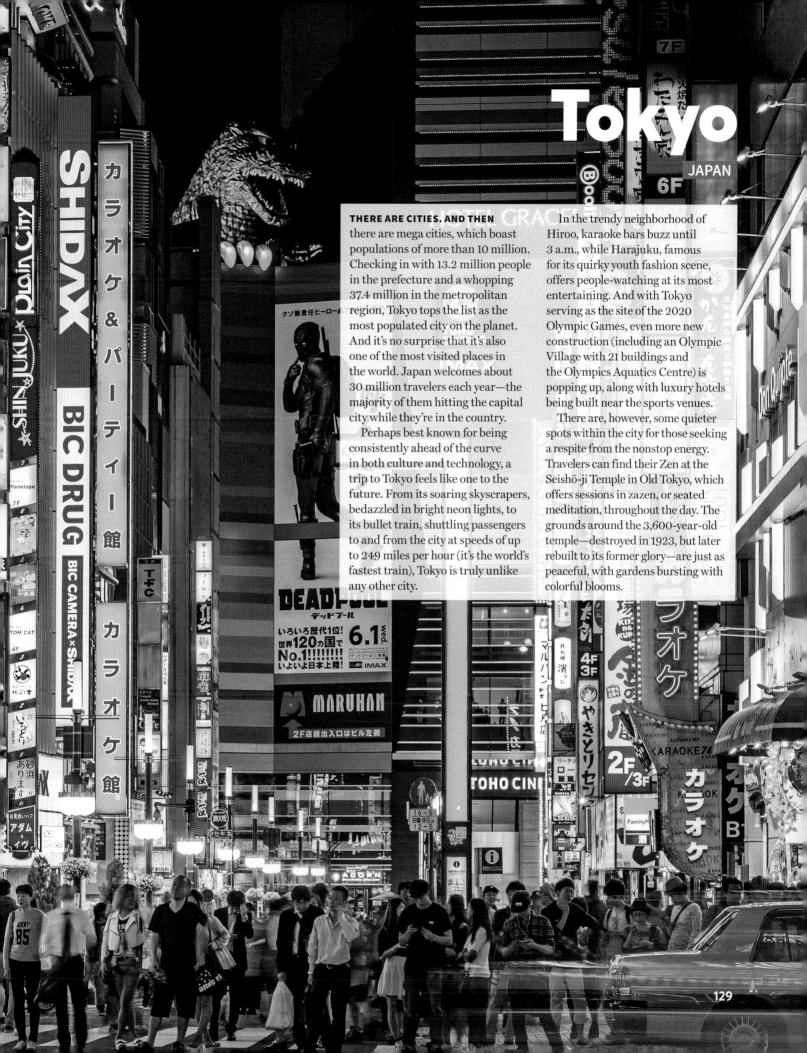

Tokyo

JAPAN

THERE ARE CITIES. AND THEN there are mega cities, which boast populations of more than 10 million. Checking in with 13.2 million people in the prefecture and a whopping 37.4 million in the metropolitan region, Tokyo tops the list as the most populated city on the planet. And it's no surprise that it's also one of the most visited places in the world. Japan welcomes about 30 million travelers each year—the majority of them hitting the capital city while they're in the country.

Perhaps best known for being consistently ahead of the curve in both culture and technology, a trip to Tokyo feels like one to the future. From its soaring skyscrapers, bedazzled in bright neon lights, to its bullet train, shuttling passengers to and from the city at speeds of up to 249 miles per hour (it's the world's fastest train), Tokyo is truly unlike any other city.

In the trendy neighborhood of Hiroo, karaoke bars buzz until 3 a.m., while Harajuku, famous for its quirky youth fashion scene, offers people-watching at its most entertaining. And with Tokyo serving as the site of the 2020 Olympic Games, even more new construction (including an Olympic Village with 21 buildings and the Olympics Aquatics Centre) is popping up, along with luxury hotels being built near the sports venues.

There are, however, some quieter spots within the city for those seeking a respite from the nonstop energy. Travelers can find their Zen at the Seishō-ji Temple in Old Tokyo, which offers sessions in zazen, or seated meditation, throughout the day. The grounds around the 3,600-year-old temple—destroyed in 1923, but later rebuilt to its former glory—are just as peaceful, with gardens bursting with colorful blooms.

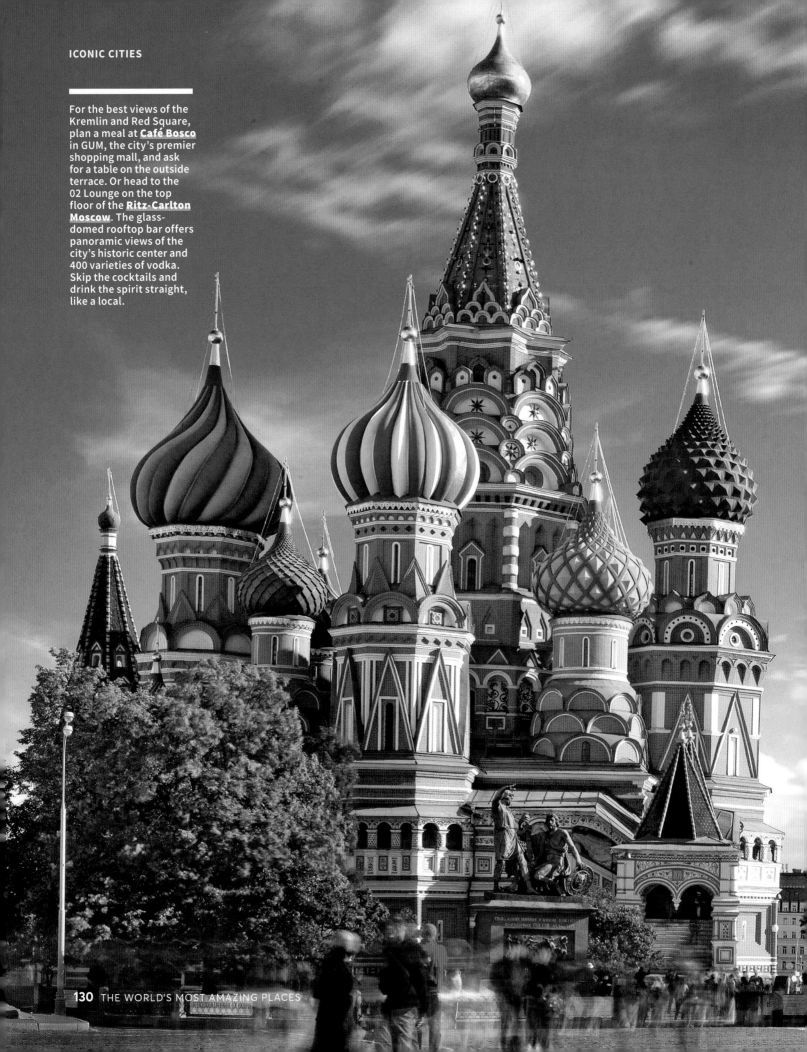

For the best views of the Kremlin and Red Square, plan a meal at **Café Bosco** in GUM, the city's premier shopping mall, and ask for a table on the outside terrace. Or head to the 02 Lounge on the top floor of the **Ritz-Carlton Moscow**. The glass-domed rooftop bar offers panoramic views of the city's historic center and 400 varieties of vodka. Skip the cocktails and drink the spirit straight, like a local.

MOSCOW

Ivan the Terrible ordered St. Basil's construction to mark a military victory over Mongols.

THE COLORFUL ONION DOMES OF the 16th-century St. Basil's Cathedral may make it the most recognizable building in Moscow's skyline, but it's just the beginning. Follow the city's concentric rings that radiate out from the Kremlin at its heart to find the Stalin-era Seven Sisters skyscrapers and the modern Moscow International Business Center claiming their share of the cityscape. The architectural layers serve as a visual history of the capital from its origins in 1147.

The Kremlin complex and Red Square in the center of the city, along Moskva River, still demand the attention of the roughly 21 million travelers drawn to Moscow each year. The UNESCO World Heritage site is home to not just St. Basil's, but also the Cathedral of the Assumption, where Russia's tsars were crowned (yes, those Romanovs) and, of course, Lenin's Mausoleum. Escape the crowds in the nearby Zaryadye Park, which opened in 2017. The park features a year-round ice cave and a floating bridge within its 32 acres.

Join the city's 12 million residents in the ornately decorated Moscow Metro (traffic can be some of the worst in the world) to get to the Tretyakov galleries. Pre- and post-revolutionary art are separated between the two buildings. The Graveyard of Fallen Monuments, relics of the Soviet era, are in the garden outside the new gallery. For a very different take on Russian culture, attend a ballet at the Bolshoi Theater or visit the steam rooms and cold-plunge pools of Sanduny Baths.

Built in the mid-16th century, St. Basil's Cathedral is made up of nine chapels.

131

For an authentic understanding of Cuba, join Intrepid Travel's **Hola Cuba** tour for U.S. citizens (nine days, from $2,145). The itinerary starts in Havana by diving into the city's fabric with an Afro-Cuban religion tour, American vintage car drive and walking tour of Old Havana. From there, see the other sides of Cuba, including farms in **Vinales**, **Bay of Pigs** and the colonial town of **Trinidad**. And homestays along the way let you mingle with the locals.

Modern-day Havana has expanded, but the borders of the old town date back to its origin.

Havana was founded in 1515 in a swampy area near where Batabanó is now, but moved to its present location four years later.

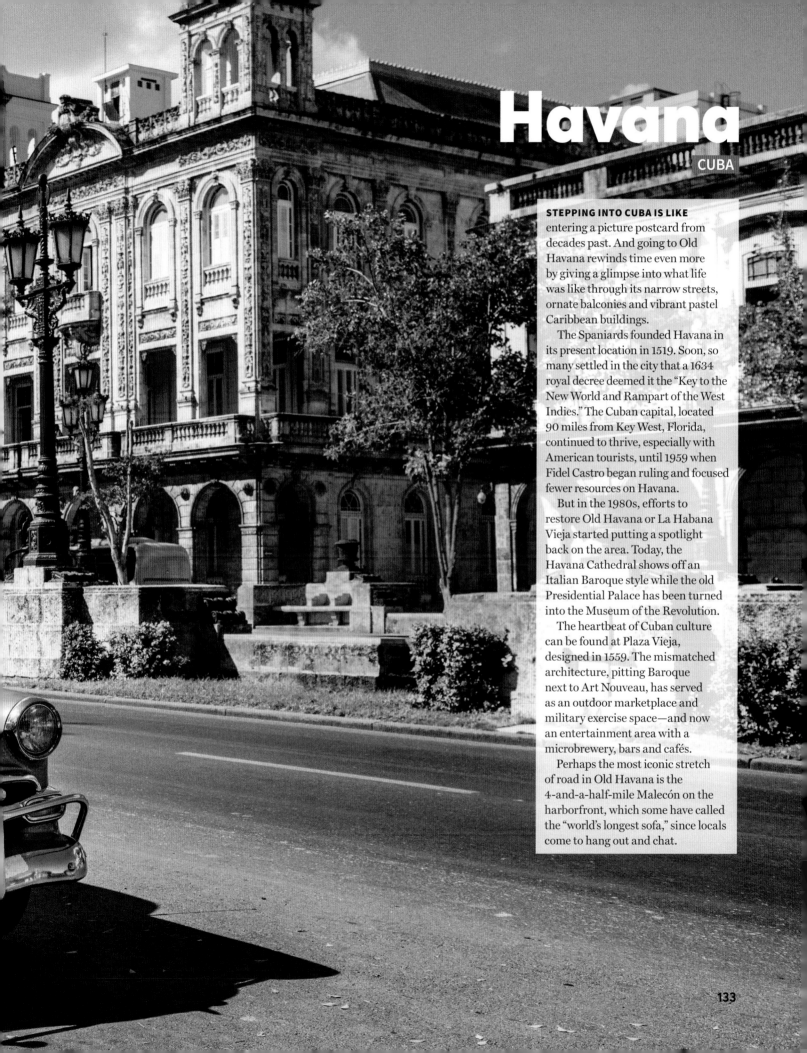

Havana

CUBA

STEPPING INTO CUBA IS LIKE entering a picture postcard from decades past. And going to Old Havana rewinds time even more by giving a glimpse into what life was like through its narrow streets, ornate balconies and vibrant pastel Caribbean buildings.

The Spaniards founded Havana in its present location in 1519. Soon, so many settled in the city that a 1634 royal decree deemed it the "Key to the New World and Rampart of the West Indies." The Cuban capital, located 90 miles from Key West, Florida, continued to thrive, especially with American tourists, until 1959 when Fidel Castro began ruling and focused fewer resources on Havana.

But in the 1980s, efforts to restore Old Havana or La Habana Vieja started putting a spotlight back on the area. Today, the Havana Cathedral shows off an Italian Baroque style while the old Presidential Palace has been turned into the Museum of the Revolution.

The heartbeat of Cuban culture can be found at Plaza Vieja, designed in 1559. The mismatched architecture, pitting Baroque next to Art Nouveau, has served as an outdoor marketplace and military exercise space—and now an entertainment area with a microbrewery, bars and cafés.

Perhaps the most iconic stretch of road in Old Havana is the 4-and-a-half-mile Malecón on the harborfront, which some have called the "world's longest sofa," since locals come to hang out and chat.

San Francisco

"SAN FRANCISCO IS THE ONLY city I can think of that can survive all the things you people are doing to it and still look beautiful," American architect Frank Lloyd Wright once said. And resilient it is. The 46-square-mile city on a peninsula in the Bay Area has survived the seven Gold Rush-era fires (including the worst in 1851), the 1906 earthquake that measured about 7.9, and the 1989 Loma Prieta 6.9 quake.

The innate strength has given the city (which shares its borderline with the county of the same name) the power to prevail. From the steep streets over its 43 hills (the steepest is Filbert between Leavenworth and Hyde with a 31.5 percent grade) to its windy and foggy summers (in short it's due to the pressure systems over the city's unique geography), there's nothing that can faze the metropolis of 884,000 residents.

Instead, San Francisco charms with its historic cable car system (covering 8.8 miles of tracks), Alamo Square's row of Victorian homes dubbed the Painted Ladies, the bustling Pier 39 with sea lions lounging on the docks, the Ferry Building's food hall, Golden Gate Park's sprawling views of the bridge and the iconic Fisherman's Wharf—home to two San Francisco treats: sourdough bread from Boudin Bakery Café and sweets from Ghirardelli Chocolate Company.

The diverse city has a 34.5 percent Asian population, making its Chinatown one of the most vibrant in the nation—and the place to indulge in traditional dim sum. Old school favorite Great Eastern has served Barack Obama, while Yank Sing boasts 2018 Michelin Bib Gourmand honors and 2017 newcomer China Live offers an entire experience in its 30,000-square-foot space.

The theater scene is also strong in the city, with *Hamilton* and *Harry Potter and the Cursed Child* recently bringing their magic to the West Coast. Be sure to download the TodayTix app for discounts to shows while in town.

The Golden Gate Bridge's cables are made by Roebling's Sons Co.—the same company that made the Brooklyn Bridge's cables 52 years prior.

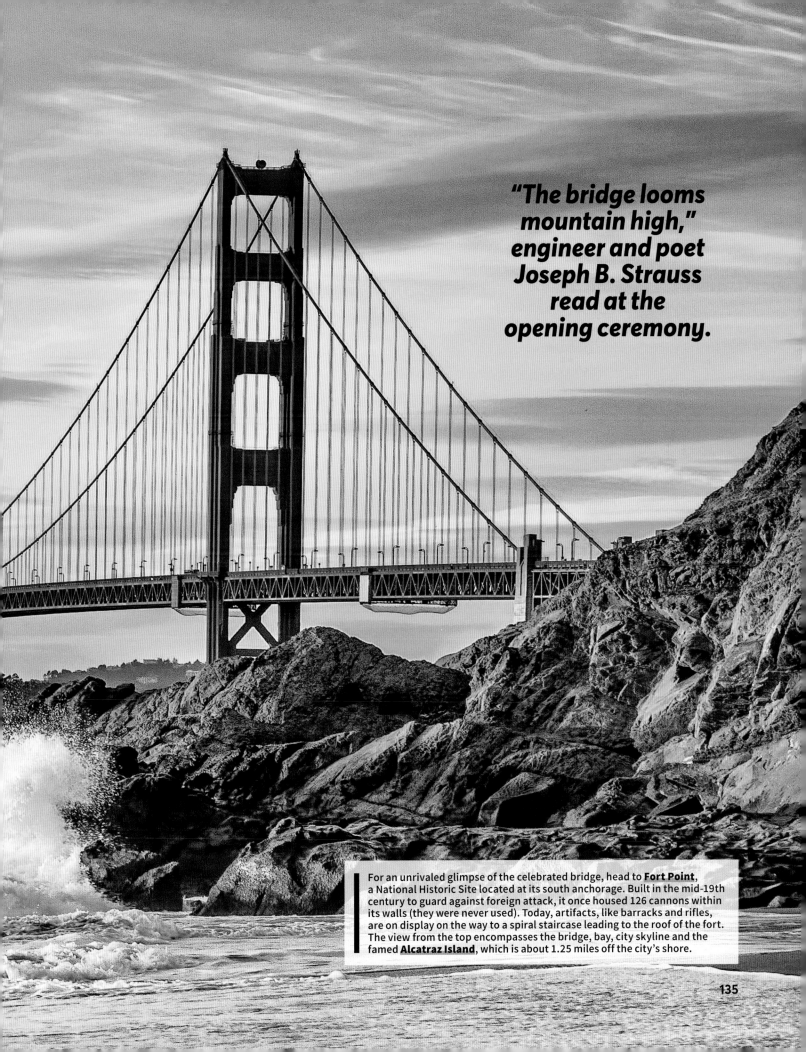

"The bridge looms mountain high," engineer and poet Joseph B. Strauss read at the opening ceremony.

For an unrivaled glimpse of the celebrated bridge, head to **Fort Point**, a National Historic Site located at its south anchorage. Built in the mid-19th century to guard against foreign attack, it once housed 126 cannons within its walls (they were never used). Today, artifacts, like barracks and rifles, are on display on the way to a spiral staircase leading to the roof of the fort. The view from the top encompasses the bridge, bay, city skyline and the famed **Alcatraz Island**, which is about 1.25 miles off the city's shore.

Dubai

UNITED ARAB EMIRATES

EVEN THE JETSONS WOULD BE impressed with Dubai's skyline: No other major city looks as ripped out of the future as the United Arab Emirates city of 2.7 million. And when it comes to holding records, the desert city takes the cake.

The Burj Khalifa is the world's tallest building at 2,723 feet (that's 163 floors, with 58 elevators!), the 1,358-foot Princess Tower is the tallest residential tower with 101 floors and the five-star JW Marriott Marquis reaches 1,165 feet. And not just that: They're all still shiny and new. The average age of Dubai's skyscrapers is only 9 years old—in fact, the Burj Khalifa just opened in 2010, the Princess Tower in 2012 and the JW Marriott Marquis in 2013.

The Dubai Creek Tower, or the Tower, will debut as the world's highest structure—more than 3,000 feet high. It's expected to be completed in late 2020 or early 2021.

While it doesn't quite reach such heights, the sail-shaped Burj Al Arab Jumeirah is still a respectable 1,053 feet tall on its own island. From its aerial views, additional modern marvels stand out: the Palm Islands and the World Islands, two sets of artificial islands that, when viewed from above, form a palm tree and world map, respectively. The Palm Islands have 50 miles of coastline with each of the "leaves" being lined with beachfront homes. The World Islands haven't had as much success—only a small number of the 300 islands have been developed and some of the borders are eroding.

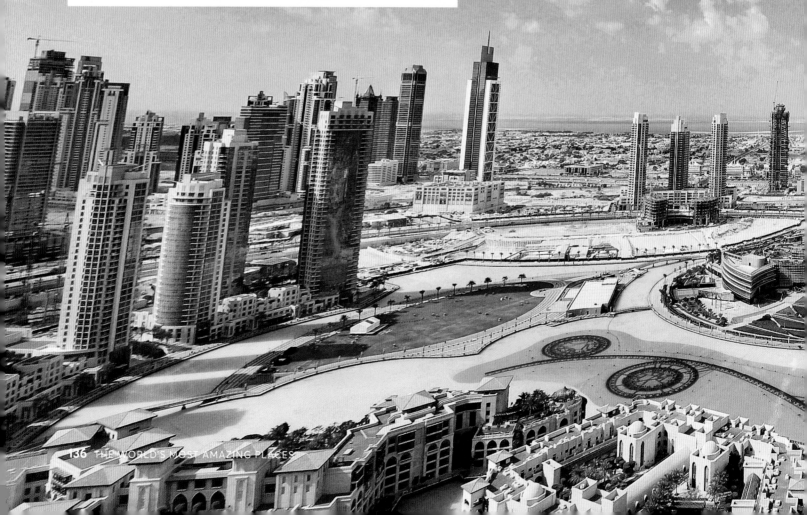

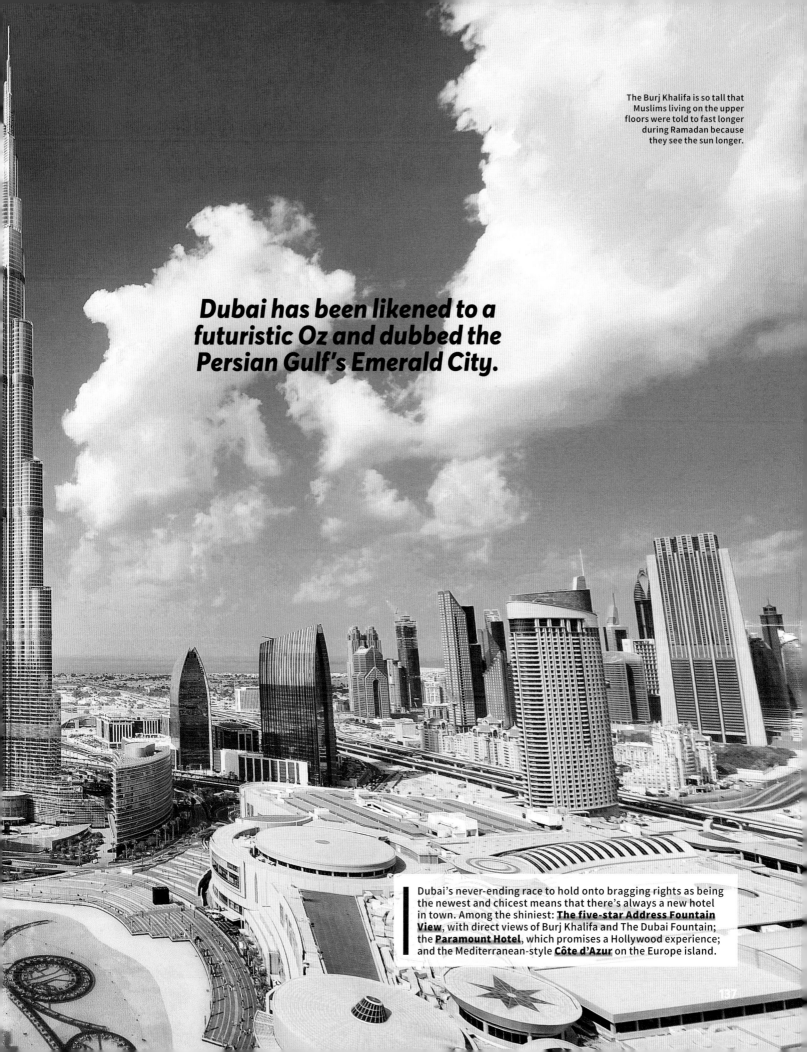

The Burj Khalifa is so tall that Muslims living on the upper floors were told to fast longer during Ramadan because they see the sun longer.

Dubai has been likened to a futuristic Oz and dubbed the Persian Gulf's Emerald City.

Dubai's never-ending race to hold onto bragging rights as being the newest and chicest means that there's always a new hotel in town. Among the shiniest: **The five-star Address Fountain View**, with direct views of Burj Khalifa and The Dubai Fountain; the **Paramount Hotel**, which promises a Hollywood experience; and the Mediterranean-style **Côte d'Azur** on the Europe island.

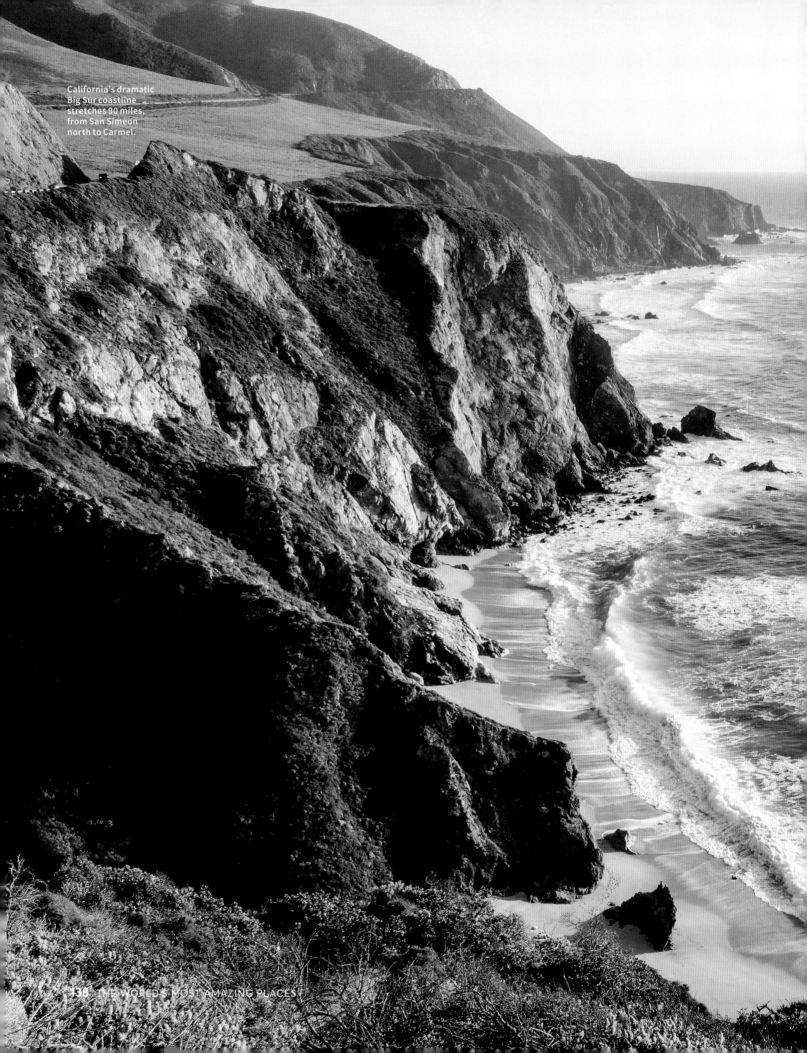

California's dramatic Big Sur coastline stretches 90 miles, from San Simeon north to Carmel.

CHAPTER 6

Captivating COASTLINES

SOME OF THE MOST PICTURESQUE SITES—AND SIGHTS—CAN BE FOUND WHERE THE LAND MEETS THE SEA. SET SAIL FOR AN INTERNATIONAL JOURNEY TO THESE TROPICAL PARADISES, BRILLIANT BEACHES, INCREDIBLE CLIFFS AND MORE.

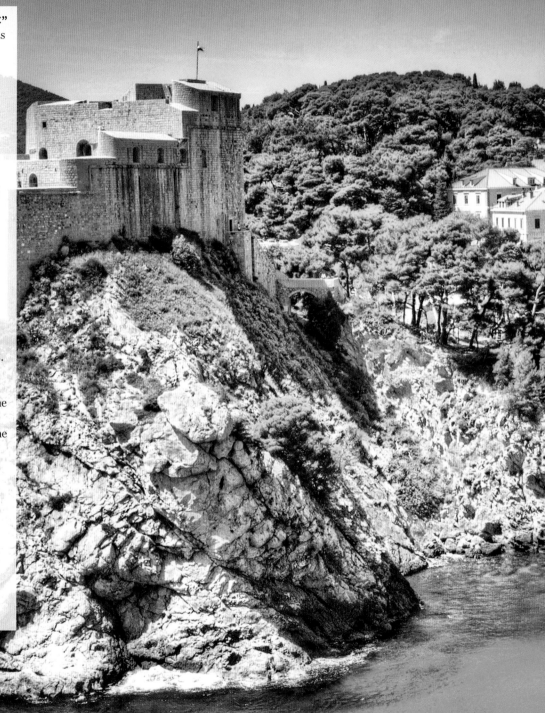

Dubrovnik

CROATIA

NAMED THE "PEARL OF THE ADRIATIC" by poet Lord Byron and described as "paradise on Earth" by playwright George Bernard Shaw, the white limestone-and-terra-cotta-roofed Old Town of Dubrovnik sits like a fortress atop dramatic cliffs of the Dalmatian Coast lapped by clear blue waters.

Encircled by protective walls and five forts—which made it the perfect stand-in for King's Landing on HBO's *Game of Thrones*—the UNESCO World Heritage site dates back to the sixth century and became a thriving republic by the 15th century, due to its prime location on maritime trade routes. The medieval ramparts protected the city from invaders, but it could not guard against a devastating earthquake in 1667 or considerable bombing by Serbia in 1991 and 1992. Fortunately, on both occasions, the city was restored to its former glory.

Today, the 1.2-mile perimeter of the limestone walls is a walkway, which peers down at the narrow cobblestone streets on one side and the Adriatic Sea on the other. While Dubrovnik has been a popular stop by boat for hundreds of years, it's only grown in popularity as a port for cruises and sailboats touring the coast as well as scuba divers exploring nearby shipwrecks. Since 2017, the city has been putting new measures in place to curtail overcrowding and to help maintain Dubrovnik's beauty for years to come.

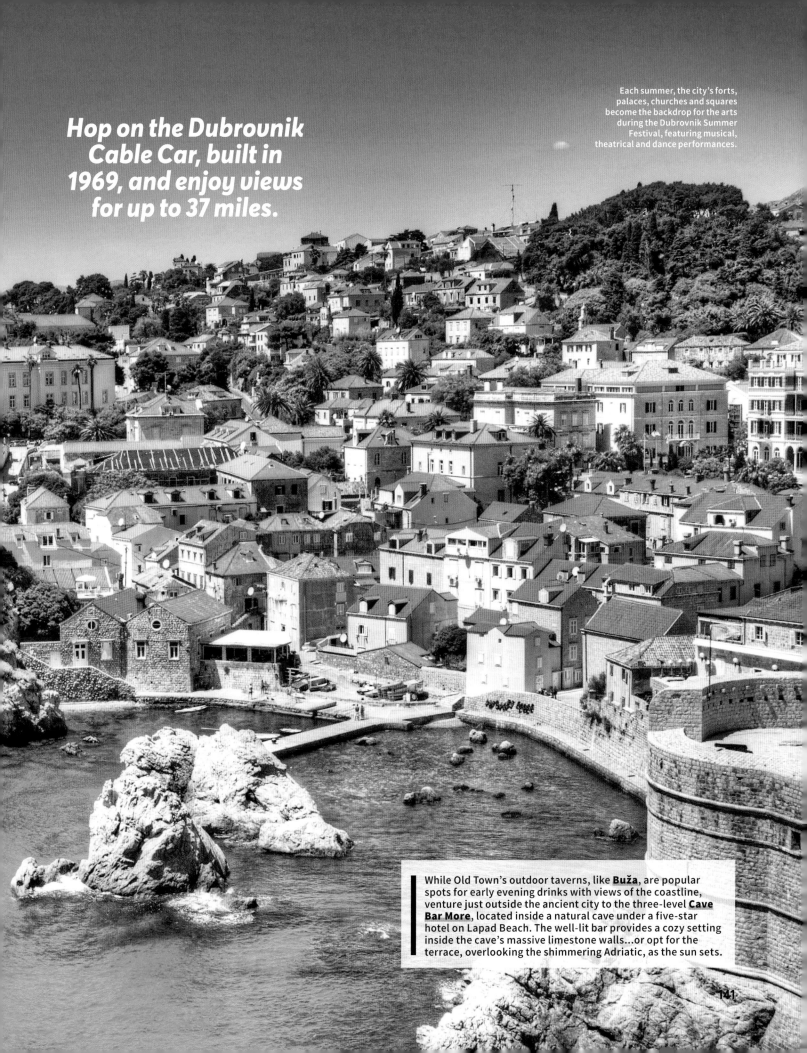

Hop on the Dubrovnik Cable Car, built in 1969, and enjoy views for up to 37 miles.

Each summer, the city's forts, palaces, churches and squares become the backdrop for the arts during the Dubrovnik Summer Festival, featuring musical, theatrical and dance performances.

While Old Town's outdoor taverns, like **Buža**, are popular spots for early evening drinks with views of the coastline, venture just outside the ancient city to the three-level **Cave Bar More**, located inside a natural cave under a five-star hotel on Lapad Beach. The well-lit bar provides a cozy setting inside the cave's massive limestone walls...or opt for the terrace, overlooking the shimmering Adriatic, as the sun sets.

141

The Hawaiian Islands

UNITED STATES

You could easily spend a week on each of Hawaii's main islands. **Hawaiian Airlines** offers island-hopping packages, or see four Hawaiian isles in one trip with **Norwegian Cruise Line**. Standout activities include **Roberts Hawaii's** Hawaii Movie Tour (Kauai); the **Dole Plantation** (Oahu); **Sheraton Maui**'s cliff-dive ceremony (Maui); and **Hawaii Forest & Trail**'s Kohala Waterfalls Adventure (Hawaii Island). Three of Hawaii's beaches made it onto Dr. Beach's top 10 list for 2019, with Oahu's **Kailua Beach Park** nabbing the top spot!

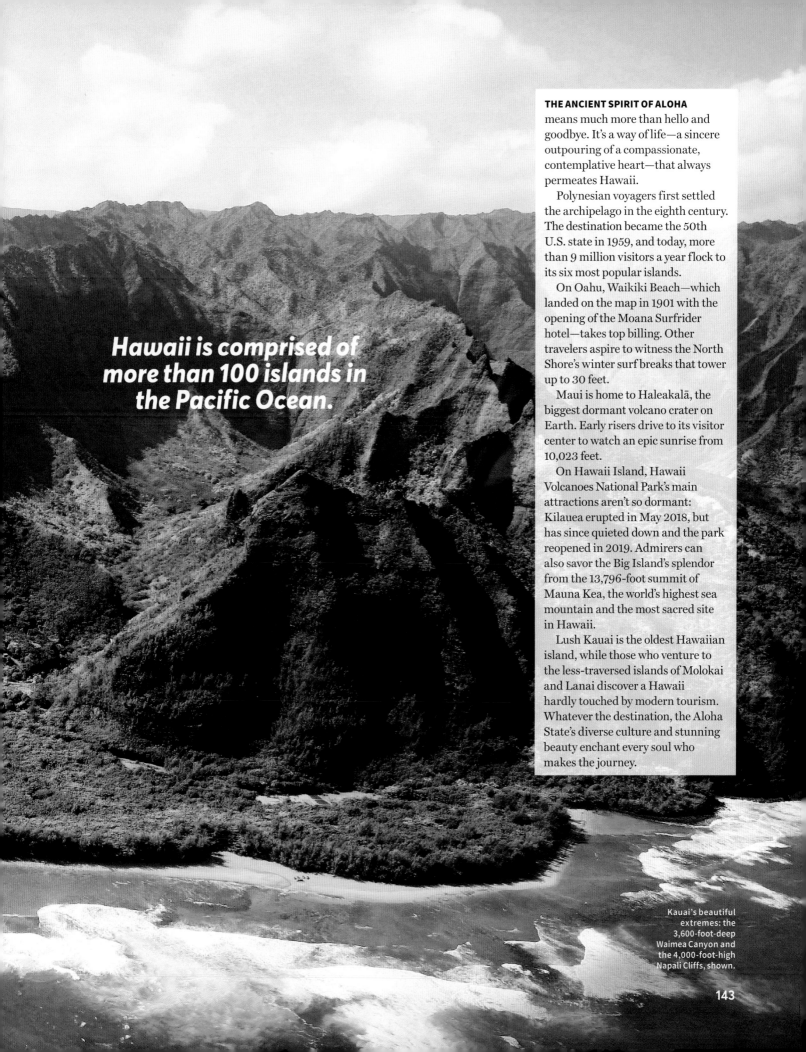

Hawaii is comprised of more than 100 islands in the Pacific Ocean.

THE ANCIENT SPIRIT OF ALOHA
means much more than hello and goodbye. It's a way of life—a sincere outpouring of a compassionate, contemplative heart—that always permeates Hawaii.

Polynesian voyagers first settled the archipelago in the eighth century. The destination became the 50th U.S. state in 1959, and today, more than 9 million visitors a year flock to its six most popular islands.

On Oahu, Waikiki Beach—which landed on the map in 1901 with the opening of the Moana Surfrider hotel—takes top billing. Other travelers aspire to witness the North Shore's winter surf breaks that tower up to 30 feet.

Maui is home to Haleakalā, the biggest dormant volcano crater on Earth. Early risers drive to its visitor center to watch an epic sunrise from 10,023 feet.

On Hawaii Island, Hawaii Volcanoes National Park's main attractions aren't so dormant: Kilauea erupted in May 2018, but has since quieted down and the park reopened in 2019. Admirers can also savor the Big Island's splendor from the 13,796-foot summit of Mauna Kea, the world's highest sea mountain and the most sacred site in Hawaii.

Lush Kauai is the oldest Hawaiian island, while those who venture to the less-traversed islands of Molokai and Lanai discover a Hawaii hardly touched by modern tourism. Whatever the destination, the Aloha State's diverse culture and stunning beauty enchant every soul who makes the journey.

Kauai's beautiful extremes: the 3,600-foot-deep Waimea Canyon and the 4,000-foot-high Napali Cliffs, shown.

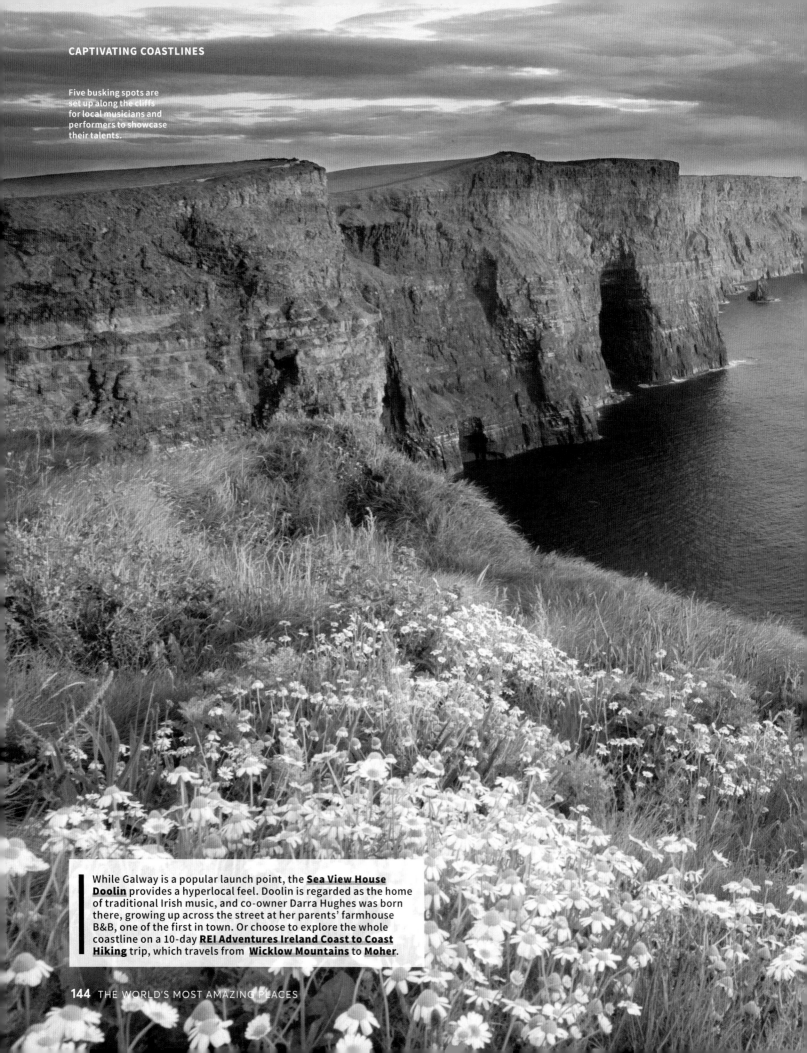

Five busking spots are set up along the cliffs for local musicians and performers to showcase their talents.

While Galway is a popular launch point, the **Sea View House Doolin** provides a hyperlocal feel. Doolin is regarded as the home of traditional Irish music, and co-owner Darra Hughes was born there, growing up across the street at her parents' farmhouse B&B, one of the first in town. Or choose to explore the whole coastline on a 10-day **REI Adventures Ireland Coast to Coast Hiking** trip, which travels from **Wicklow Mountains** to **Moher**.

Cliffs of Moher

The magical cliffs were featured in 1987's The Princess Bride *and* 2009's Harry Potter and the Half-Blood Prince.

IT'S A SHEER DROP INTO THE ATLANTIC Ocean from the abrupt edge of the Cliffs of Moher, a geological masterpiece of sand, silt and mud layered and compacted into rock more than 300 million years ago. The crown jewel of Ireland's 1,554-mile Wild Atlantic Way and part of a UNESCO Global Geopark, the 702-foot-high cliffs have faced the pounding ocean and unpredictable weather all those years, slowly eroding to form even caves, sea stacks and sea stumps.

Drawing about 1.5 million visitors a year, the cliffs face due west, making them prime sunset-viewing real estate. Three viewing platforms and O'Brien's Tower, spaced along 5 miles of dramatic coast, also offer opportunities to look out on Hag's Head and Galway Bay and see as far as the Aran Islands (when not blanketed in thick fog).

The South Platform is the perfect vantage point for watching the puffin colony that nests on nearby Goat Island from late May to mid-July. Another 19 species of nesting seabirds, like peregrine falcons, kittiwakes and razorbills, can be found, providing a delightful soundtrack while scanning the water below for whales, basking sharks, seals and even dolphins.

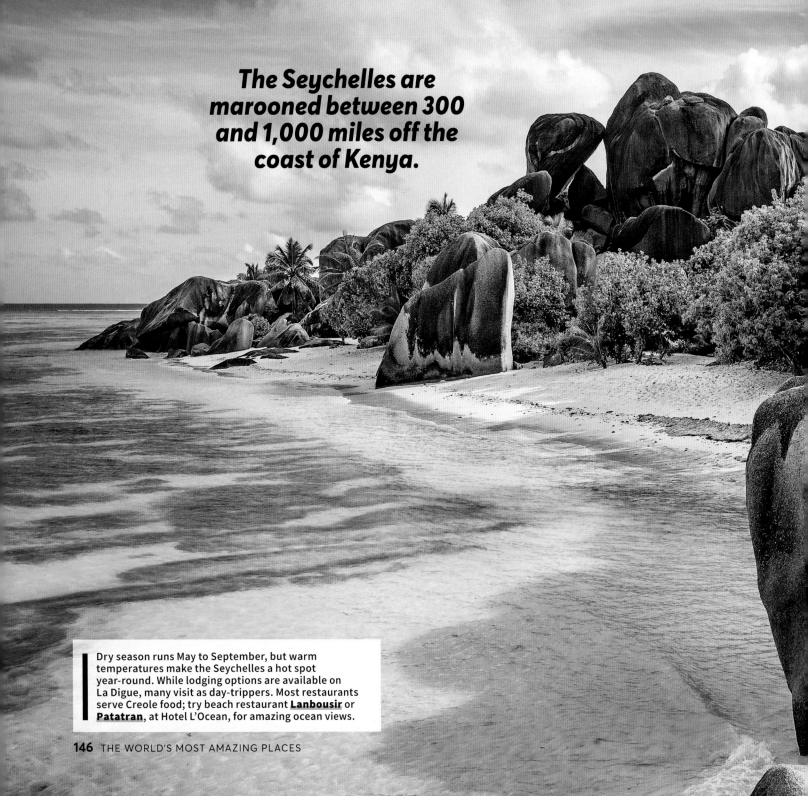

Anse Source d'Argent

SEYCHELLES

The Seychelles are marooned between 300 and 1,000 miles off the coast of Kenya.

Dry season runs May to September, but warm temperatures make the Seychelles a hot spot year-round. While lodging options are available on La Digue, many visit as day-trippers. Most restaurants serve Creole food; try beach restaurant **Lanbousir** or **Patatran**, at Hotel L'Ocean, for amazing ocean views.

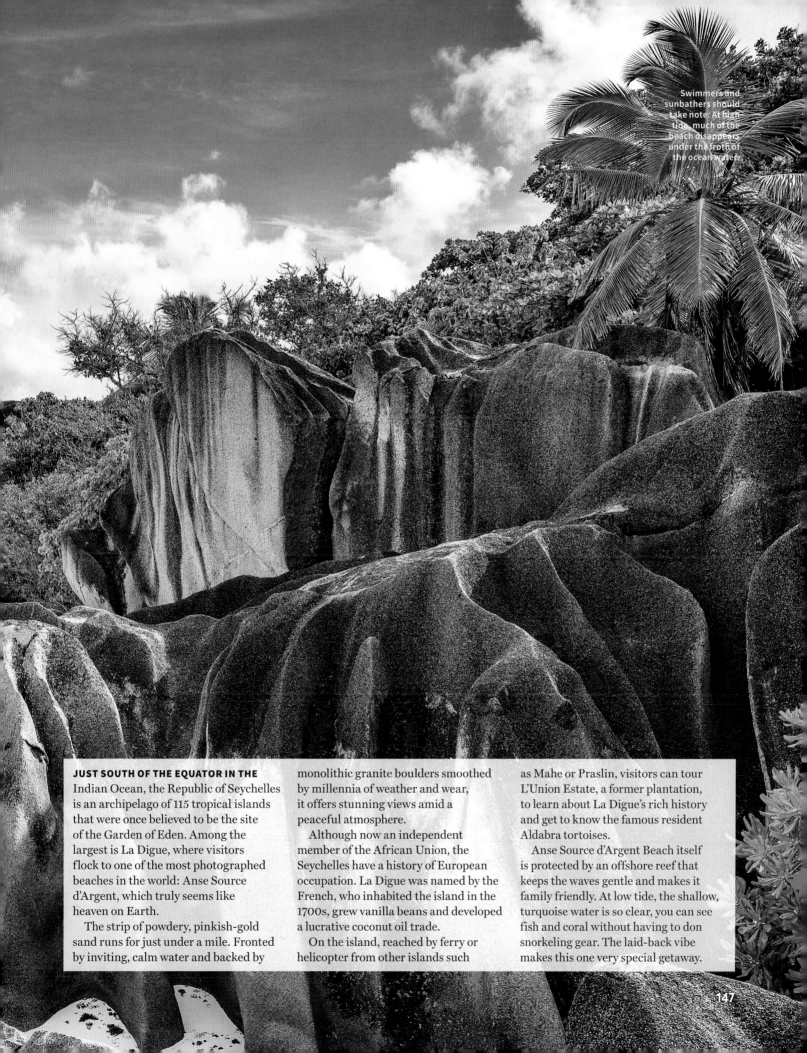

JUST SOUTH OF THE EQUATOR IN THE Indian Ocean, the Republic of Seychelles is an archipelago of 115 tropical islands that were once believed to be the site of the Garden of Eden. Among the largest is La Digue, where visitors flock to one of the most photographed beaches in the world: Anse Source d'Argent, which truly seems like heaven on Earth.

The strip of powdery, pinkish-gold sand runs for just under a mile. Fronted by inviting, calm water and backed by monolithic granite boulders smoothed by millennia of weather and wear, it offers stunning views amid a peaceful atmosphere.

Although now an independent member of the African Union, the Seychelles have a history of European occupation. La Digue was named by the French, who inhabited the island in the 1700s, grew vanilla beans and developed a lucrative coconut oil trade.

On the island, reached by ferry or helicopter from other islands such as Mahe or Praslin, visitors can tour L'Union Estate, a former plantation, to learn about La Digue's rich history and get to know the famous resident Aldabra tortoises.

Anse Source d'Argent Beach itself is protected by an offshore reef that keeps the waves gentle and makes it family friendly. At low tide, the shallow, turquoise water is so clear, you can see fish and coral without having to don snorkeling gear. The laid-back vibe makes this one very special getaway.

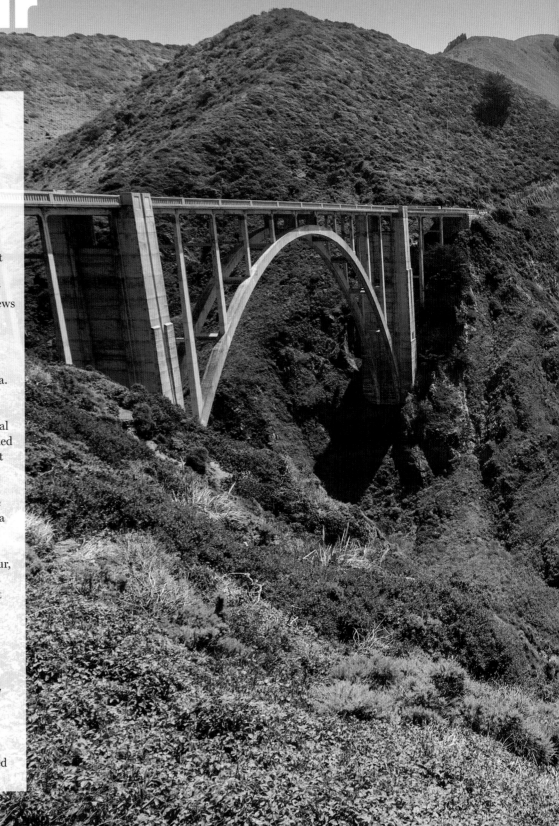

Big Sur

CALIFORNIA , USA

ONCE A SWATH OF UNEXPLORED coastal wilderness called simply El Sur Grande (The Big South) by Spanish settlers, Big Sur is now practically synonymous with its classic drive along cliff-hugging Highway 1. To the east of this designated California Scenic Highway, the Santa Lucia Mountains loom; to the west, rocky bluffs drop hundreds of feet to rugged coves lashed by frothy waves. Stands of redwoods, misty fog and sublime Pacific Ocean views combine on one of the country's most beautiful coastlines.

Striking sights await all along the 60-mile stretch of Highway 1 southbound from Carmel to Gorda. Road-trippers can watch harbor seals and sea otters frolic in the waters of Point Lobos State Natural Reserve, then wander an uncrowded trail in Garrapata State Park. Next up is photogenic Bixby Bridge, followed by the circa 1889 Point Sur Lighthouse. From there, more state parks—Andrew Molera, Julia Pfeiffer Burns and Limekiln—roll out in scenic succession.

Perhaps worth the longest detour, Pfeiffer Big Sur State Park flaunts myriad standout spots: 3,379-foot Manuel Peak; Partington Cove, accessed down a 300-foot sea cliff; the popular Ewoldsen Trail; and Pfeiffer Beach, marked by Keyhole Arch Rock.

With all of this natural splendor, it's no wonder Big Sur inspired luminaries like Henry Miller, Jack Kerouac and Ansel Adams. Any modern-day visitor exploring this dramatic coastal enclave is destined to be spellbound as well.

Highway 1 snakes along the rugged coast from Monterey down to San Luis Obispo.

After being closed for more than a year following a massive 2017 landslide near **Big Sur**, **Highway 1** along the central coast is now open for travel. It takes about five hours to drive at a leisurely pace from **Monterey** south to **San Luis Obispo**. The **Majestic Yosemite Hotel** has been restored to beyond its original splendor; advance reservations are essential. **The Post Ranch Inn**, 30 miles south of Carmel, offers 40 guest rooms perched high on the cliffs overlooking the Pacific Ocean. **The Sierra Mar** restaurant boasts one of the largest wine selections in North America.

Algarve

PORTUGAL

April to June and mid-September through October are the best times to visit Algarve, when the weather is wonderful but the crowds are smaller. Explore the coast and take in the massive rock formations with an independent boat or kayak trip, available from Praia da Marinha beach; more formal tours can be booked in nearby towns. The gorgeous **Benagil Sea Cave** can be reached only by boat, kayak or paddleboard. It's advisable to bring a snack to the beach, since the nearest restaurants are about a mile away by car. If you're hungry, try **O Algar,** in nearby Lagoa, for its delicious seafood and beautiful sea views.

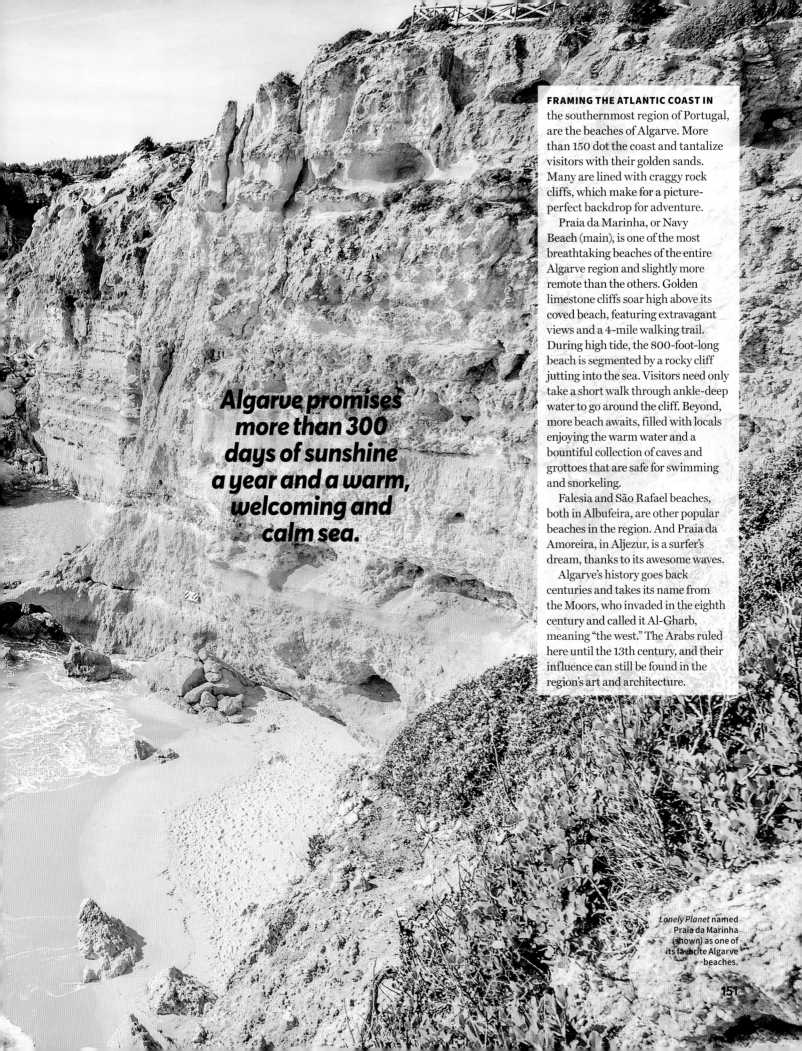

Algarve promises more than 300 days of sunshine a year and a warm, welcoming and calm sea.

FRAMING THE ATLANTIC COAST IN the southernmost region of Portugal, are the beaches of Algarve. More than 150 dot the coast and tantalize visitors with their golden sands. Many are lined with craggy rock cliffs, which make for a picture-perfect backdrop for adventure.

Praia da Marinha, or Navy Beach (main), is one of the most breathtaking beaches of the entire Algarve region and slightly more remote than the others. Golden limestone cliffs soar high above its coved beach, featuring extravagant views and a 4-mile walking trail. During high tide, the 800-foot-long beach is segmented by a rocky cliff jutting into the sea. Visitors need only take a short walk through ankle-deep water to go around the cliff. Beyond, more beach awaits, filled with locals enjoying the warm water and a bountiful collection of caves and grottoes that are safe for swimming and snorkeling.

Falesia and São Rafael beaches, both in Albufeira, are other popular beaches in the region. And Praia da Amoreira, in Aljezur, is a surfer's dream, thanks to its awesome waves.

Algarve's history goes back centuries and takes its name from the Moors, who invaded in the eighth century and called it Al-Gharb, meaning "the west." The Arabs ruled here until the 13th century, and their influence can still be found in the region's art and architecture.

Lonely Planet named Praia da Marinha (shown) as one of its favorite Algarve beaches.

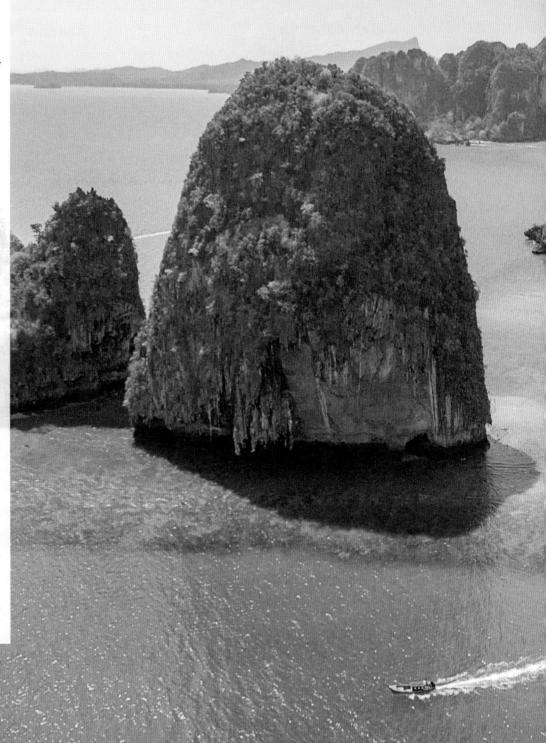

Phi Phi Islands

THAILAND

THE PHI PHI ISLANDS ARE SO ravishing, they receive more than 1.2 million tourists a year—but it wasn't always this way. This archipelago of six limestone islands rising strikingly from the Andaman Sea was a little-known backpacker destination until a movie came along and changed everything. In 2000, *The Beach*, starring Leonardo DiCaprio and shot on Phi Phi Le's paradisal Maya Bay, sparked an international obsession with the islands that hasn't waned since.

Visitors arrive to Phi Phi Don, the largest and only inhabited island, where the village of Tonsai Bay bustles with a selection of open-air restaurants, souvenir shops, small tour operators and rustic resorts. Adding to the island's charm, no cars or roads crisscross the island, only footpaths.

From there, traditional longtail boats whisk travelers off to Phi Phi Le. Here, 300-foot cliffs shelter Maya Bay's famous—and heavily trafficked—white-sand shores. The tourism impact on Maya Bay is so severe, in fact, that the country's Department of National Parks, Wildlife and Plant Conservation closed the popular bay in 2018 to allow the ecosystem to recover.

Happily, plenty of other pristine reefs await island-hoppers who journey to Bamboo Island, Mosquito Island, Koh Bida Nok and Koh Bida Nai. It's a chance to escape the crowds and find your own secret lagoon, much like DiCaprio's character did in the film.

The majestic Maya Bay is expected to reopen in 2021.

The Phi Phi Islands are located in Krabi province, a 45-minute speedboat ride from both **Krabi** and **Phuket**. Snorkeling and diving are best during the November-to-April dry season. On Phi Phi Don, try a cooking class with **Pum's Thai Cooking School**; for lodging, **Zeavola** offers teakwood suites and villas, some with private pools. New regulations will prohibit boats from mooring in **Maya Bay**, and daily visitors will be limited to 2,000.

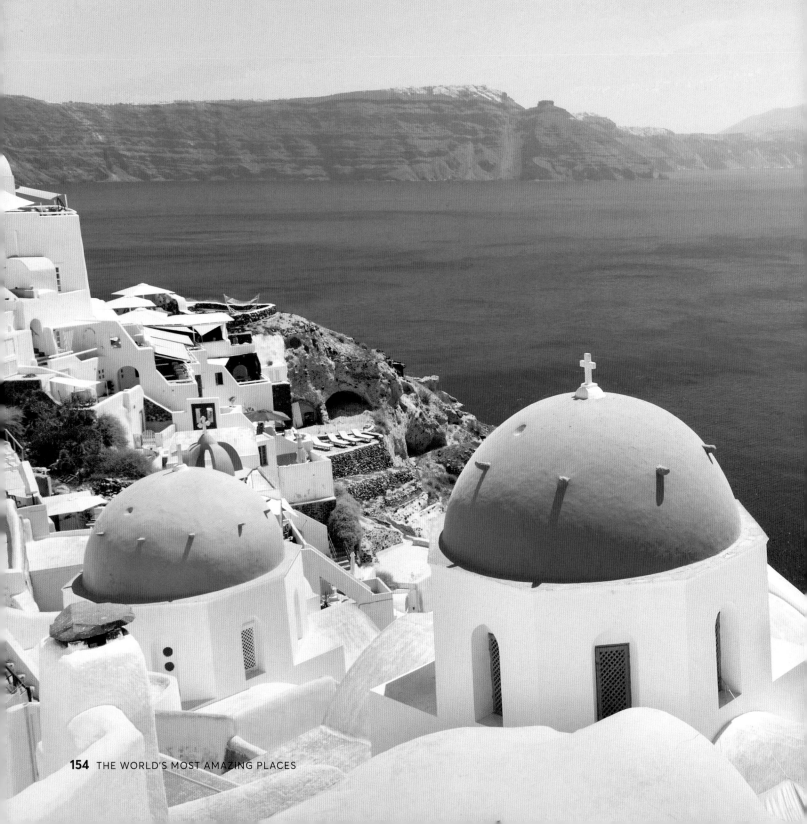

Santorini

GREECE

FROM GRAND (DELOS, THE birthplace of Apollo) to humble (ancient village pathways), the Greek Isles are a gateway to the past. Gorgeous Santorini lies roughly 120 miles off the coast of Greece, within the Aegean Sea, and it hosts 1.5 million tourists every year, making it one of the most popular in the country. An enormous volcanic eruption 3,600 years ago, one of the largest in recorded history, helped to shape the island that is seen today, and although a volcano remains, it hasn't been active since the 1950s.

Believed to be the location of Atlantis, Santorini flaunts the recognizable scene of whitewashed buildings and blue-domed churches. One of its most popular beaches is Red Beach, which is located close to the ancient village of Akrotiri (called the Minoan Pompeii) and a 20-minute drive south of Santorini's capital of Fira.

Red Beach is just about 475 feet and its unique sand was formed from volcanic ash and rock. Set against the turquoise waters, the contrast of red earth and blue water make for a spectacular sight. Its pebbled textured, which makes it less comfortable for towels, doesn't deter its high-season crowds.

Beyond its ancient history, Red Beach offers numerous pleasures, including swimming, snorkeling and exploring the coves surrounding it. With its vibrant backdrop and deep-blue water, Red Beach truly gives visitors the impression that they've been transported to another world.

Santorini's Perivolas Lifestyle Houses celebrates the island's past while pampering its guests. The resort was once a group of 300-year-old caves that served as the homes and stables of local fisherman and farmers. Nearby boat tours can arrange private outings to Santorini's cultural and historical landmarks and the region's family-owned vineyards. Tour guides can also arrange hikes along the cliffside path between the towns of Oia and Fira, lined with chapels, colorful boats and the islands iconic sugar-cube dwellings stacked on the hillside.

The Greek Isles hold an array of colorful beaches—red sand on **Santorini**, pink sand on **Crete**, white sand on **Milos**. Top archaeological sites include Santorini's **Akrotiri** (aka the Minoan Pompeii), Crete's **Knossos** ("Europe's oldest city"), and the **Temple of Aphaia** on Aegina island. Ferries serve the large Greek Isles (greekferries.gr), but keep in mind, it's easier to travel within an island chain than it is to hop between groups. Plan to travel from mid-June to mid-September for the most options in terms of restaurants, bars and ferry routes.

The Greek Islands have endured for centuries as vaults of culture and history.

Santorini was previously known as Kallístē, which means "the most beautiful one."

Giant's Causeway

NORTHERN IRELAND

Wilderness Ireland offers tours of the Causeway Coast by land and sea with a seven-day guided family adventure called Giants, Myths and Legends, including castle tours, whiskey sampling, a puffin-colony visit, a Gobbins Path hike, a canoe experience, a Titanic Belfast visitor experience— and, of course, plenty of time at Giant's Causeway.

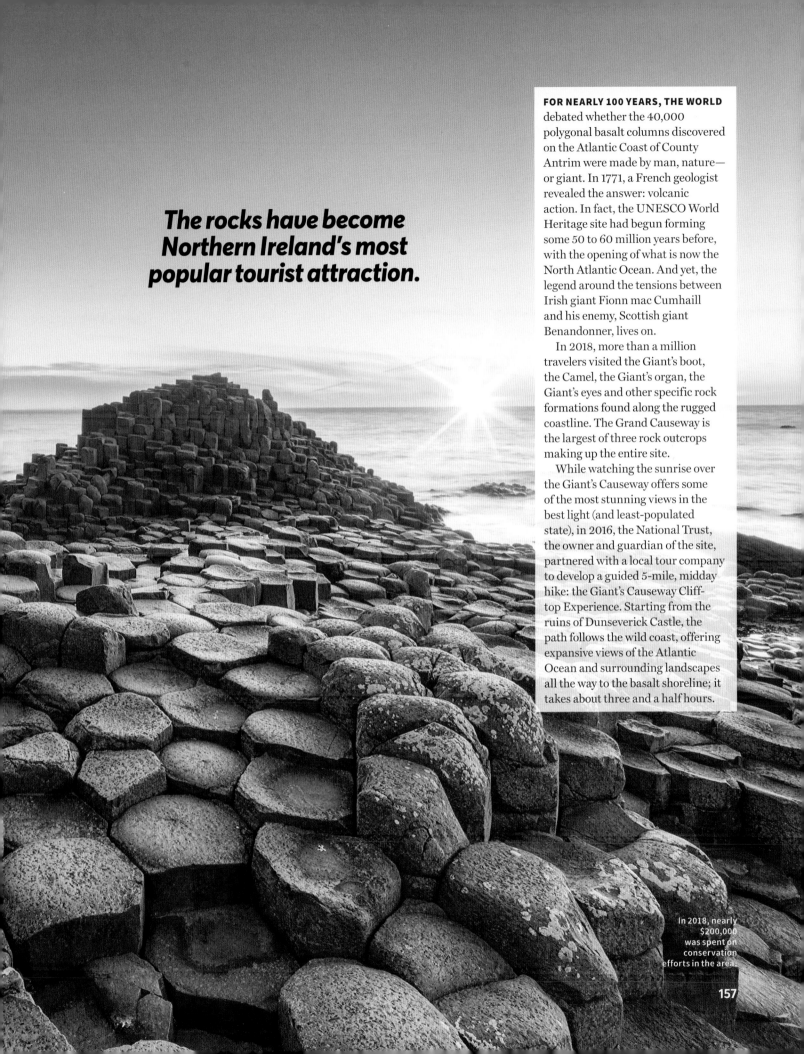

The rocks have become Northern Ireland's most popular tourist attraction.

FOR NEARLY 100 YEARS, THE WORLD debated whether the 40,000 polygonal basalt columns discovered on the Atlantic Coast of County Antrim were made by man, nature— or giant. In 1771, a French geologist revealed the answer: volcanic action. In fact, the UNESCO World Heritage site had begun forming some 50 to 60 million years before, with the opening of what is now the North Atlantic Ocean. And yet, the legend around the tensions between Irish giant Fionn mac Cumhaill and his enemy, Scottish giant Benandonner, lives on.

In 2018, more than a million travelers visited the Giant's boot, the Camel, the Giant's organ, the Giant's eyes and other specific rock formations found along the rugged coastline. The Grand Causeway is the largest of three rock outcrops making up the entire site.

While watching the sunrise over the Giant's Causeway offers some of the most stunning views in the best light (and least-populated state), in 2016, the National Trust, the owner and guardian of the site, partnered with a local tour company to develop a guided 5-mile, midday hike: the Giant's Causeway Cliff-top Experience. Starting from the ruins of Dunseverick Castle, the path follows the wild coast, offering expansive views of the Atlantic Ocean and surrounding landscapes all the way to the basalt shoreline; it takes about three and a half hours.

In 2018, nearly $200,000 was spent on conservation efforts in the area.

Amalfi Coast

ITALY

A UNESCO World Heritage site since 1997, the Amalfi Coast is also home to miles of Italy's best hiking trails.

Live like a celebrity on the six-day **Classic Journeys** small-group tour from Naples, with overnight stays at luxury hotels in **Positano**. Led by a local guide, the itinerary includes a day trip to the ruins of **Pompeii**, several scenic hikes, lunch in **Sorrento**, an afternoon in Amalfi and a tasting at a limoncello factory.

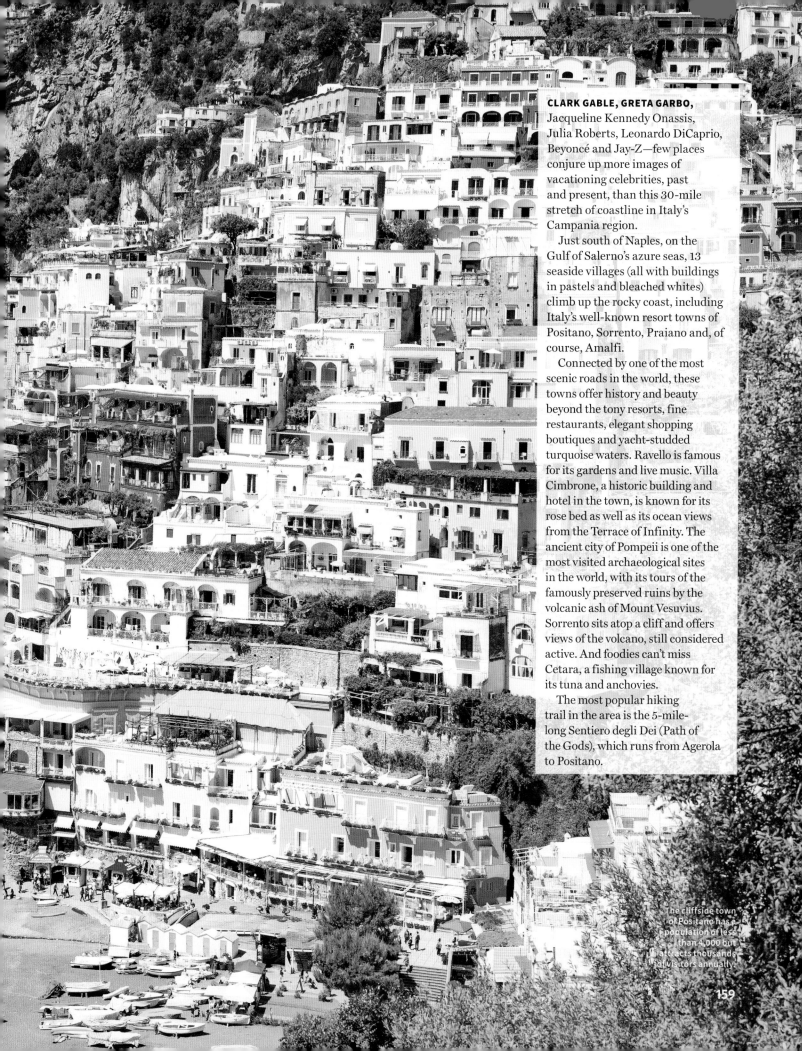

CLARK GABLE, GRETA GARBO, Jacqueline Kennedy Onassis, Julia Roberts, Leonardo DiCaprio, Beyoncé and Jay-Z—few places conjure up more images of vacationing celebrities, past and present, than this 30-mile stretch of coastline in Italy's Campania region.

Just south of Naples, on the Gulf of Salerno's azure seas, 13 seaside villages (all with buildings in pastels and bleached whites) climb up the rocky coast, including Italy's well-known resort towns of Positano, Sorrento, Praiano and, of course, Amalfi.

Connected by one of the most scenic roads in the world, these towns offer history and beauty beyond the tony resorts, fine restaurants, elegant shopping boutiques and yacht-studded turquoise waters. Ravello is famous for its gardens and live music. Villa Cimbrone, a historic building and hotel in the town, is known for its rose bed as well as its ocean views from the Terrace of Infinity. The ancient city of Pompeii is one of the most visited archaeological sites in the world, with its tours of the famously preserved ruins by the volcanic ash of Mount Vesuvius. Sorrento sits atop a cliff and offers views of the volcano, still considered active. And foodies can't miss Cetara, a fishing village known for its tuna and anchovies.

The most popular hiking trail in the area is the 5-mile-long Sentiero degli Dei (Path of the Gods), which runs from Agerola to Positano.

The cliffside town of Positano has a population of less than 4,000 but attracts thousands of visitors annually.

159

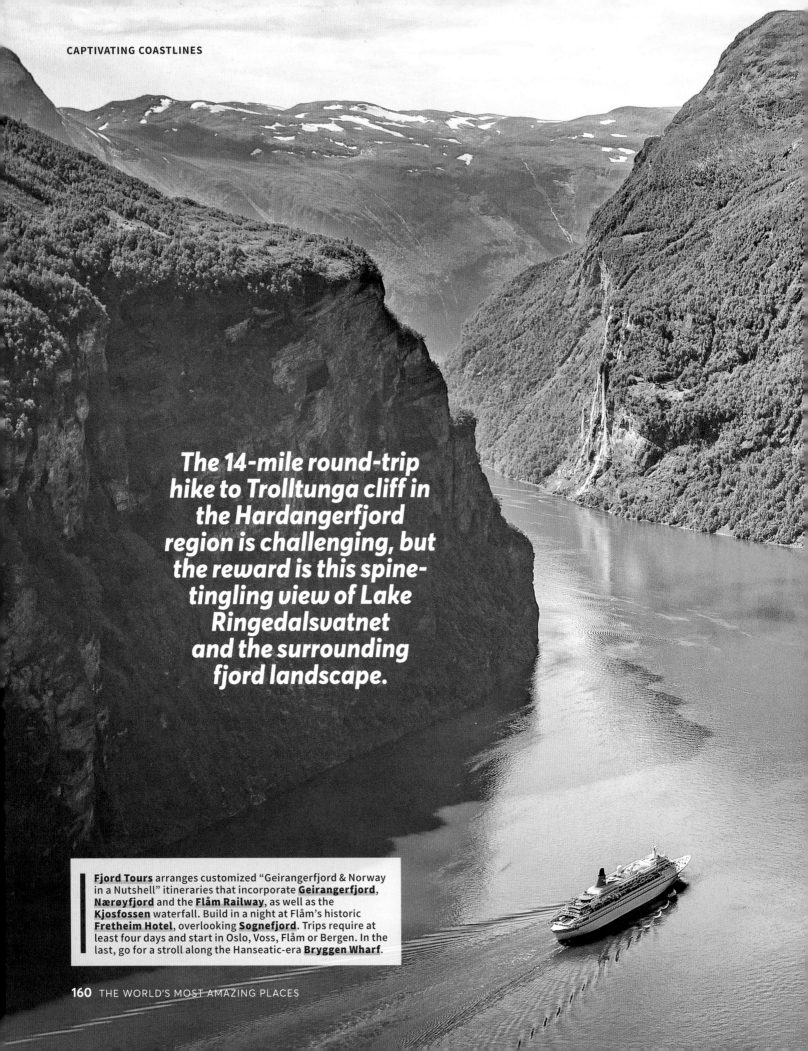

The 14-mile round-trip hike to Trolltunga cliff in the Hardangerfjord region is challenging, but the reward is this spine-tingling view of Lake Ringedalsvatnet and the surrounding fjord landscape.

Fjord Tours arranges customized "Geirangerfjord & Norway in a Nutshell" itineraries that incorporate **Geirangerfjord**, **Nærøyfjord** and the **Flåm Railway**, as well as the **Kjosfossen** waterfall. Build in a night at Flåm's historic **Fretheim Hotel**, overlooking **Sognefjord**. Trips require at least four days and start in Oslo, Voss, Flåm or Bergen. In the last, go for a stroll along the Hanseatic-era **Bryggen Wharf**.

Norwegian Fjords

FJORDS (LONG, DEEP INLETS BETWEEN high cliffs) are found all over the world, from Chile and New Zealand to Canada and Alaska. But it is Norway's fjords—specifically Nærøyfjord and Geirangerfjord—that wrote the book. So archetypal were these two southwesterly fjords, in fact, that UNESCO listed them together as a World Heritage site in 2005.

More than 1,000 fjords—formed when seawater poured into the U-shaped valleys left behind by retreating ice-age glaciers— dot Norway's Atlantic coast. Of these, the country's 200 West Norwegian Fjords get the most attention, thanks to their breathtaking mix of high and steep cliffs, rushing rivers and tumbling waterfalls fed by melting glaciers high above.

Popular tours transport visitors between the cities of Oslo and Bergen, combining cruises past the fjords' crystalline rock walls, verdant valleys and quiet villages with a ride on the Flåm Railway, one of the steepest standard-gauge tracks in the world. Not surprisingly, Nærøyfjord and Geirangerfjord headline many of these trips; set 75 miles apart, their near-vertical mountains rise 4,593 feet from the Norwegian Sea and continue 1,640 feet below sea level.

Daily life in Fjord Norway's small villages hasn't changed much in 30 years, despite the ever-increasing number of tourists drawn by affordable new flight options and the chance to walk in the footsteps of *Frozen*'s Anna and Elsa. Locals maintain long-held traditions and continue to live off the land, growing fruit, rearing sheep and making cheese. As travelers sail past, they can only begin to appreciate the stark beauty that has presided over this windswept coast for thousands of years.

More than a million visitors make the trek to Geirangerfjord each year.

The world's first overwater bungalow was invented on these islands 50 years ago, and now more than 20 Tahitian resorts feature rooms hovering mere feet above clear lagoons.

Tahiti is home to the only museum in the world dedicated solely to pearls.

On Bora Bora, feed blacktip sharks and snorkel the luminous coral-garden reef on an outrigger day tour with **Lagoon Service**. Devour Tahiti's signature dish, *poisson cru* (ahi tuna ceviche bathed in coconut milk) and sip local Hinano beer at **Four Seasons Resort Bora Bora**. Don fresh leis and watch as tiki torches light up Polynesian performers at **Sofitel Bora Bora Private Island Resort**. **Le Meridien Bora Bora** boasts bungalows with the largest glass floors in the archipelago. On Tetiaroa, sleep in a thatched beach villa on Marlon Brando's own private atoll, now home to **The Brando** resort.

Islands of Tahiti

A HIDDEN CONSTELLATION OF 118 specks of land lost in the South Pacific, the Islands of Tahiti exude exotic luxury. With their unique fusion of French and Polynesian culture, lush volcanic peaks and aquamarine lagoons, these islands are the holy grail of secluded paradise.

Under France's protection since 1842, the destination is clustered into five archipelagos, the most westerly being the Society Islands. Here, an eight-hour flight from Los Angeles lands travelers on the largest island of Tahiti. A lush mountain isle encircled by black-sand beaches and coral reefs, Tahiti is the best place to shop for black pearls, Tahitian vanilla and fragrant monoi oil.

From Tahiti, ferries shuttle visitors to the emerald-green cliffs and waterfalls of Moorea. Interisland flights transport adventurers farther west, to the untamed forests of Huahine, the tranquil coral heads of Tahaa and the Polynesian cultural homeland of Raiatea—whose sacred Taputapuatea marae complex was named the country's first UNESCO World Heritage site in 2017.

Then, of course, there is Bora Bora, the most iconic isle of the Society archipelago. At its heart is 2,385-foot Mount Otemanu, visible from every part of the island.

Some of the world's best snorkeling and diving surround the Fakarava atoll. The landscape here is so pristine, it was designated a UNESCO Biosphere Reserve, where whales, manta rays and dolphins play against a backdrop of fluorescent corals. This beauty below is only rivaled by the impossibly vibrant shades of turquoise, white, green and blue above.

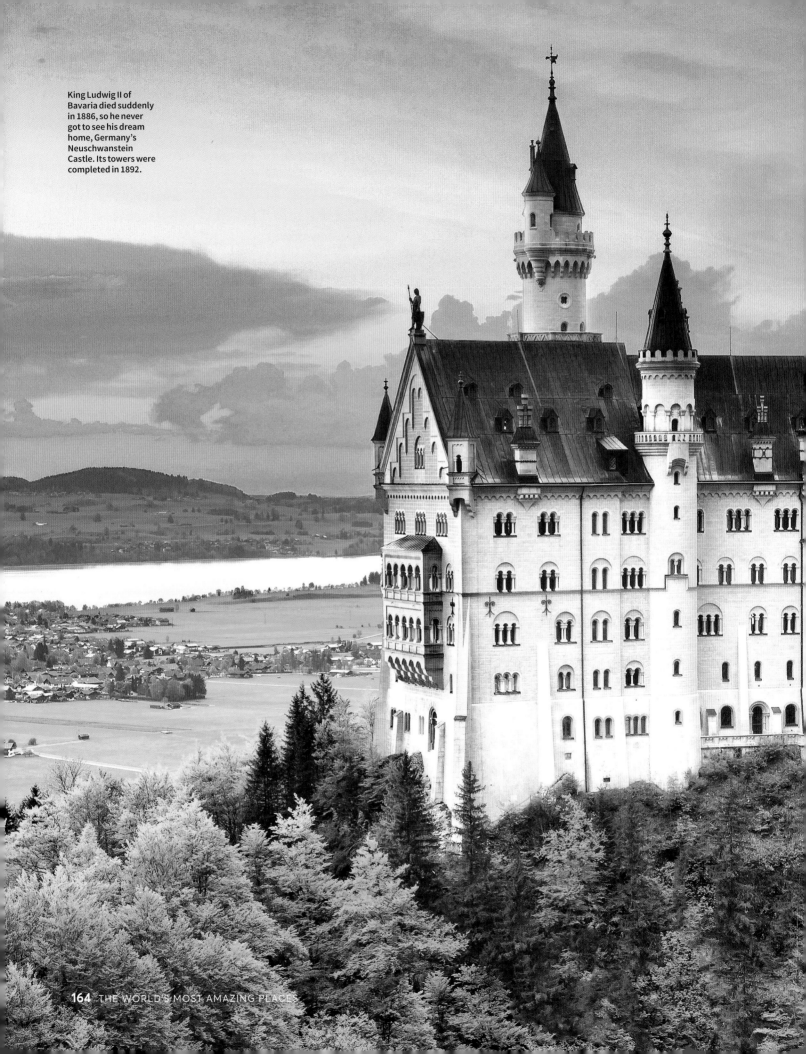

King Ludwig II of Bavaria died suddenly in 1886, so he never got to see his dream home, Germany's Neuschwanstein Castle. Its towers were completed in 1892.

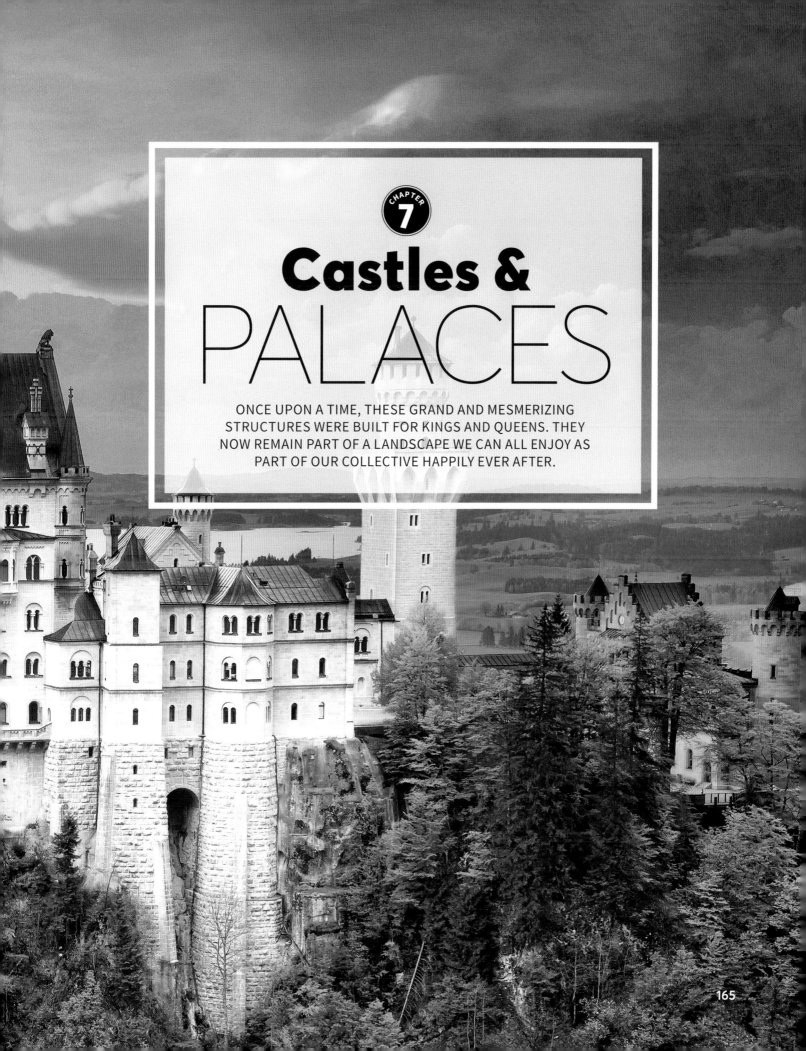

CHAPTER 7
Castles & PALACES

ONCE UPON A TIME, THESE GRAND AND MESMERIZING STRUCTURES WERE BUILT FOR KINGS AND QUEENS. THEY NOW REMAIN PART OF A LANDSCAPE WE CAN ALL ENJOY AS PART OF OUR COLLECTIVE HAPPILY EVER AFTER.

Queen Elizabeth II passes the majority of her private weekends at Windsor Castle, the biggest and oldest occupied castle on Earth.

ARGUABLY THE MOST FAMOUS CASTLE IN the world, Windsor Castle checks all the boxes: crenelated towers, imposing masonry, lavish royal rooms. But this 13-acre estate, which overlooks the River Thames 25 miles west of London, didn't start out as the majestic stone structure it is today. Its nearly 1,000-year history goes back to around 1070, when William the Conqueror began constructing a wooden fortress on the site.

Over the centuries, some 39 kings and queens made their mark on the structure, expanding and redecorating it. Henry I, who married at Windsor Castle in 1121, was the first monarch to use the stronghold as a residence. His grandson Henry II added true royal apartments and began replacing the timber walls with stone. In the 14th century, Edward III restored the castle in Gothic style. But George IV is most credited for giving the palace its current look—fashioning the romantic "castle" facade and extravagantly furnishing the inside in the 1820s.

In 1845, Queen Victoria first opened the State Apartments to the public, and today's visitors can still tour these sumptuous suites, along with the ornate Semi-State Rooms, the gilded Grand Reception Room and the historic St. George's Chapel, which hosted the 2018 wedding of the now reluctant royals Prince Harry and Meghan Markle. Today, the castle continues to be used as a functioning home and a grand venue for state and ceremonial engagements. It's living history in action—a fascinating window into the life of the crown.

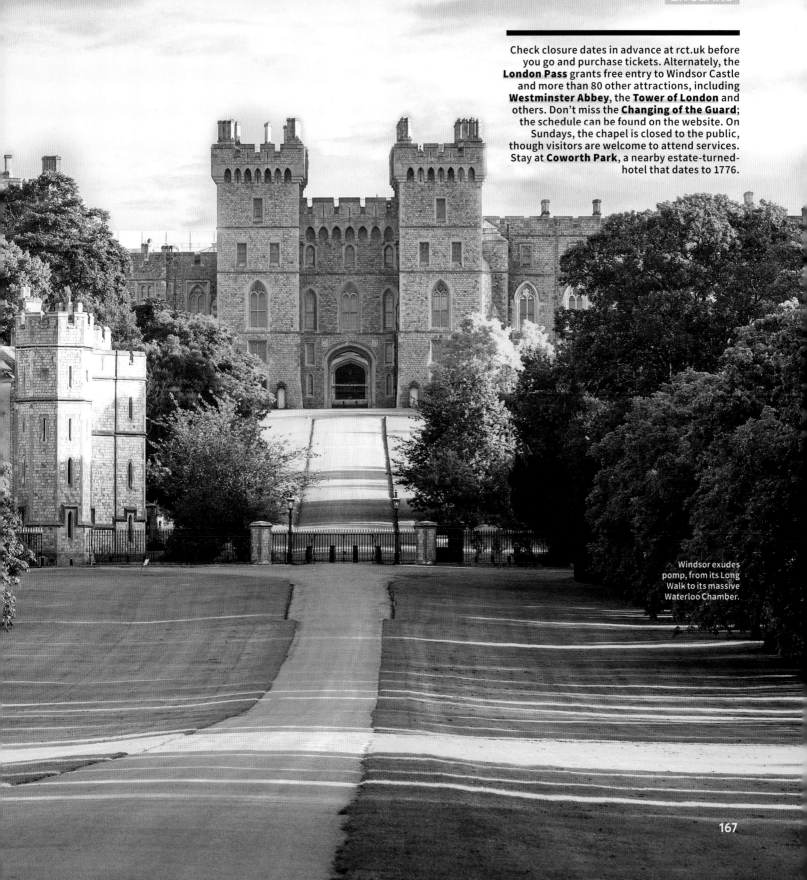

Windsor Castle

Check closure dates in advance at rct.uk before you go and purchase tickets. Alternately, the **London Pass** grants free entry to Windsor Castle and more than 80 other attractions, including **Westminster Abbey**, the **Tower of London** and others. Don't miss the **Changing of the Guard**; the schedule can be found on the website. On Sundays, the chapel is closed to the public, though visitors are welcome to attend services. Stay at **Coworth Park**, a nearby estate-turned-hotel that dates to 1776.

Windsor exudes pomp, from its Long Walk to its massive Waterloo Chamber.

Swallow's Nest

YALTA, CRIMEA

HOVERING 130 FEET ABOVE THE Black Sea, near the resort town of Yalta, Swallow's Nest castle seems oblivious to the controversy swirling around its location: Crimea, a subtropical peninsula stretching from the south of Ukraine. Russia has occupied the region since 2014, and the U.S. State Department has declared it unsafe for American travelers. Currently, the castle welcomes mainly Russian tourists, although it remains on "most amazing castles" lists—and for good reason.

Built in 1912, the neo-Gothic structure was the holiday residence of German oil magnate Baron von Steingel. Despite its small size, the castle quickly drew attention for its fanciful facade and precarious setting extending over the edge of the Aurora Cliff.

In 1927, Swallow's Nest withstood a major earthquake that caused part of the rock face to crumble into the sea. Afterward, the castle sat neglected for decades; more recent restorations transformed the interior first into a restaurant, then into rotating exhibition spaces.

Though few Americans will see this monument in person, it remains a proud symbol of Crimea—a disputed land of undisputable beauty.

Intrepid visitors climb 800 steps to reach this celebrated landmark.

The U.S. State Department has issued a "Level 4: Do Not Travel" advisory for Crimea and is not able to provide emergency services to U.S. citizens in the region. Determined travelers can visit by way of Russia on a Russian visa; the flight from **Moscow** takes 2.5 hours. Work with a reputable tour operator, such as **Crimea Travels**, founded by a Canadian couple in 2016. Be aware that entering Crimea without crossing a Ukrainian border may prohibit you from entering Ukraine in the future.

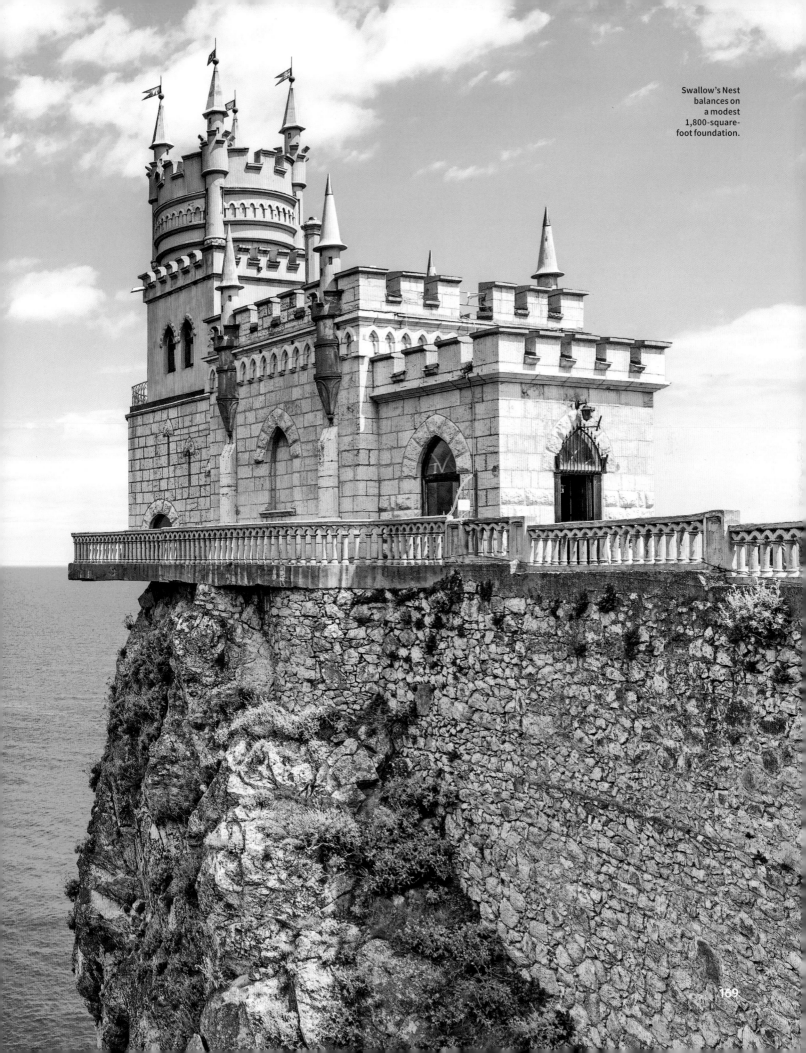

Swallow's Nest balances on a modest 1,800-square-foot foundation.

Bran Castle

BRAN, ROMANIA

THE STORY GOES THAT AN ILLUSTRATION of Bran Castle inspired the description of the fictional castle in Bram Stoker's 1897 novel, *Dracula*. The two castles are remarkably similar: Both overlook a river valley from a high, rocky perch in Transylvania. The main character also bears a resemblance to the real-life figure of Vlad Tepes (or Vlad Dracula, meaning "son of Dracul"), a 15th-century Romanian prince allied with the castle and notorious for impaling traitors.

Historians debate the veracity of the connection, and locals are similarly divided: Some pooh-pooh the correlation, while others capitalize on it. Like it or not, the association is here to stay.

Built in 1388, the citadel served for centuries as a fortress and a customs post before being gifted to Queen Maria of Romania by her subjects in 1920. The castle was transformed into a royal residence by the queen, whose heirs continued to live there until 1948, when they were exiled by the newly instated communist regime. It wasn't until 2009 that the castle would be legally returned to the royal family, who happily share it with an eager public.

Tourists unanimously delight in the air of mystery and foreboding that surround the castle, but the reality is far from sinister.

Bran Castle is open daily; fight fewer crowds during the October-to-March low season. Savor classic local specialties in the **Casa de Ceai** restaurant, located on the grounds. Many other attractions surround the castle, including **Rasnov Fortress**, **Peles Castle** and, farther out, the medieval towns of **Sibiu** and **Sighisoara** (birthplace of Vlad Dracula). Markets just outside the castle sell souvenirs, from Romanian handicrafts to vampire coffee mugs.

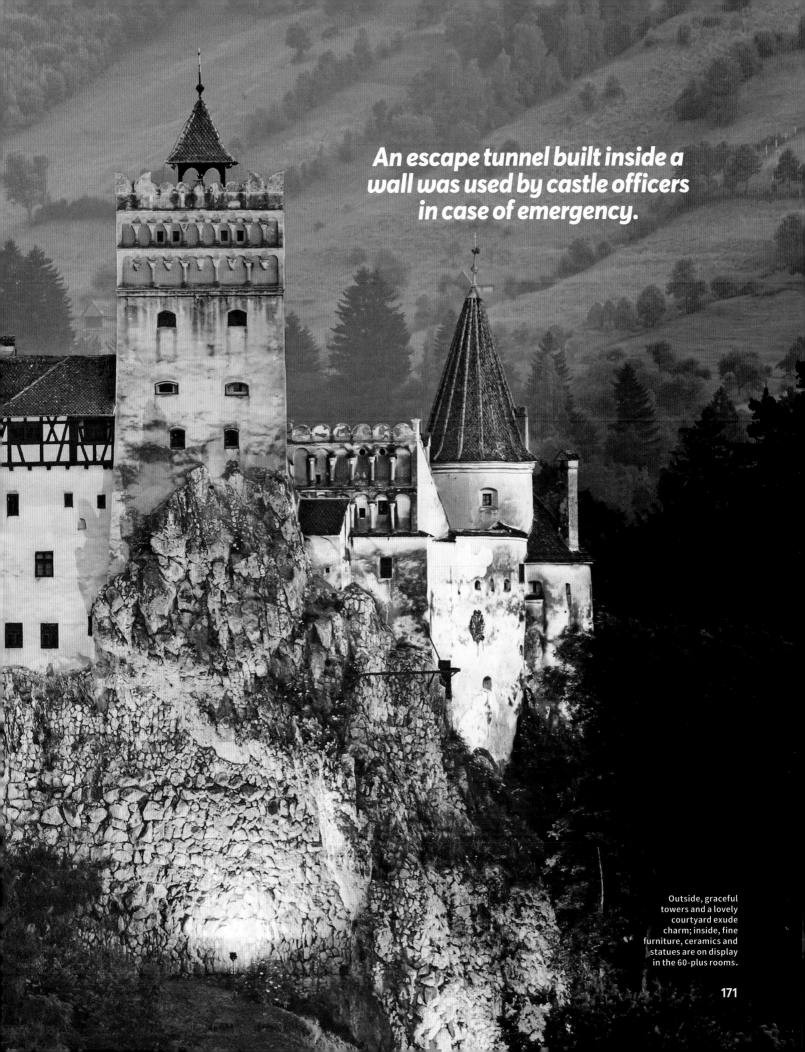

An escape tunnel built inside a wall was used by castle officers in case of emergency.

Outside, graceful towers and a lovely courtyard exude charm; inside, fine furniture, ceramics and statues are on display in the 60-plus rooms.

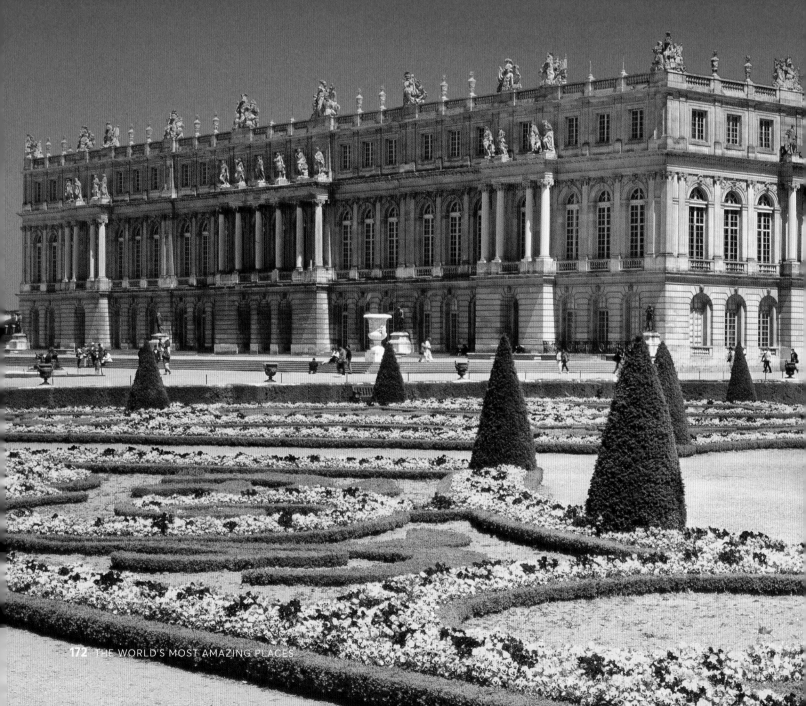

Château de Versailles

VERSAILLES, FRANCE

The First World War ended here in 1919 with the signing of the Treaty of Versailles.

SPREAD OVER MORE THAN 15 acres and boasting 2,300 rooms with 60,000-plus works of art, the Château de Versailles is one of the largest palace estates in the world. Construction began in 1631 under Louis XIII, with the intention of providing a modest hunting lodge. During the reign of his son Louis XIV (better known as the Sun King), the estate grew exponentially and became an expression of power and authority as well as the center for grand parties, which continued into the reigns of other French monarchs—including its most infamous residents, King Louis XVI and Queen Marie Antoinette.

To reconcile with citizens after the French Revolution, King Louis-Philippe converted the Royal Palace into a museum in 1831. Emblazoned outside the château are the words *A Toutes Les Glories de la France*, meaning: "To all the glories of France." And that is no exaggeration.

Today, the estate has five parts: the Gardens, which took 40 years to complete; the Park, spanning 1,900 acres; the Gallery of Coaches, a collection of carriages and fantastical vehicles; the Estate of Trianon, with two royal residences built for Marie Antoinette's amusement; and the palace itself.

The C line of the RER train stops at Versailles Château—Rive Gauche, which is a 10-minute walk to the Palace. Those under the age of 18 (or under 26, for residents of the European Union) receive free access to the Palace and the Estate of Trianon. For a more royal treatment, book a day trip from Paris with skip-the-line access through a company like **City Wonders** or **Guidatours**.

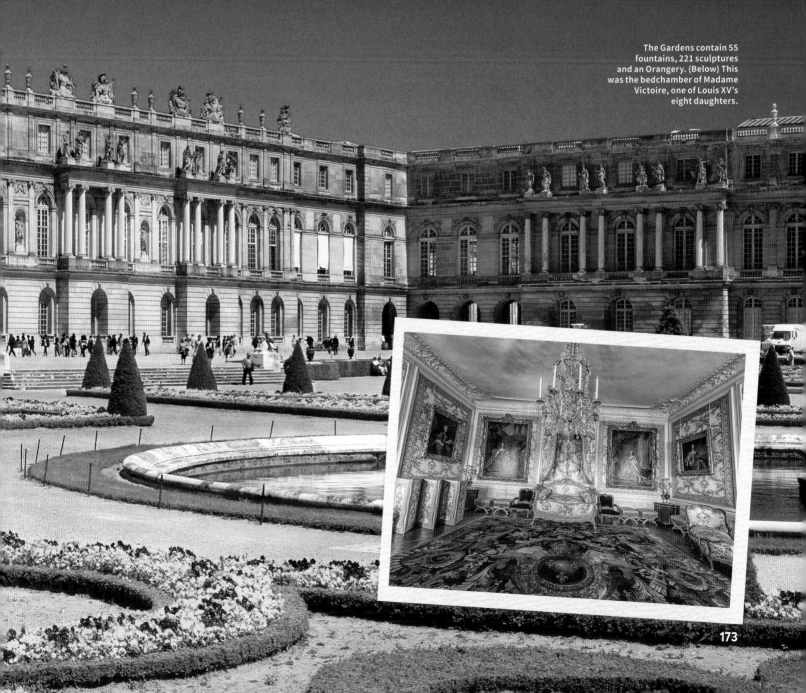

The Gardens contain 55 fountains, 221 sculptures and an Orangery. (Below) This was the bedchamber of Madame Victoire, one of Louis XV's eight daughters.

173

Himeji Castle

HIMEJI, JAPAN

THE FIRST THING VISITORS DISCOVER upon entering Himeji Castle, built in 1609, is how easy it is to get lost. The maze of passages connecting the three watchtowers was designed to confuse invaders, thus preventing them from reaching the central keep.

Other defensive features include a moat, 84 gates (21 are still intact) and windows with mechanisms for dropping stones on enemies below. As it happens, the castle never did come under attack, and a five-year program of extensive renovations has also contributed to its impressive state of preservation.

Both a UNESCO site and a Japan National Treasure, Himeji Castle is one of the largest castles in the country, featuring 75 buildings connected by intersecting paths. Its multiple white-plastered tiers, resembling a bird with beating wings, earned it the nickname the White Heron Castle. The surrounding wall dates from 1346, when warlord Toyotomi Hideyoshi first established a stronghold here.

Savvy sightseers keep an eye out for architectural subtleties designed to indicate status. For example, in Princess Senhime's quarters of Nishinomaru, the corridor slants gradually upward, elevating each room slightly above the next to reflect the rank of the resident.

Just inside the Hishi gate, the outer garden is free and open to the public, and its cherry-tree-lined paths and green lawns are popular for walking and picnicking.

Himeji majestically stands as one of Japan's original castles, 12 of which remain.

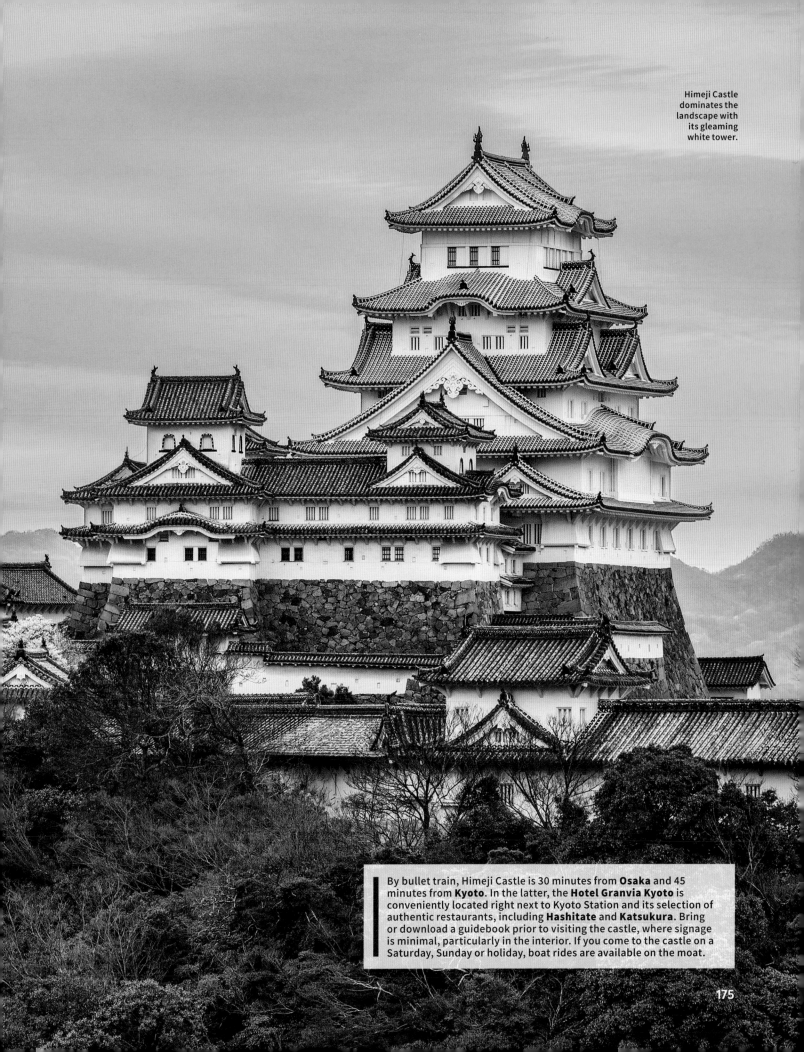

Himeji Castle dominates the landscape with its gleaming white tower.

By bullet train, Himeji Castle is 30 minutes from **Osaka** and 45 minutes from **Kyoto**. In the latter, the **Hotel Granvia Kyoto** is conveniently located right next to Kyoto Station and its selection of authentic restaurants, including **Hashitate** and **Katsukura**. Bring or download a guidebook prior to visiting the castle, where signage is minimal, particularly in the interior. If you come to the castle on a Saturday, Sunday or holiday, boat rides are available on the moat.

175

Neuschwanstein Castle

SCHWANGAU, GERMANY

WITH SOARING TURRETS, SQUARE towers and Gothic arches rising from the slopes of the Bavarian Alps, Neuschwanstein Castle appears straight out of a fairy tale—a fact not lost on Walt Disney, who chose it as the model for Disneyland's Sleeping Beauty Castle.

While it looks positively medieval, Neuschwanstein was built in the late 19th century, commissioned by King Ludwig II to fulfill his fantasy of ruling as royalty after he'd been all but stripped of his power by Prussian conquest. And true to the extravagant nature of the man some called "the mad king," he hired not an architect but a theater designer to develop the gravity-defying Romanesque palace.

Only 19 when he ascended to the throne and a true romantic, Ludwig took inspiration from the operas of his friend Richard Wagner when decorating Neuschwanstein (which translates as "New Swan") with fantastical abandon. In addition to the two-story Byzantine throne room done up almost entirely in gold, the king incorporated an artificial indoor grotto that originally flaunted an artificial waterfall.

Every year, 1.5 million visitors come to see the cliffside castle, which was still incomplete on Ludwig's death in 1886 but opened to the public a few years later. Some parts of the castle were never finished, and an informative film explores the extent of Ludwig's complete vision.

One of the most spectacular features is actually outside the castle: Marienbrücke, or Mary's Bridge, seems to float over a gorge between sheer rock walls, offering the best view of the castle from its span.

Neuschwanstein Castle receives the most visitors of any castle in Germany and is one of the most popular tourist attractions in all of Europe.

You must make reservations at least two days in advance in order to visit the castle, which is an easy day trip from **Munich** by train. From the village of **Füssen** it's a 10-minute bus ride to the village of **Hohenschwangau**, where you can also visit its eponymous castle, which was Ludwig's childhood home. You'll find the area's best restaurants in Füssen, where **Madame Plüsch** offers a fresh take on traditional German food in a cozy setting.

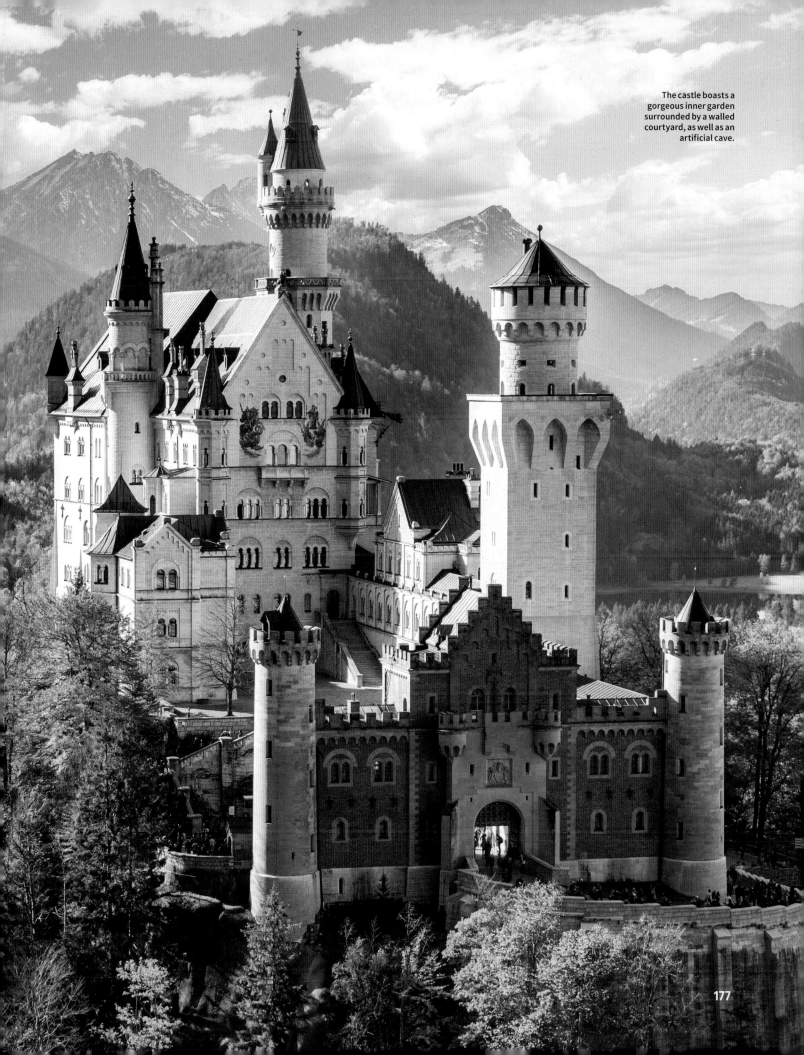

The castle boasts a gorgeous inner garden surrounded by a walled courtyard, as well as an artificial cave.

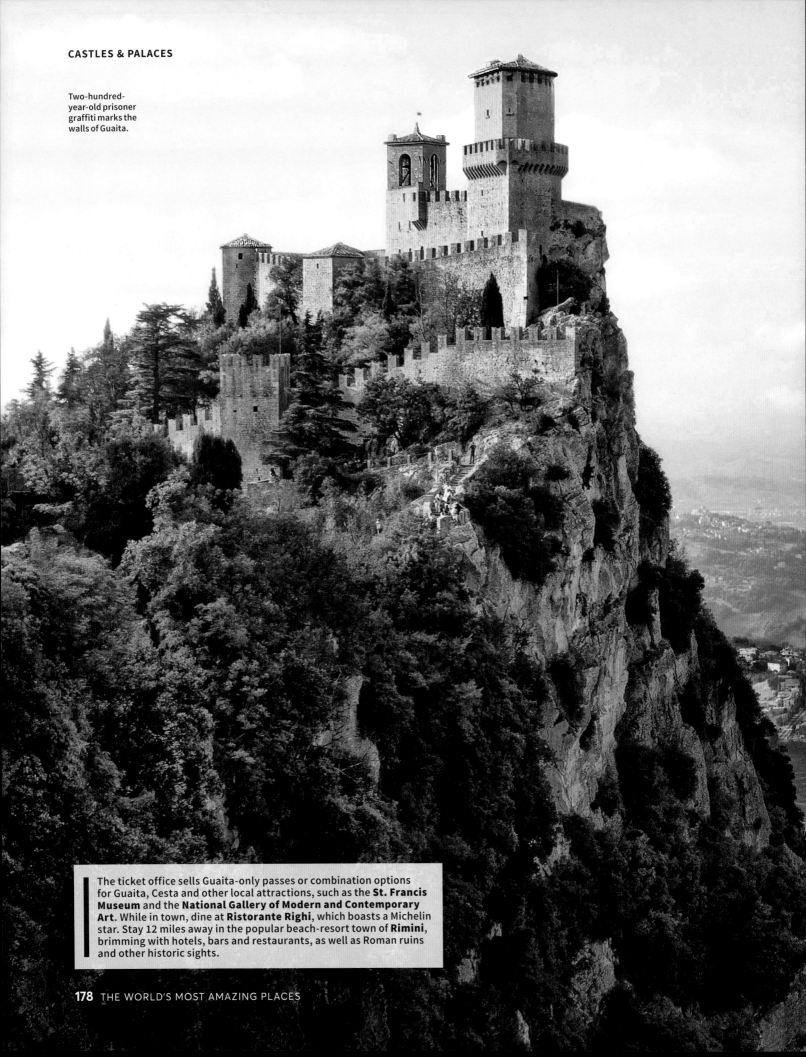

Two-hundred-year-old prisoner graffiti marks the walls of Guaita.

The ticket office sells Guaita-only passes or combination options for Guaita, Cesta and other local attractions, such as the **St. Francis Museum** and the **National Gallery of Modern and Contemporary Art**. While in town, dine at **Ristorante Righi**, which boasts a Michelin star. Stay 12 miles away in the popular beach-resort town of **Rimini**, brimming with hotels, bars and restaurants, as well as Roman ruins and other historic sights.

Guaita Castle

Guaita towers over San Marino's historic town center, which has been UNESCO-listed since 2008.

EVEN FREQUENT TRAVELERS COULD BE forgiven for not knowing about San Marino, one of the world's smallest countries and oldest republics. A mere 23 square miles and surrounded on all sides by The Boot, it's the last of the Italian city-states that subdivided the region in the Middle Ages. And its great symbol is Guaita, an 11th-century defensive tower that presides over the destination from 2,500 feet.

Two other fortresses also rise from the peaks of Mount Titano: Cesta (the highest) and Montale (the smallest). Since the 13th century, San Marino's high, rocky setting and resilient fortifications protected its residents from invasion and isolated them from urbanization, contributing to the site's current charm.

Guaita's stone ramparts afford breathtaking views of the Apennine Mountains and the sister tower of Cesta, also open to the public. Likewise, sightseers climb Cesta for the classic outlook toward Guaita (a Museum of Ancient Weapons is also located inside Cesta).

More than 3 million visitors descend on this modest nation every year—a testament to the allure of this medieval enclave, where time has stood still.

Perched on a São Pedro de Penaferrim hill, the palace can be seen from any spot in the park.

The 40-minute train from Lisbon is the fastest way to Sintra. Across from the station is **Green Walk**, which provides customized Jeep tours to the region's highlights. For a more in-depth adventure through Portugal, including a Sintra stop, join the eight-day **G Adventures National Geographic Journeys Discover Portugal** itinerary.

Palace of Pena

WITH DOZENS OF CASTLES SCATTERED throughout Portugal, none is more vibrantly stunning than Palácio da Pena. Made up of two distinct wings, the original structure—the exterior of which is entirely colored red—was the site of a monastery sanctioned by King Manuel I in 1511. When it fell into ruin, King Ferdinand II purchased it at auction in 1838 and began construction on the ocher-colored "new" palace in 1843. The unified space, its interiors a glorious mash-up of Moorish, Gothic, traditional European and Islamic influences, took two decades to complete and is today considered one of the grandest examples of Romantic architecture in the world. In fact, Hans Christian Andersen's fantastical tales are said to have been inspired by the castle.

Just as impressive is the sprawling Park of Pena—an expanse of 200-plus acres of manicured gardens and lush woodlands, home to more than 500 species of trees, waterfalls, lakes and fountains.

On the park's western end sits the Chalet of the Countess of Edla, a summer residence built in 1864 for King Ferdinand's second wife, Elise Hensler. The charming two-story home, inspired by Alpine chalets, offers views of the Palace of Pena, the nearby Moorish Castle and the Cruz Alta, the highest point in the Serra de Sintra. After King Ferdinand's death in 1885, the countess lived in the Chalet until 1904. In 1995, UNESCO declared the Sintra hills, including the Chalet's location, a World Heritage site.

The interior of the castle reflects 19th-century Romantic architecture style.

Alhambra

GRANADA, SPAIN

The palace was the residence of the Islamic royalty who once ruled the region.

THE WORD *FORTRESS* SOUNDS foreboding, but when a hilltop stronghold is designed with Moorish grandeur and set in sunny Andalusia, the result is stunning. That's the Alhambra, named for the red color of its walls (*qa'lat al-Hamra* means Red Castle in Arabic). Its origins trace back to the 13th century, when Mohammed I of the Nasrid dynasty established a royal residence here. But it was Yusuf I and Mohammed V, in the 14th century, who dreamed up the structures we most appreciate today: the Nasrid Palaces, the Patio of the Lions, the Justice Gate, the Camares Room and the Alcazaba.

Visitors feel instantly in awe of the craftsmanship of the era. The Nasrid kings covered every square inch of their palaces with carvings, ceramics and plasterwork and reveled in the symmetry of grand arches and slender pillars. Travelers linger in the mesmerizing Palace of the Lions and pose against the mossy green reflecting pool of the Court of the Myrtles.

There are exceptional gardens as well—if the carvings and ceramics don't make guests swoon, the cypresses and roses certainly will.

The Alhambra is open daily except Christmas and New Year's Day; visit alhambradegranada.org to buy tickets in advance (highly recommended). You must enter the Nasrid Palaces only during the time indicated on your ticket. Daytime tours are most comprehensive, while evening visits require choosing between the Nasrid Palaces and the gardens. Stay at **Hotel Hospes Palacio de los Patos**, a 19th-century palace in the center of town that juxtaposes the historic and the modern.

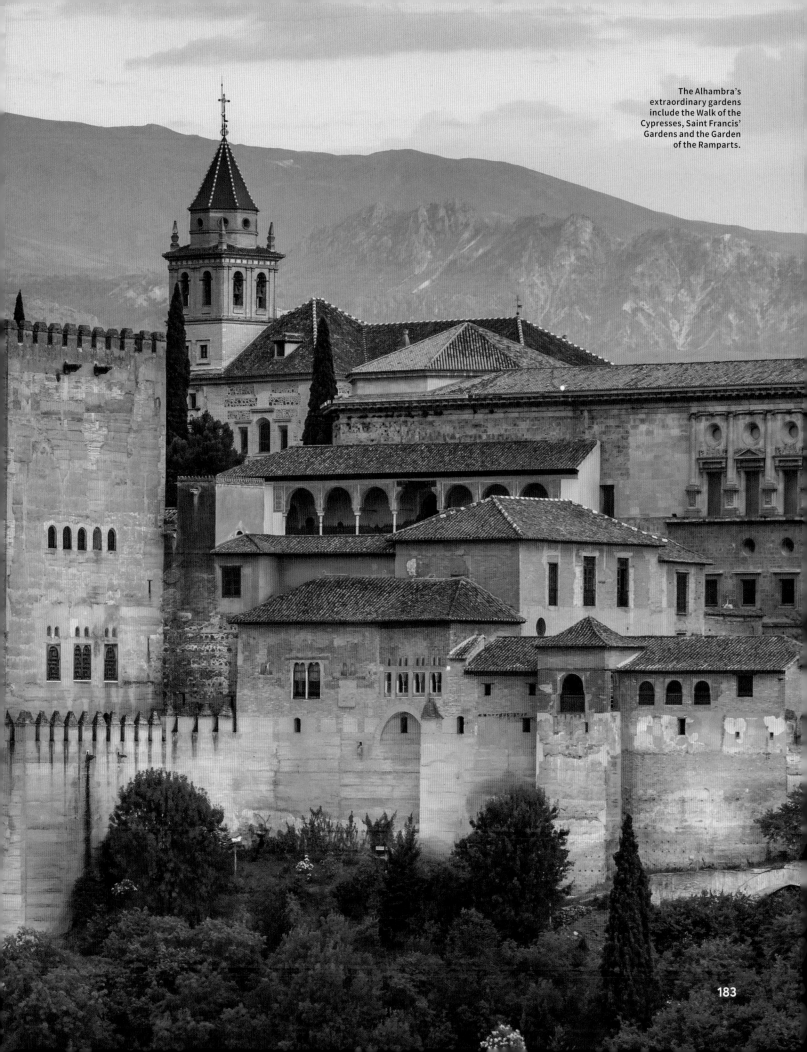

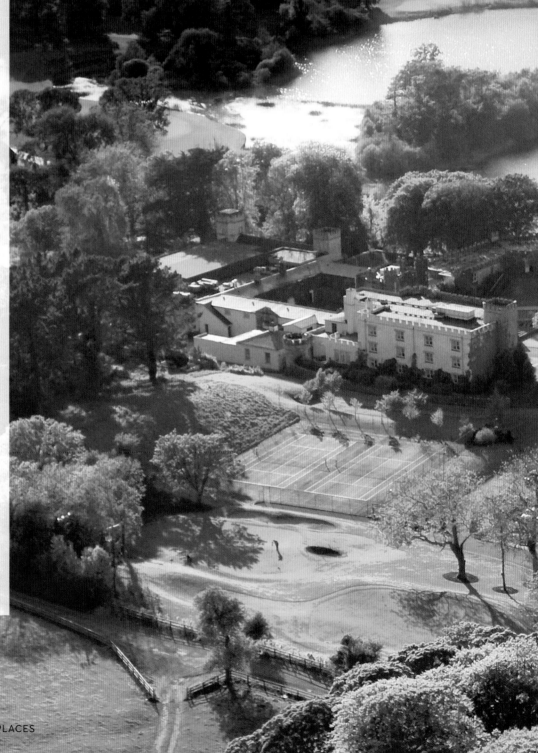

Dromoland Castle

COUNTY CLARE, IRELAND

WANT TO LIVE OUT YOUR IRISH-ROYALTY or *Game of Thrones* (minus the high stakes) fantasies? Dromoland Castle is the place. It dates to the 16th century and was once the home of the O'Brien family, the Kings of Thomond, whose lineage traces back to the High King of Ireland, Brian Boru. Its gray, Gothic-style stone walls tell tales of a storied past, which includes nearly being gambled away in a horse race in the 18th century, and threats of destruction by the IRA in the 1920s.

Transformed into a luxury hotel in 1962, the castle's main areas are frozen in time—life-size paintings of royalty line the walls; suits of armor guard the hallways. Afternoon tea is served in the main drawing room or the formal rose garden, followed by six-course meals under antique chandeliers in Earl of Thomond's Restaurant. The baronial vibe continues in the 98 rooms and suites, fitted with four-poster beds, specially commissioned wall fabrics and bespoke furnishings. The two-story Honeymoon Suite is what happily-ever-after dreams are made of: It features a sitting room, a dining area, a bedroom and a Jacuzzi tub, all lodged in one of the castle's turrets.

The estate's grounds are a 450-acre emerald playground: Deer and pheasant pass through to drink from the lily pond. Guests can play a round at the golf course, fish for trout in the lake or unwind in the spa. At night, patrons gather in the Library Bar for Irish whiskey and lively sing-alongs. After a stay here, even cynics will acknowledge that fantasies can come to life.

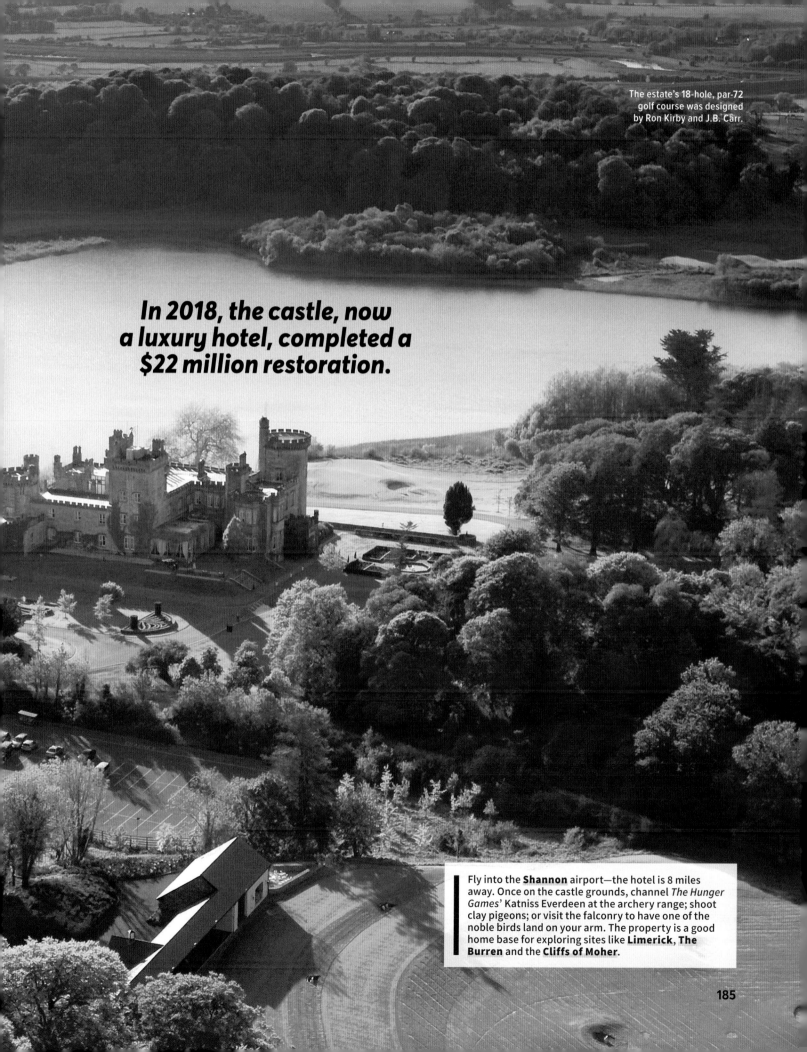

The estate's 18-hole, par-72 golf course was designed by Ron Kirby and J.B. Carr.

In 2018, the castle, now a luxury hotel, completed a $22 million restoration.

Fly into the **Shannon** airport—the hotel is 8 miles away. Once on the castle grounds, channel *The Hunger Games*' Katniss Everdeen at the archery range; shoot clay pigeons; or visit the falconry to have one of the noble birds land on your arm. The property is a good home base for exploring sites like **Limerick**, **The Burren** and the **Cliffs of Moher**.

185

SPECIAL THANKS TO CONTRIBUTING WRITERS
MEGAN AFTOSMIS, JAMIE BLYNN, JACKIE CARADONIO,
LISA CHAMBERS, RACHEL CHANG, JOYCE CHEN, AMY CASSELL,
ABBY FEINER, SARAH WASSNER FLYNN, MELANIE HAIKEN,
DONNA HEIDERSTADT, VICKY HODGES, BROOKE KASIR,
REBECCA KINNEAR, JENNA MAHONEY, KATIE MCELVEEN, BROOKE MORTON,
MEREDITH ROSENBERG, AUDREY ST. CLAIR, KIMBERLY SMALL

CENTENNIAL BOOKS

An Imprint of
Centennial Media, LLC
40 Worth St., 10th Floor
New York, NY 10013, U.S.A.

CENTENNIAL BOOKS is a trademark of Centennial Media, LLC

ISBN 978-1-951274-18-4

Distributed by
Simon & Schuster, Inc.
1230 Avenue of the Americas
New York, NY 10020, U.S.A.

For information about custom editions, special sales and premium and corporate purchases,
please contact Centennial Media at contact@centennialmedia.com.

Manufactured in Singapore

Publishers & Co-Founders Ben Harris, Sebastian Raatz
Editorial Director Annabel Vered
Creative Director Jessica Power
Executive Editor Janet Giovanelli
Deputy Editors Ron Kelly, Alyssa Shaffer
Design Director Ben Margherita
Art Director Andrea Lukeman
Art Directors Natali Suasnavas, Joseph Ulatowski
Photo Editor Kim Kuhn
Production Manager Paul Rodina
Production Assistant Alyssa Swiderski
Editorial Assistant Tiana Schippa